THE SOUL OF THE SAVANNA

How Wild Animals Feel

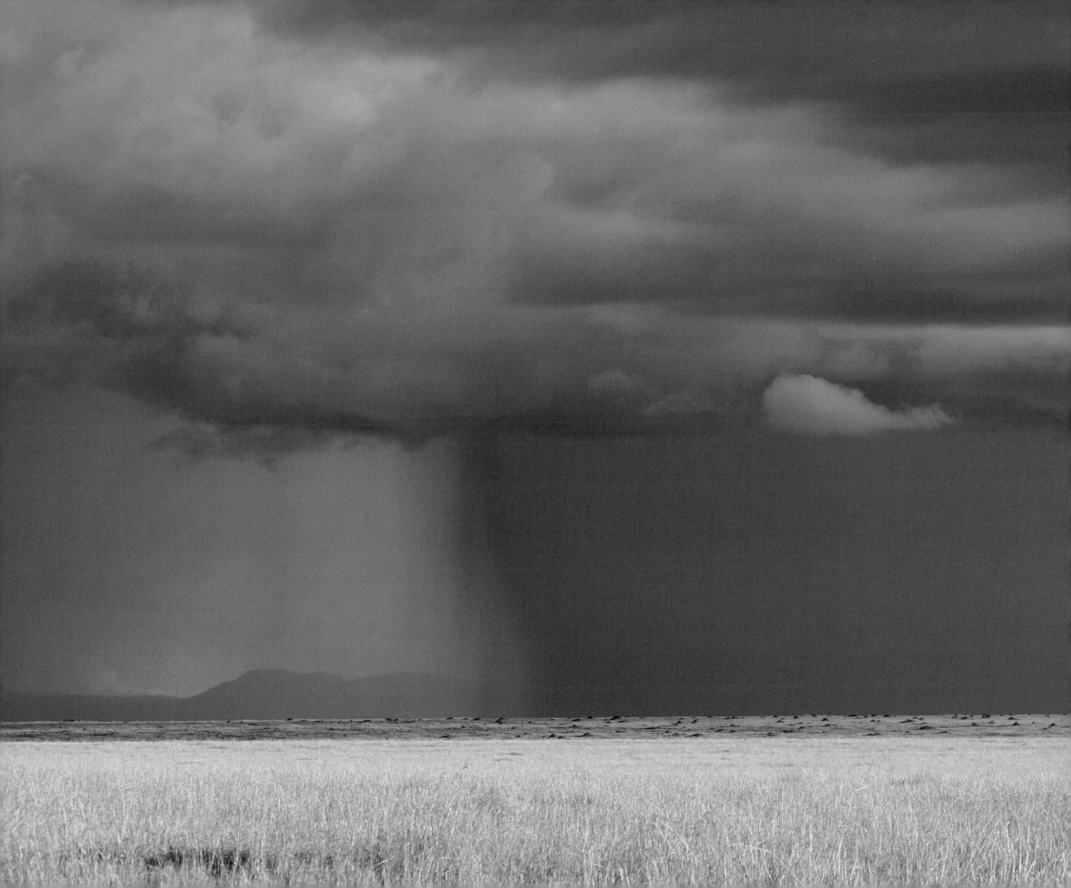

Gabriela Staebler

THE SOUL OF THE SAVANNA

How Wild Animals Feel

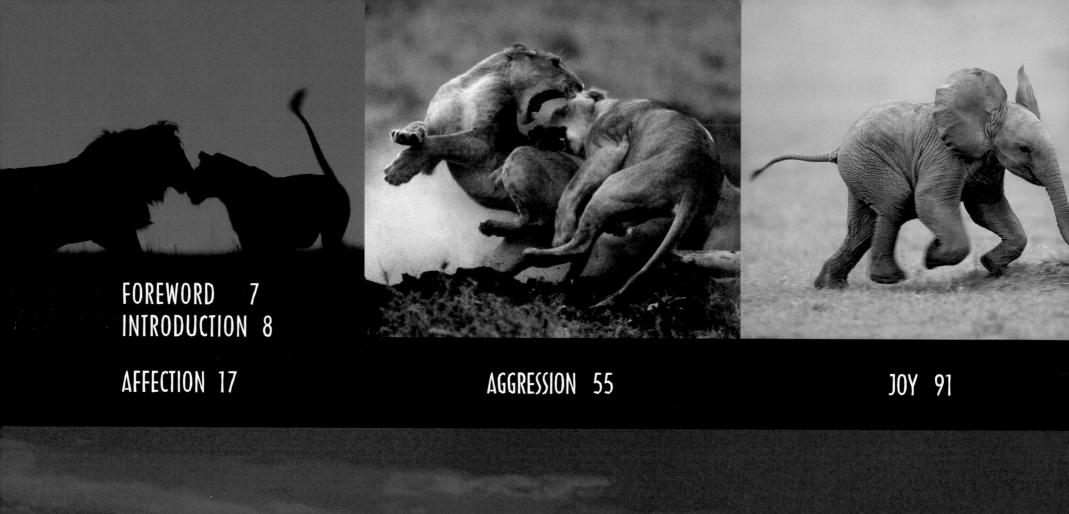

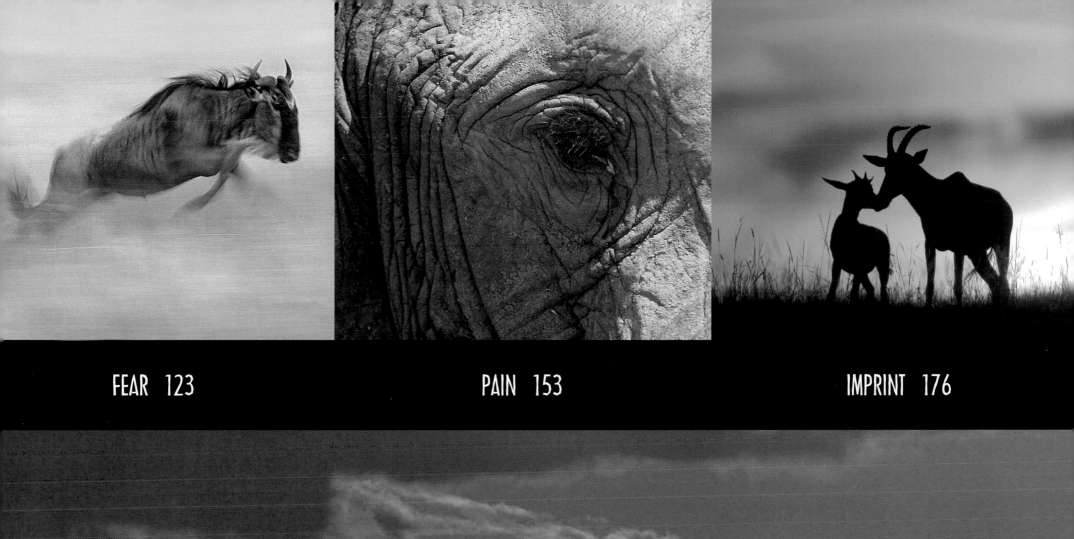

FEAR 123 PAIN 153 IMPRINT 176

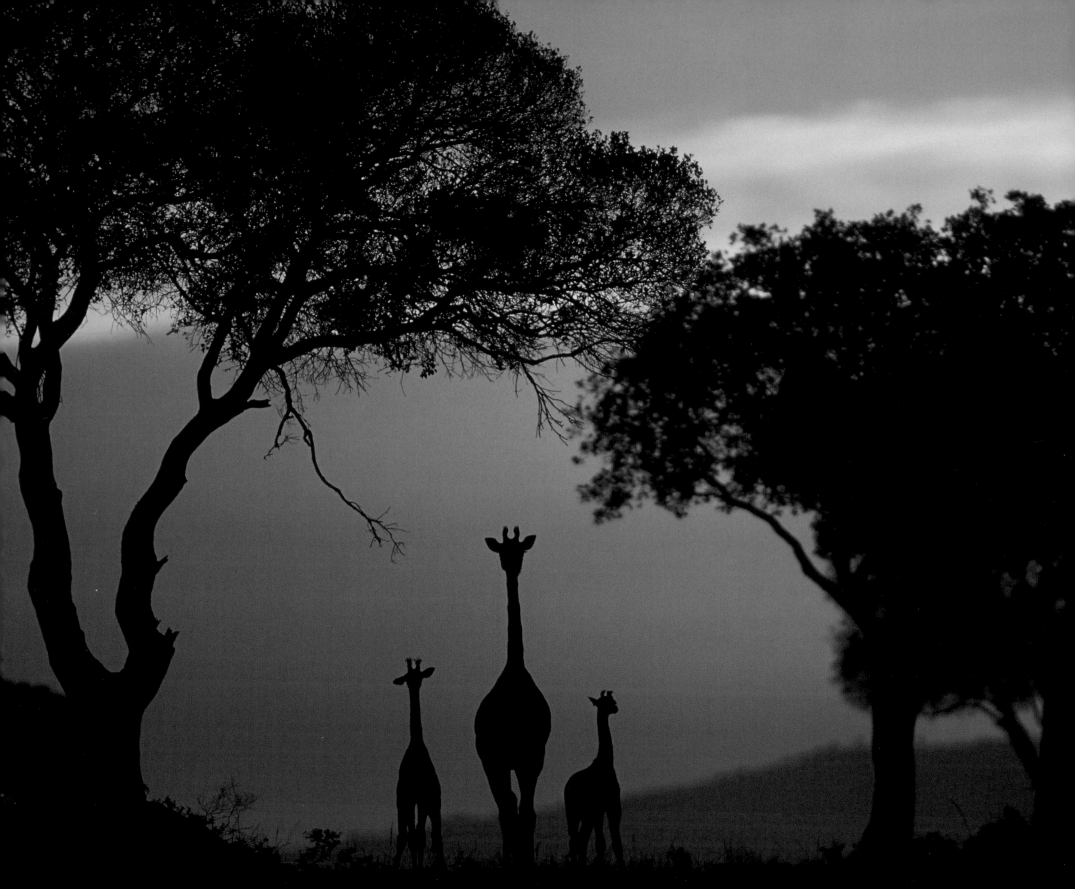

FOREWORD

"When a lion emerges from the bushes in the red dawn and lets out a booming roar, then even in fifty years humans will stand in awe, grasping their neighbors' hands at their first sight of twenty thousand zebras sweeping over the endless steppe."

Bernhard Grzimek, 1959 – Serengeti Shall Not Die

Fifty years ago, Bernhard Grzimek had already recognized that scientific data, biodiversity values and cold statistics are inadequate motivations for nature conservation. People protect nature because they love it, because they feel they are a part of it and see themselves reflected in the creatures of the wild. I have the enormous good fortune to have lived at the heart of Serengeti National Park for over thirty years, surrounded by animals every moment of the day. I live here not as lord of the manor, but as a guest, and my daily encounters with the wild animals in and around my house clearly demonstrate to me – also in my role as scientist - that animals experience emotion. A conclusion that is easy to grasp in the case of our close relatives, the baboons, playing with their young at the water-hole, for their expressions are so similar to those of human beings. Yet we can also scarcely avoid using the term "emotion" when observing lions or cheetahs with their young, or watching the types of communication employed by a family of zebras.

The fact that we can only supply limited scientific verification for our theories would not have concerned Charles Darwin, who wrote that without speculation there would be no new scientific theories. The realization that animals feel emotion is absolutely vital to our perception of nature, inspiring the needful awe and reverence for wild animals. Gabriela Staebler's breathtaking animal photography is a contribution towards bridging the gulf between animals and man, helping us to empathize with the world of the wild, always so far away, yet so near at hand.

Open your eyes to life in the African savanna, the cradle of the whole human race in the not-so-distant past before modern man set out from Africa to Asia, and thence to Europe, around 100,000 years ago. Open your heart to the sight of all the creatures in the Serengeti with which we once lived side by side. I hope that perhaps your care and compassion may inspire you to develop a new esteem and respect for the animals of the Serengeti and Africa's national parks. Let us all work together so that future generations will still be able to experience the soul of the savanna.

"There is something wonderful in every creature of nature." Aristotle

Dr. Markus Borner
Director of the Africa Program, Frankfurt Zoological Society
Serengeti-National Park, Tanzania

INTRODUCTION

"Unbiased observation of nature is the starting-point and foundation of all research, and the more complicated the subject of the research, the more indispensable the observation. Next to man himself, the higher animals are the most complex systems on our planet, and if today we know a great deal about the finest problems of physics and chemistry, but in comparison pitifully little about ourselves, this is largely due to the fact that the act of seeing has fallen out of fashion."

Konrad Lorenz, Biologist and Ethologist

Do animals have feelings? A clear question, and one much examined. A question that can spark many conflicts, and which is a topic of discussion in scientific circles and beyond.

Science distinguishes between the concepts of emotions and feelings. According to the neuroscientist Damasio, emotions are physical signals directed at external targets and elicited by external stimuli. Feelings, however, are the mental experience of an emotion directed inward. Science is still unclear as to whether an antelope truly feels fear at the sight of a big cat – in other words, whether it is aware of its fear – or whether the emotion of fear as a behavioral expression has so far proved to be a survival strategy. Do mother animals love their young as we love our children, or do they merely feed and protect them to preserve their species, only obeying an instinct connected with emotions? We naturally also speak of reproductive and brood care instincts in the context of human beings, and rightly so.

For the great thinkers of the past such as Aristotle, Descartes and Kant, animals were rational "objects" devoid of feeling. Charles Darwin was the first to concede that our fellow creatures have emotions, which to him were essential functions of survival and served the preservation of the species. Today, the majority of scientists agree that animals have emotions, at least in the biological sense. But can they truly feel joy, sorrow, fear and suffering?

Individual states of feeling, in both humans and animals, are difficult to identify using the classic methods of natural science, which value only that which can be measured, counted and weighed. As difficult the task of analyzing our own feelings is and has always been, how much more complex an issue must the question of animals' feelings be?

Our only possibility to communicate with and understand animals comprises the emotional level. We face the challenge of empathizing with or understanding the animal without resorting to anthropomorphization. As our only frame of reference is our own world of feelings, we will never be able to fully comprehend the complex emotional world of animals, even if it appears in many respects to be similar to our own.

Value-free observations have contributed a great deal to the knowledge of wildlife in Africa that we have today. Here, animal photographers make an important contribution to research, generally basing their work on extensive field and behavioral studies which they then document in their photographic work. I too have spent many years observing wild animals in Africa, watching them as impartially as possible, experiencing and "sharing" many intimate moments with them and documenting them with my camera. Like human beings, animals too follow instincts and drives. And like us, I am convinced, our fellow creatures think and feel. They possess intelligence and consciousness, and thus a personality – yet entirely at their own level of development, aligned with their

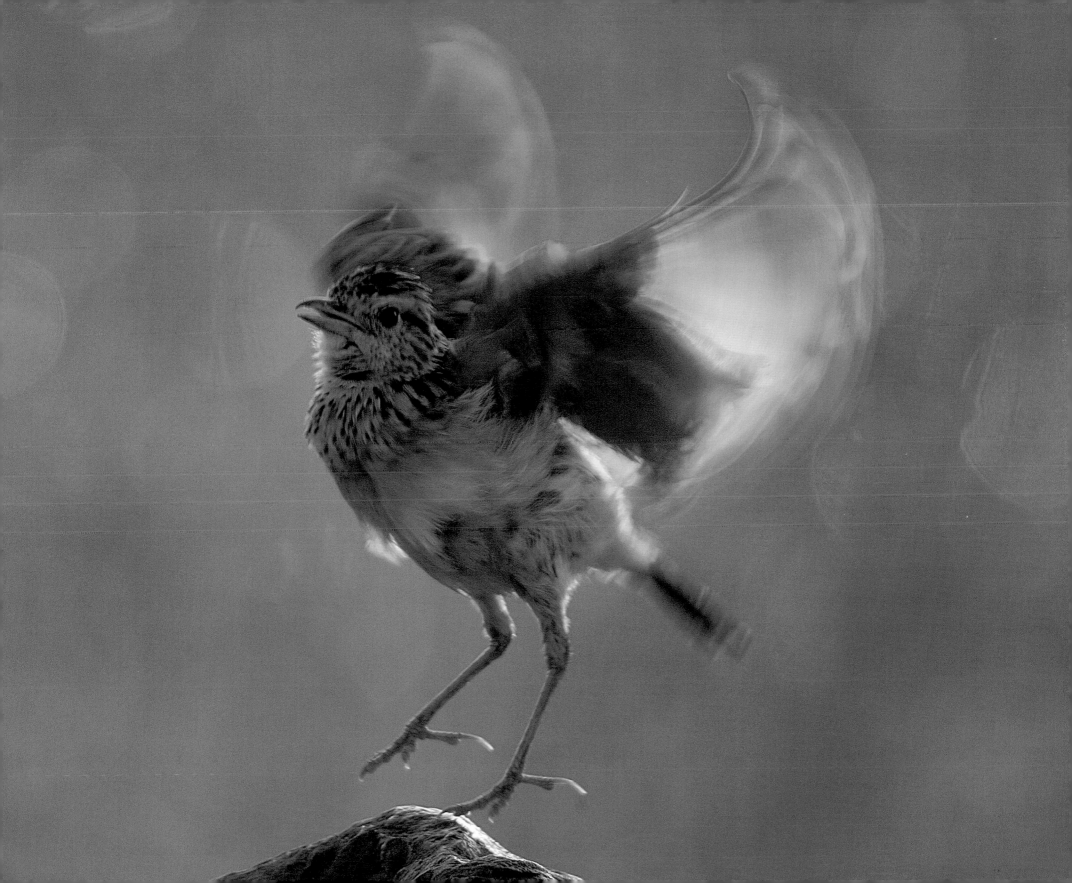

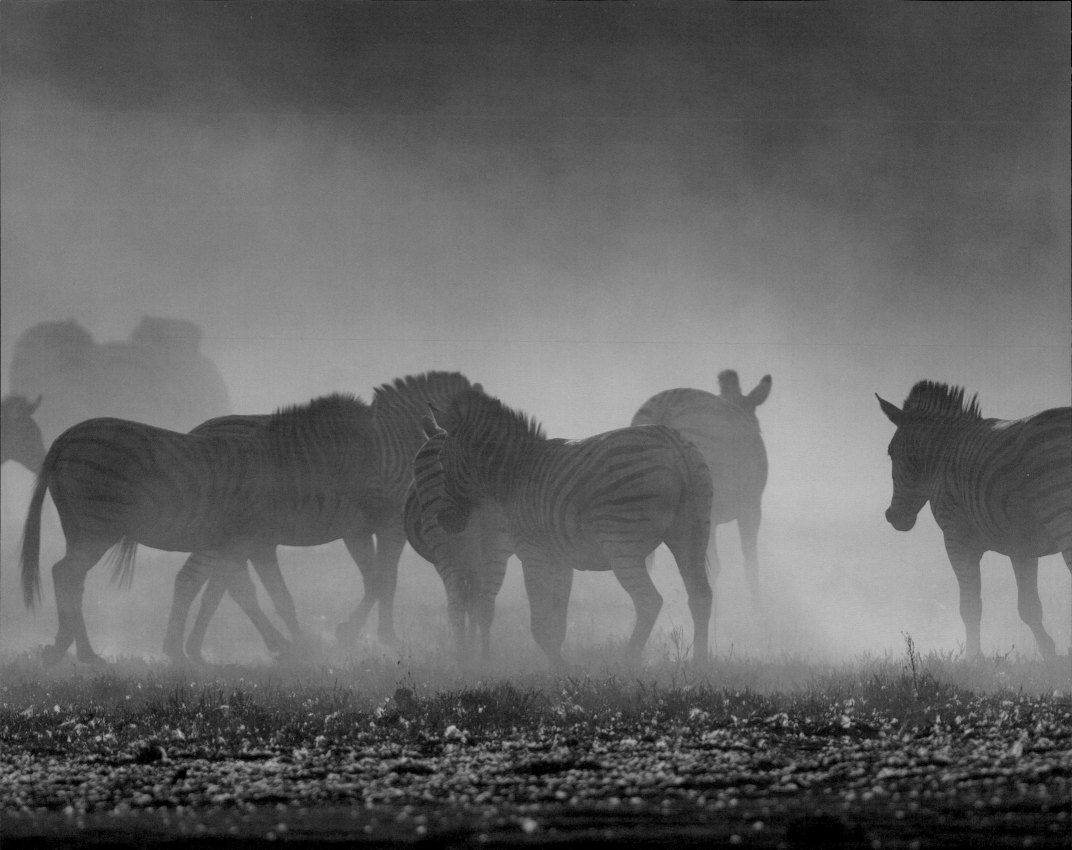

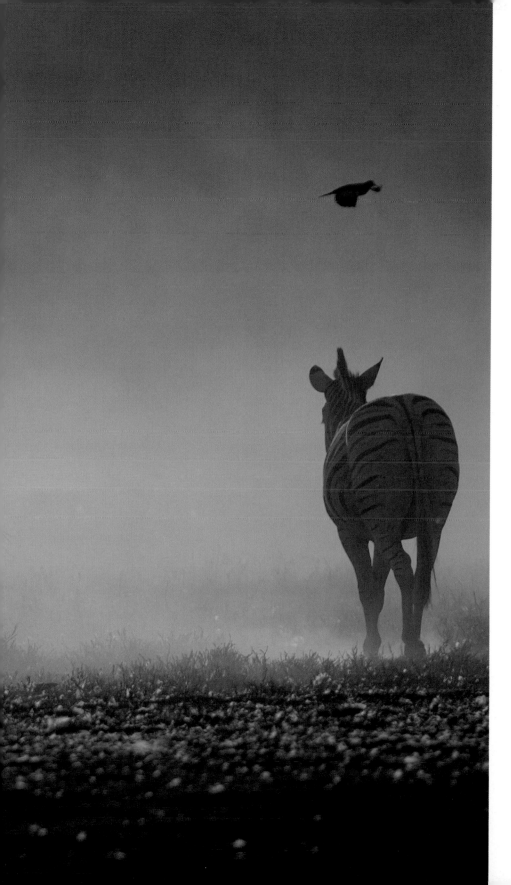

species and their habitat. In the case of higher animals or animals with a history of development that is close to our own, their "souls" may be very similar to our own in many respects. Other animals may feel and think in a way that is completely alien to us, and which we could not understand even if they were able to communicate in our language. And yet I am convinced that they have feelings.

My pictures reveal the broad range of emotions that I was lucky enough to experience with wildlife in Africa, and they will certainly inspire emotions in the readers of this book. I am occasionally asked how I "did" one or the other of my pictures. I actually don't "do" anything: quite simply, I often happen to be in the right place at the right time. This is rarely a coincidence, but is the result of extensive phases of observation, the application of intuition and my quest to establish empathy with the animal. To think and feel how the animal works is a kind of non-verbal communication –reliant, naturally, on the preconditions of photographic skill, enormous patience and zoological knowledge.

My images cannot prove it but they show it,
and I make no pretence to certainty, but for me it is clear
that animals exhibit both emotions and profound feelings
such as affection, aggression, fear, joy and sorrow,
and these feelings, in the higher animals, differ only
in degree from those of human beings.

Perhaps we have more animal in us than we think!

Gabriela Staebler

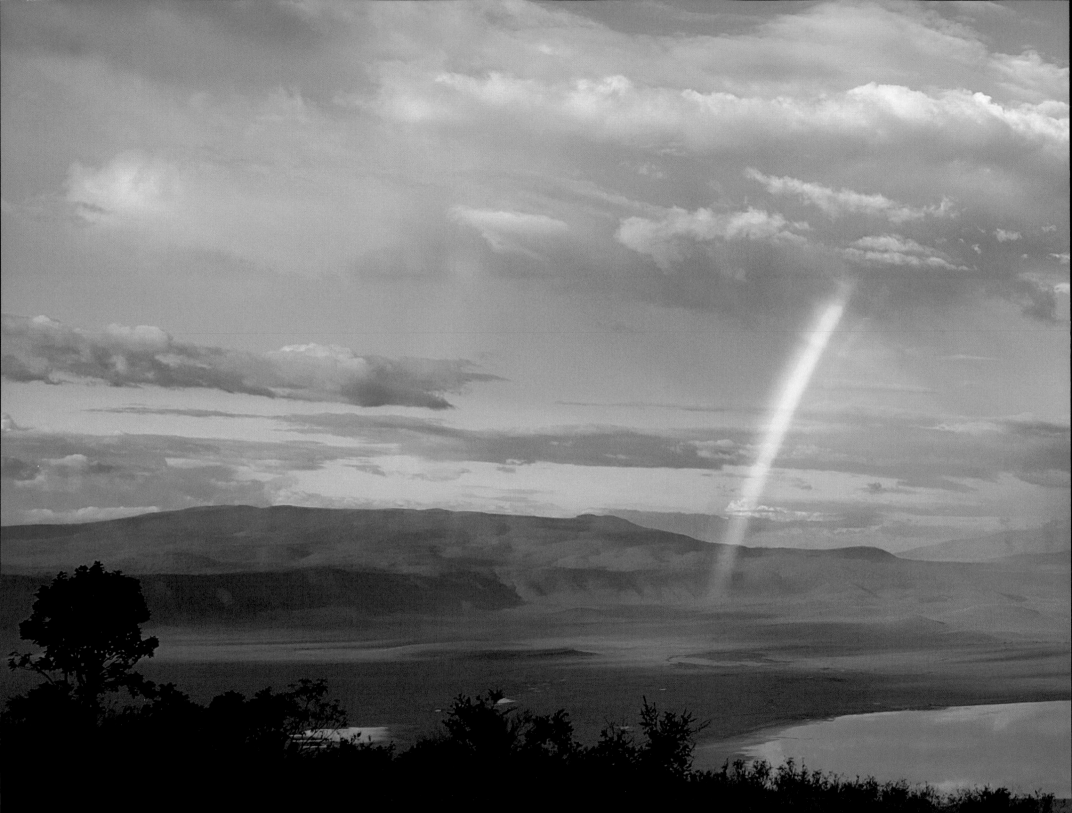

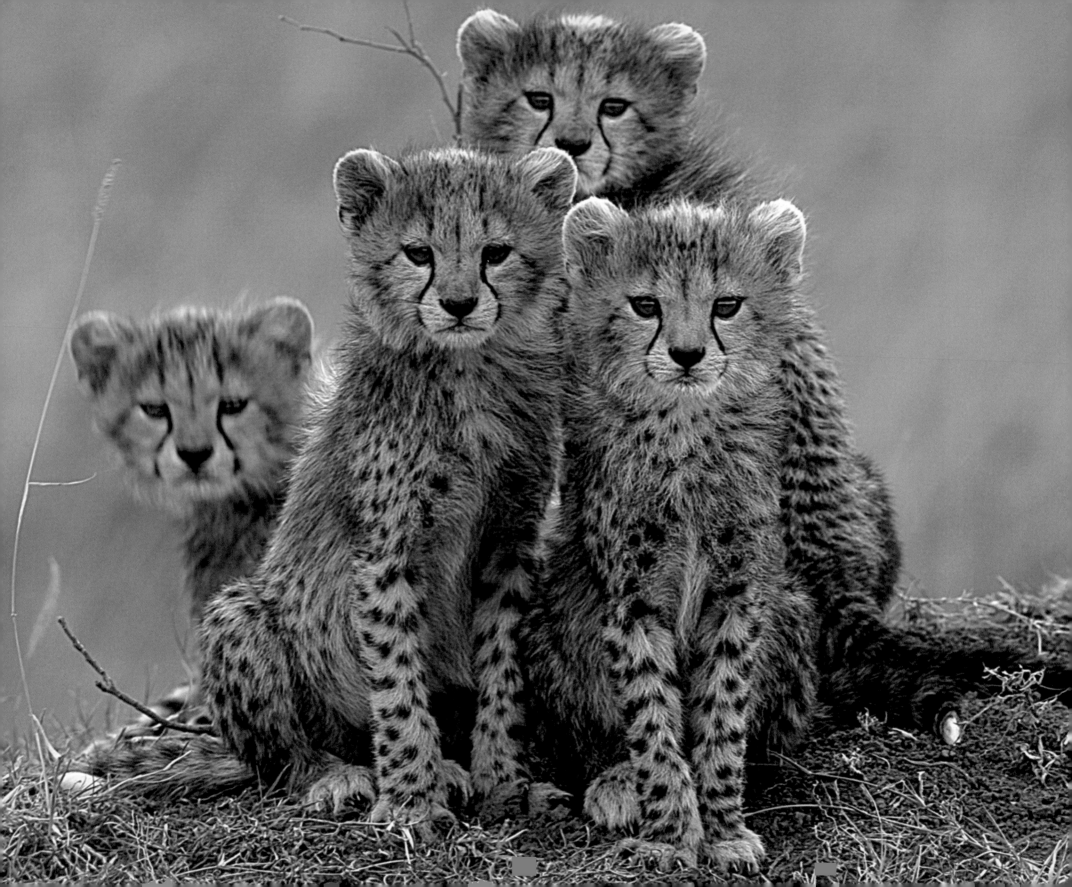

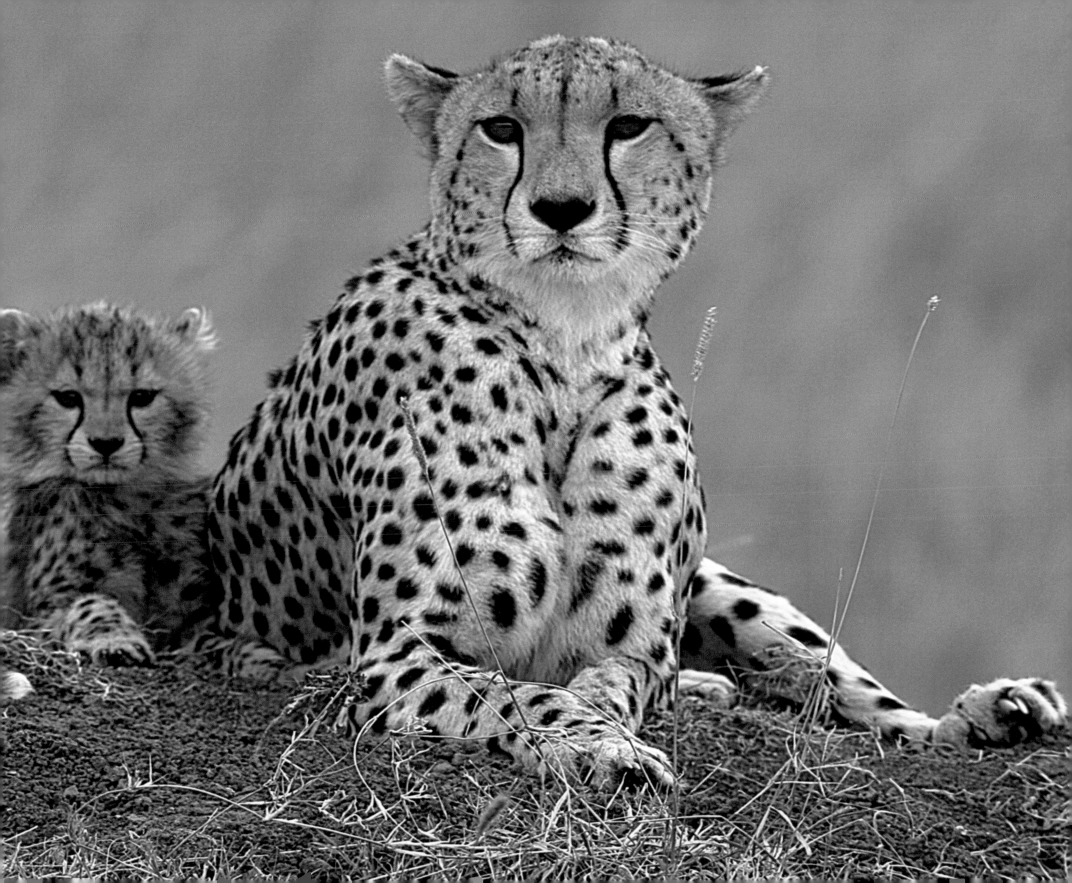

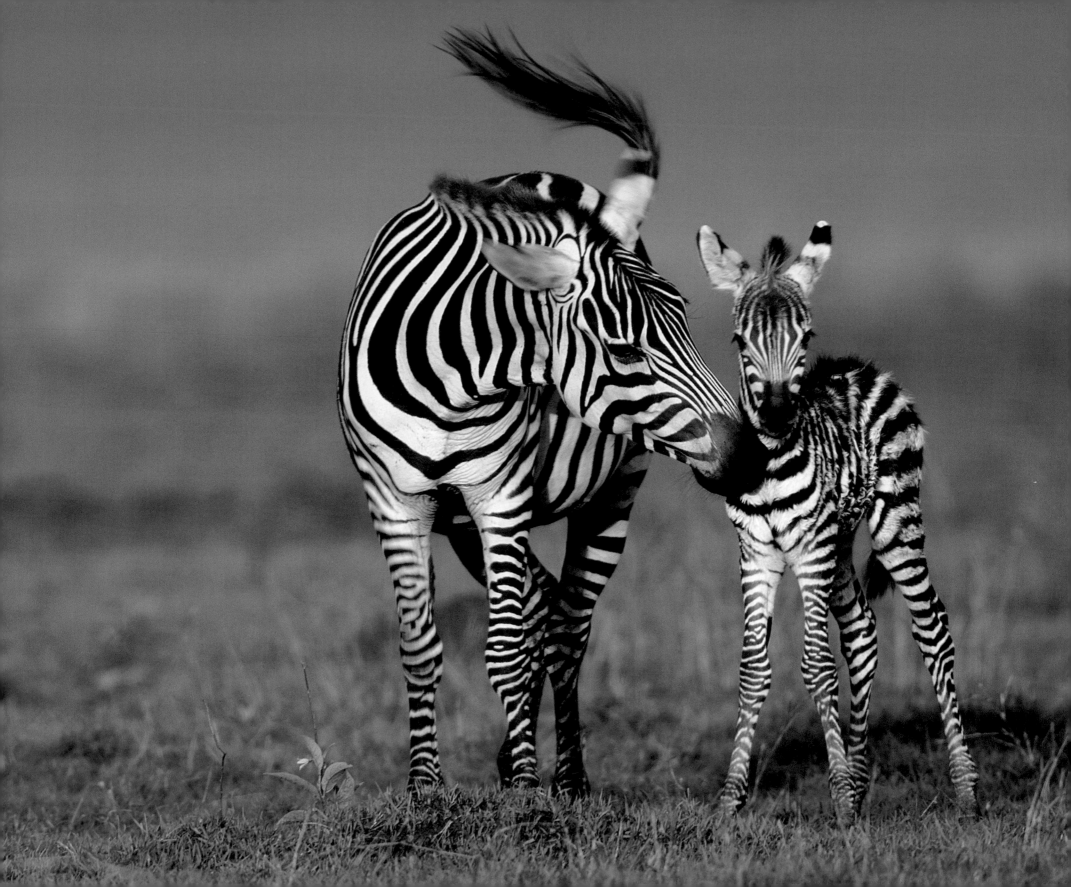

AFFECTION

Friendship – Tenderness – Faithfulness – Maternal Love – Sexuality – Loyalty

Love is too great a word – as human beings sometimes also find. Let's call it affection. Like any of the great emotions, affection has many facets. The wild animals in Africa afforded me insights into their private life, their intimate togetherness ...

Affection seeks closeness, whether of a sexual nature or purely based on friendship. Caresses are exchanged by touching, rubbing, smelling and nibbling, and, in the case of big cats, often by mutual licking and grooming. These caresses serve to strengthen social ties and release tension.

Affection would seem to be the primary factor when a bull elephant repeatedly runs his trunk gently along the back of a desirable cow. In addition to hormones, scents such as pheromones play a key role with animals, owing to their finely honed sense of smell. But can it be only the reproductive urge, triggered by scents, that awakens sexual desire and passion in the male lion, driving him to dog the footsteps of his chosen lioness for days without letting her out of his sight – or is it something more? Lifelong faithfulness is also found in animal relationships; jackals and bat-eared foxes, for example, remain with the same partner all their lives.

Many animals appear to feel a special attraction to each other. Elephant calves from different mothers may develop a close friendship lasting for years; young hippos may regularly seek out a specific playmate to play with and to sleep side by side with.

Maternal love is undoubtedly the deepest emotion in the natural world. Tireless, inexhaustible, self-sacrificing and patient, mother animals care for their young. A wildebeest displays not only courage, but also strong emotional ties when it once again crosses the raging torrent teeming with crocodiles in search of its calf.

Animals organized in social groups show a sense of family; they love being together and feel secure in their community. Buffalos show loyalty when a member of the herd needs to be defended against attacking lions. Yet this sense of community is also important in a pride of lions. All cubs receive equal amounts of affection and protection from the females.

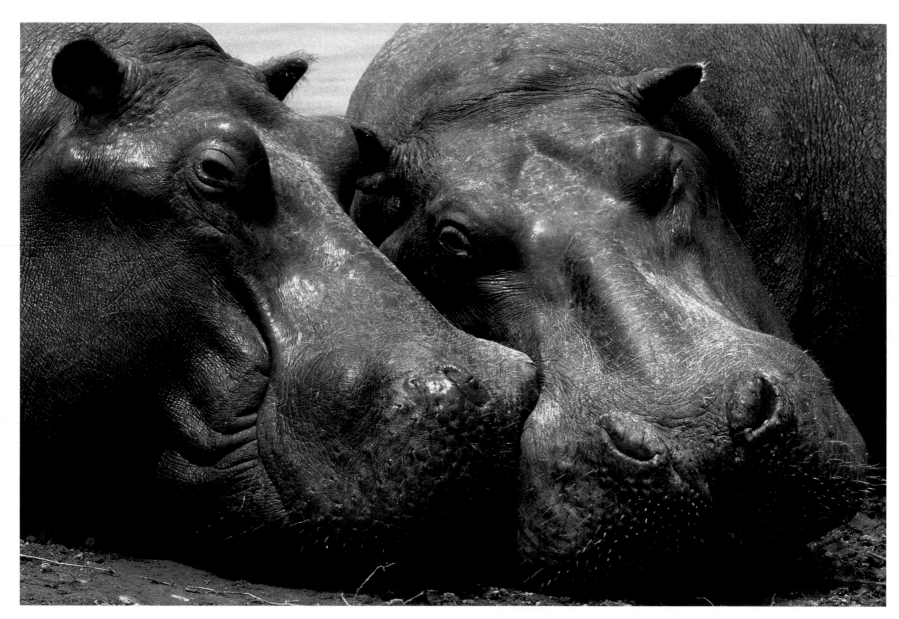

ABOVE Hippos are sociable animals, living in family groups comprising several females with their young and a single male. They peaceably gather to sleep and snooze together.

RIGHT Close relationships also develop between young elephants. Elephant calves that develop such a friendship seek each other's company when eating, sleeping and roaming through the savanna, and also prefer each other as playmates.

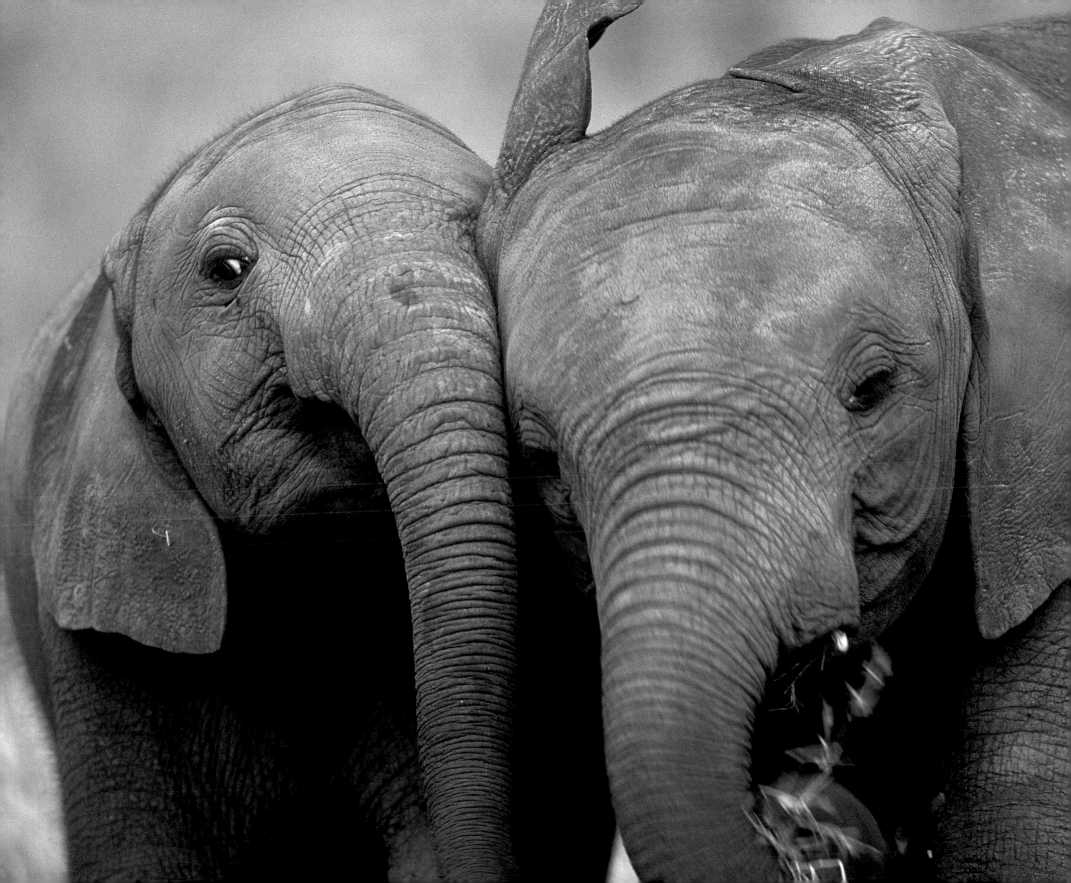

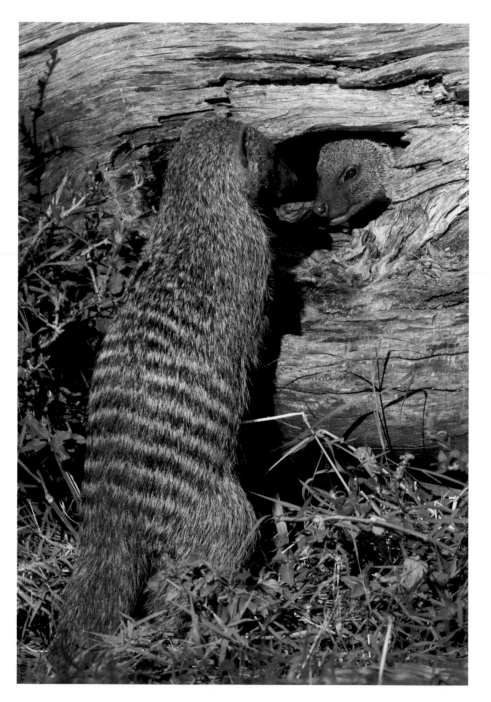

Banded mongoose live in family groups of five to thirty animals. Active by day, they communicate by giving constant twittering cries. They join forces to defend themselves against enemies such as eagles or jackals.

RIGHT These 6-month-old cheetahs are brothers and spend most of their time playing. Their tussles are good-natured, and no injuries result from even the wildest scrap. Brothers often remain together as adults – a coalition that provides them with advantages in hunting and defending their territory.

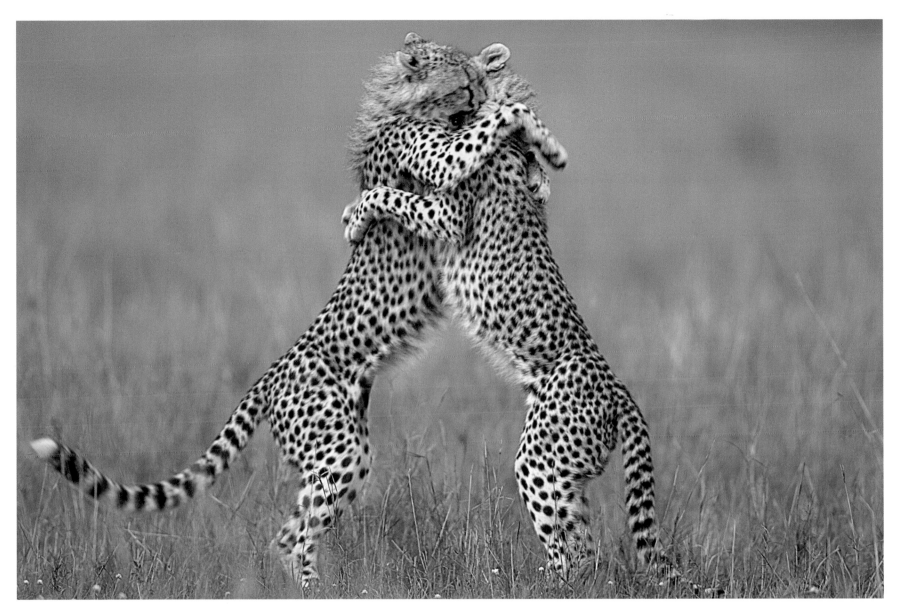

PAGE 22 Zebras reveal a broad range of emotions in their stance, in the position of their tail and ears, and in their head movements and facial expressions, including lip movements.

PAGE 23 Like many other herbivores, black-faced impala express goodwill by engaging in mutual grooming.

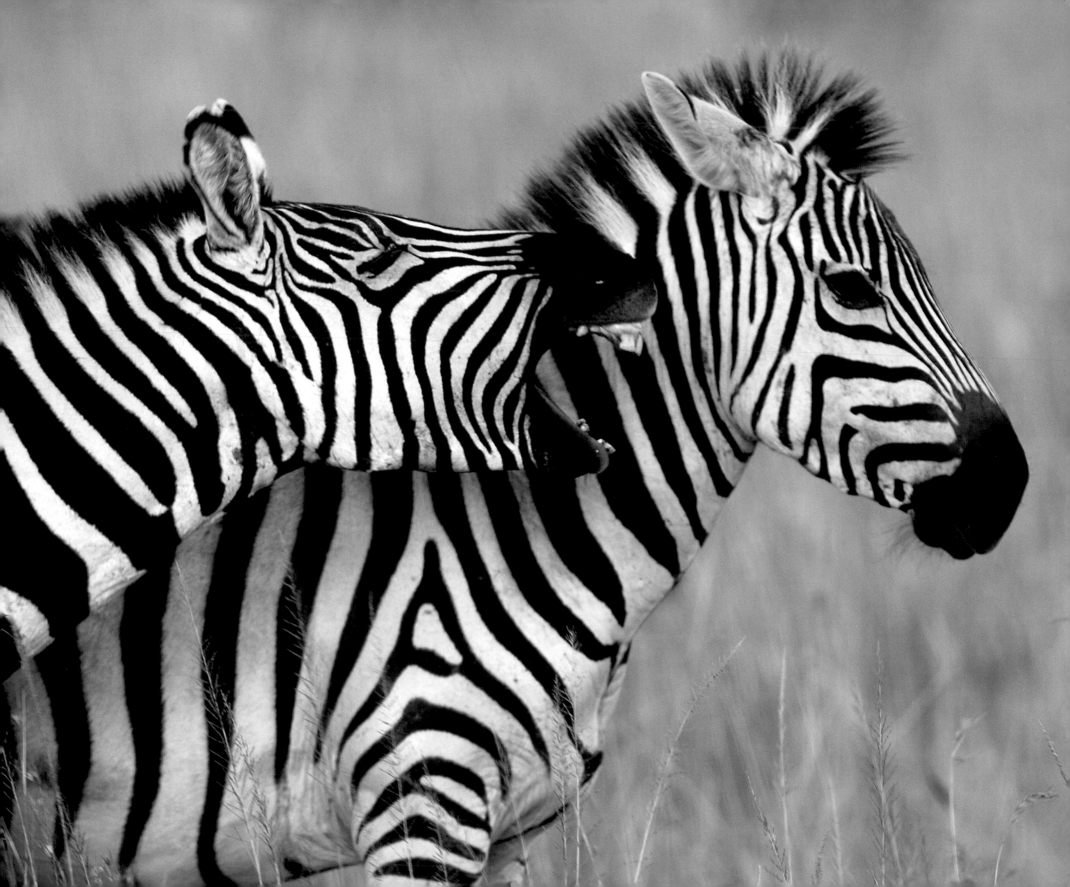

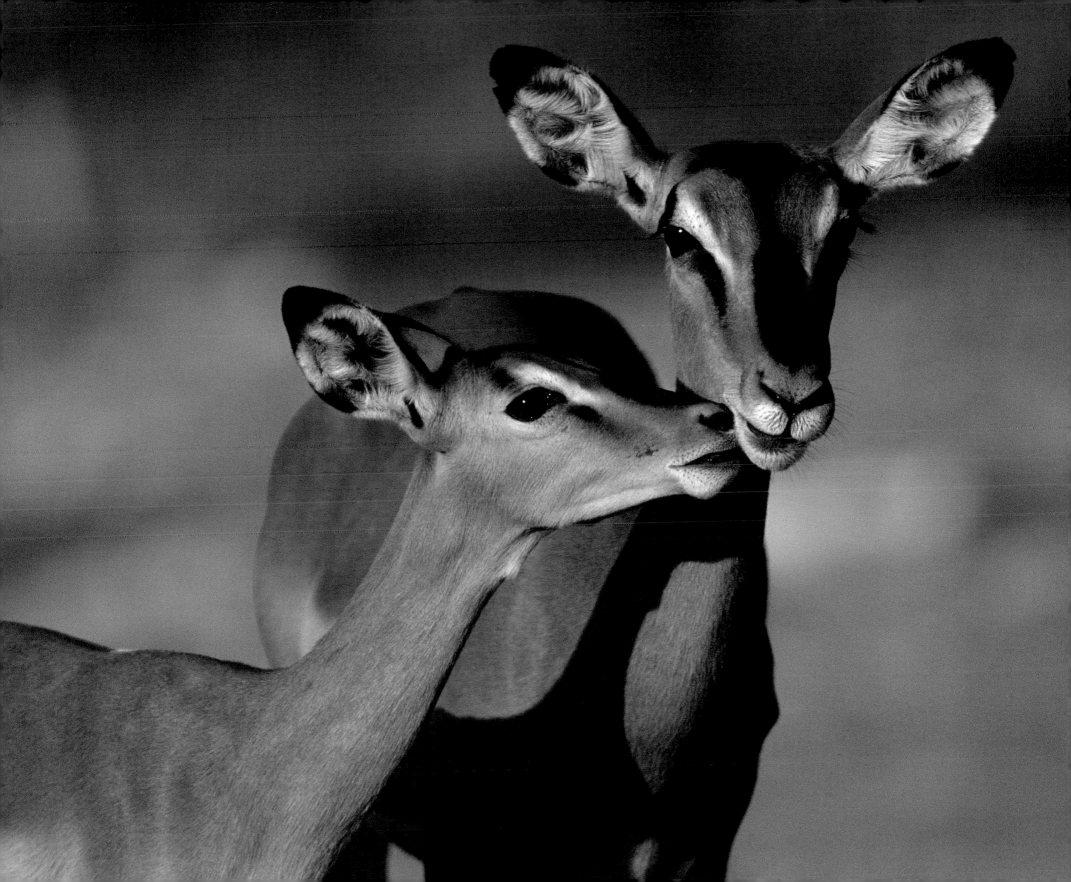

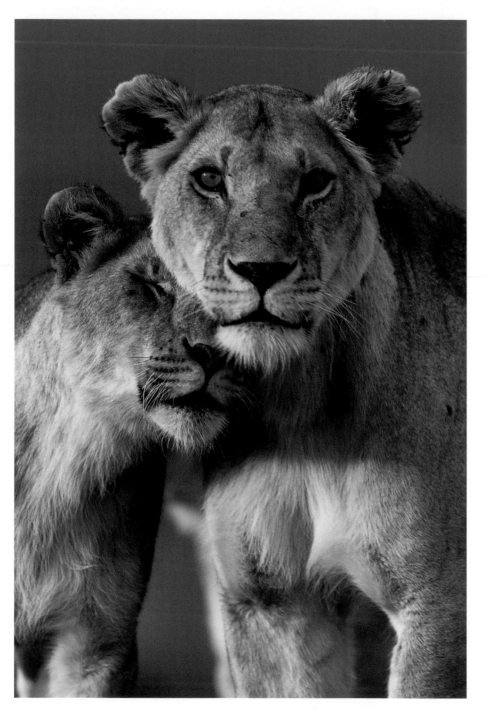

LEFT The oldest female of a pride of lions is a powerful, experienced hunter who is held in affection by the others. Lions strengthen their relationship by rubbing heads as all cats do, exchanging their scents as they do so.

RIGHT Once young male lions reach puberty, the females drive them away from the pride. When this happens, brothers often form "coalitions," hunting and roaming together for several years until they succeed in taking over a pride and territory for themselves.

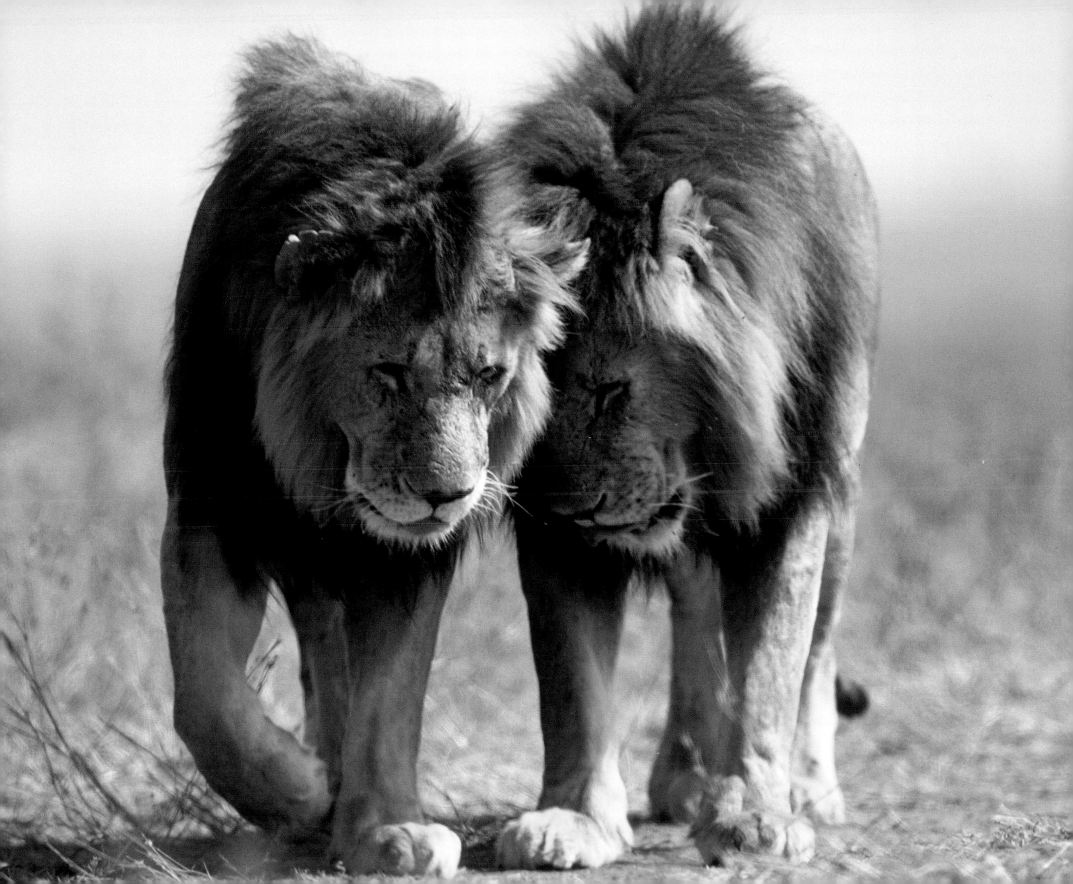

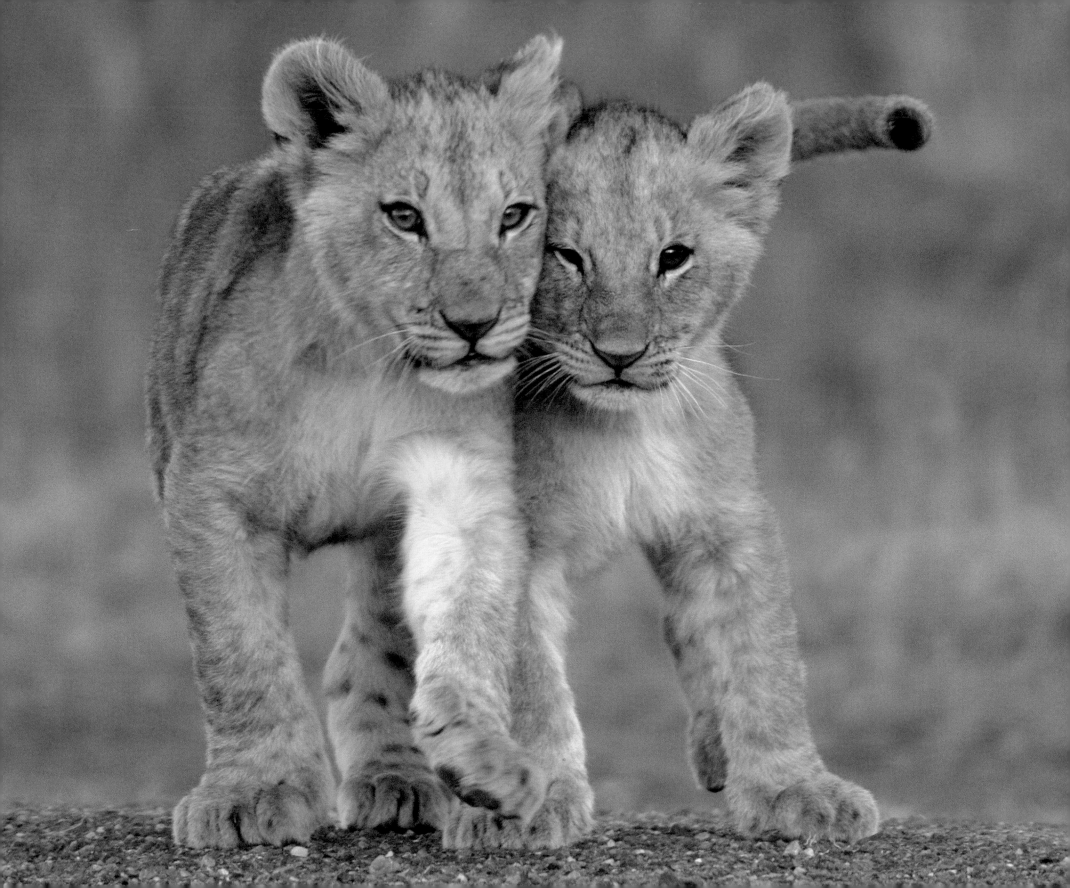

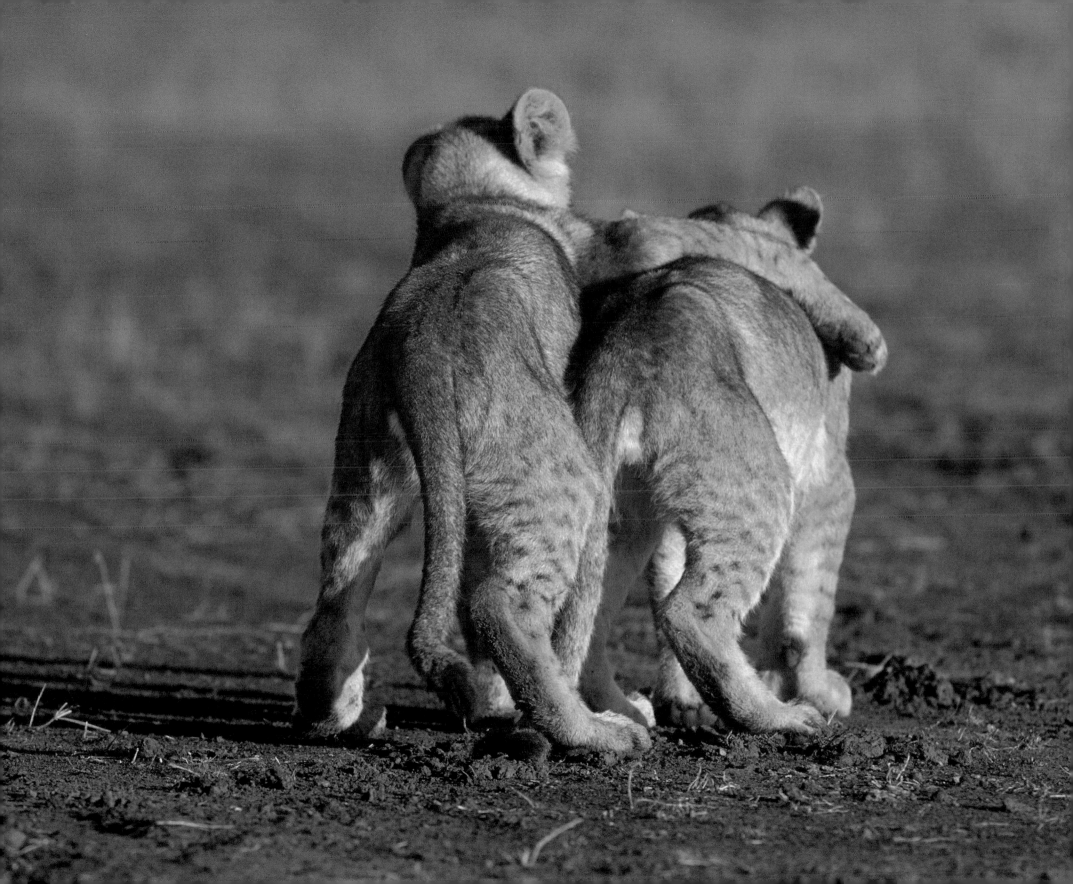

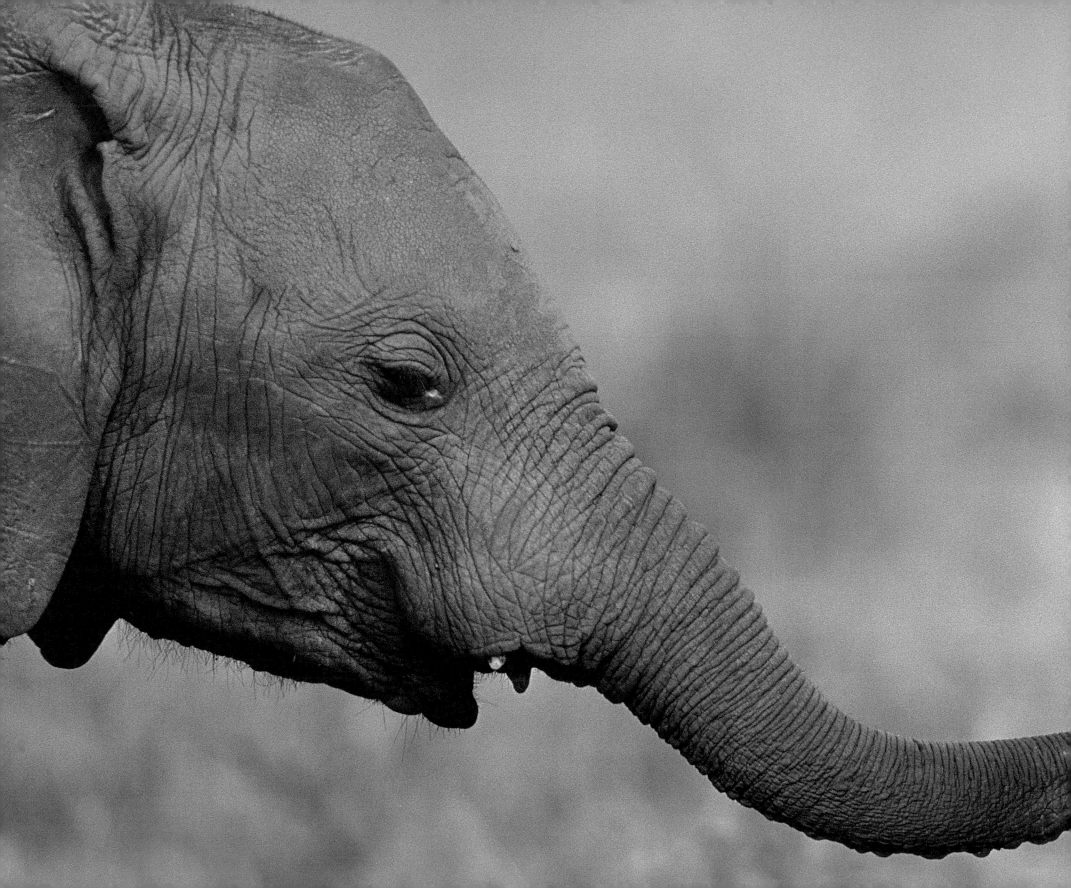

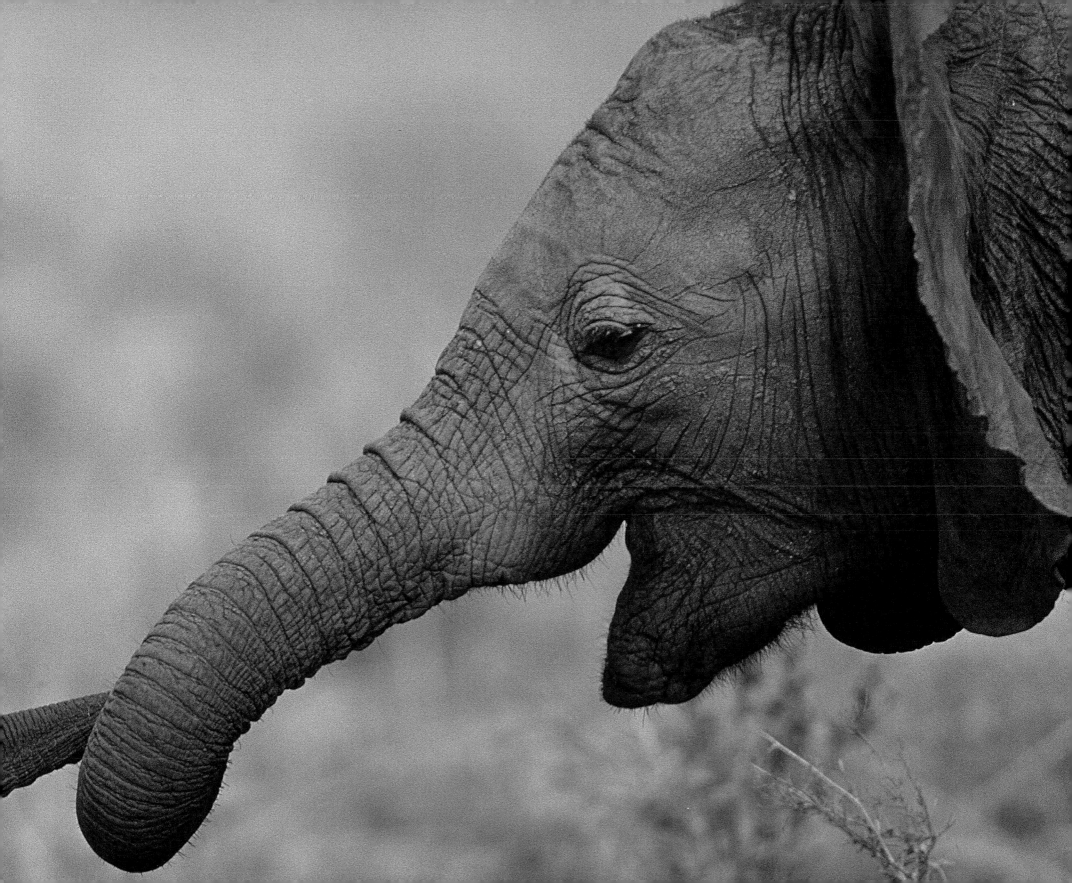

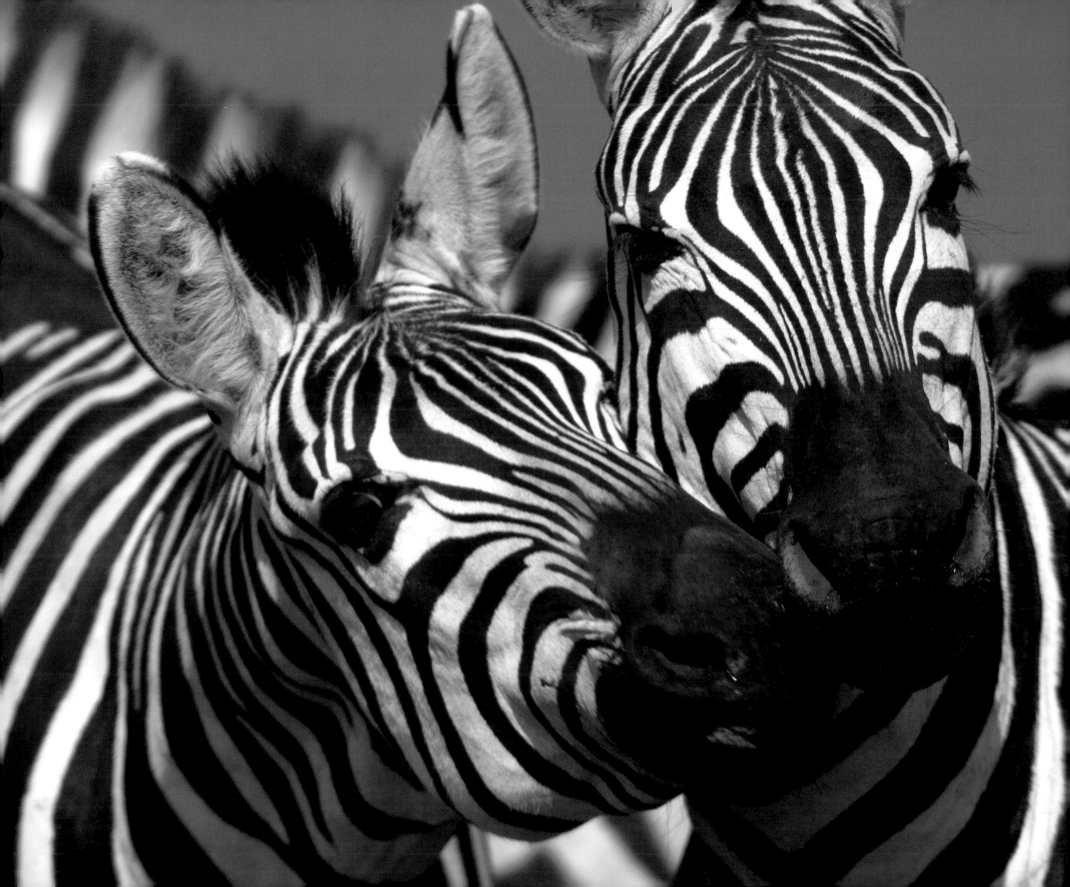

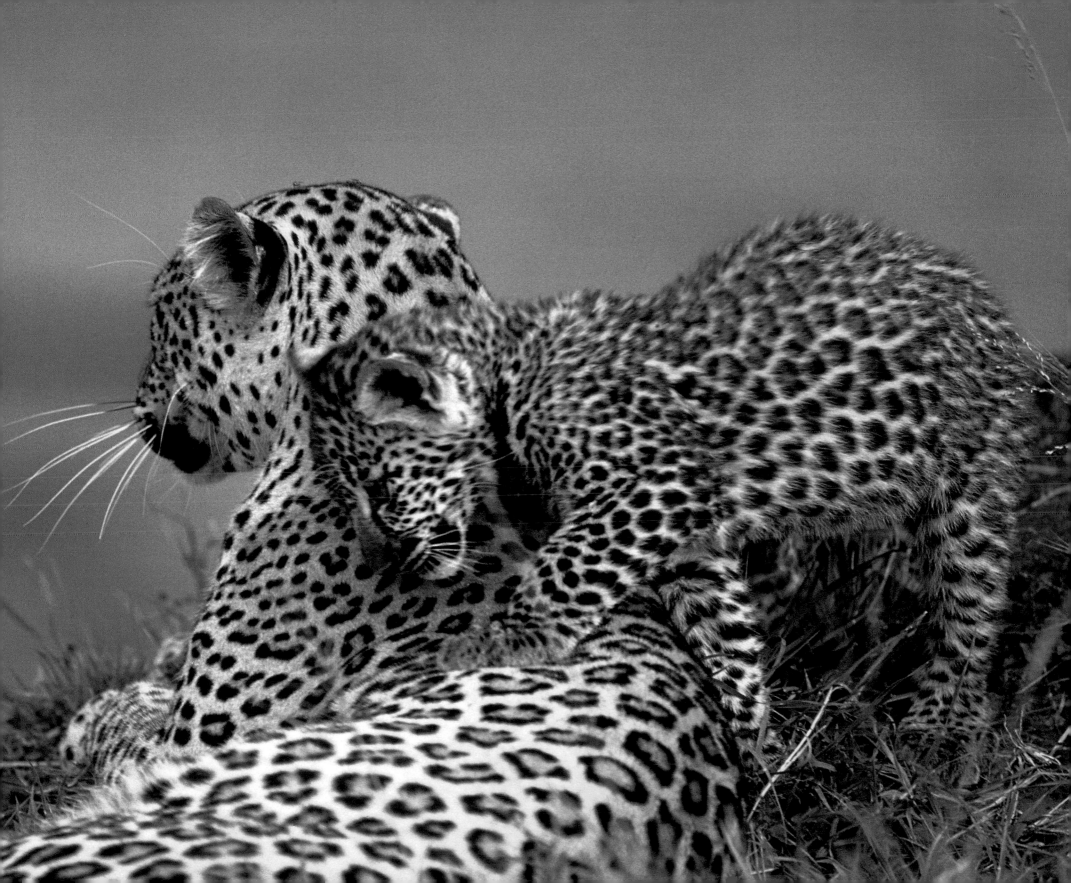

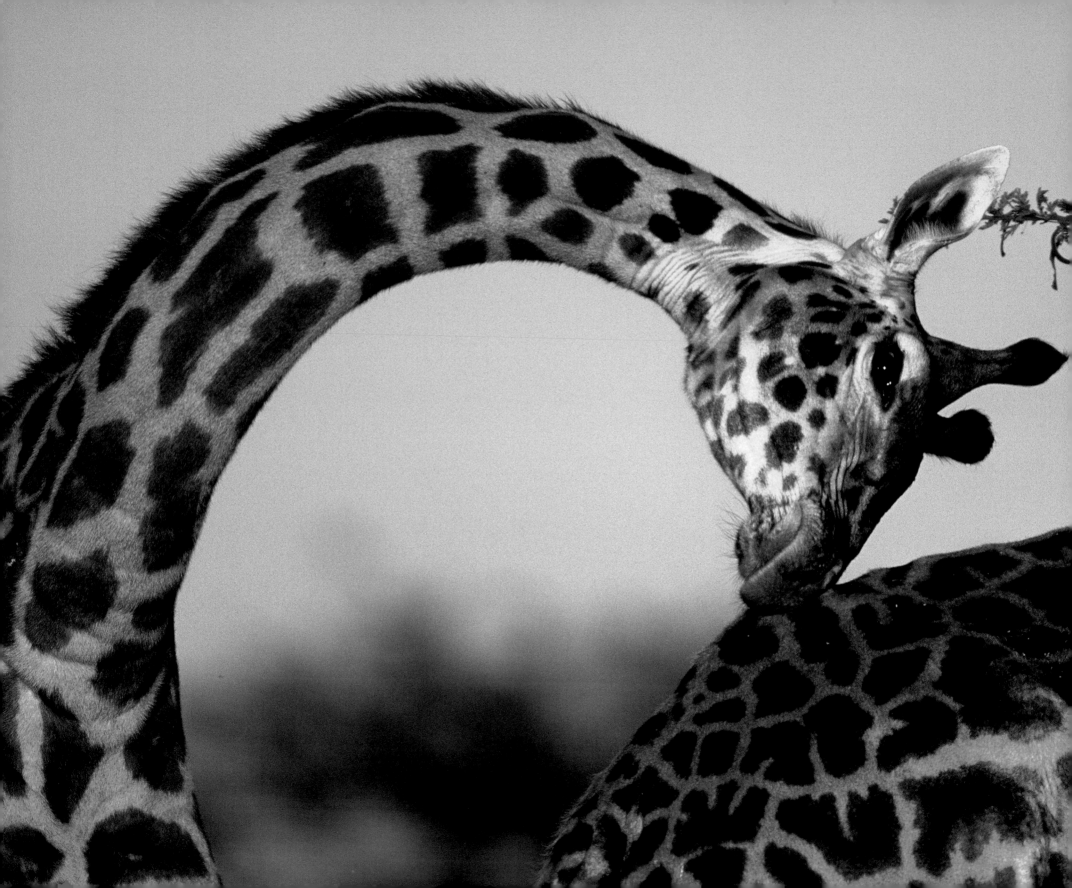

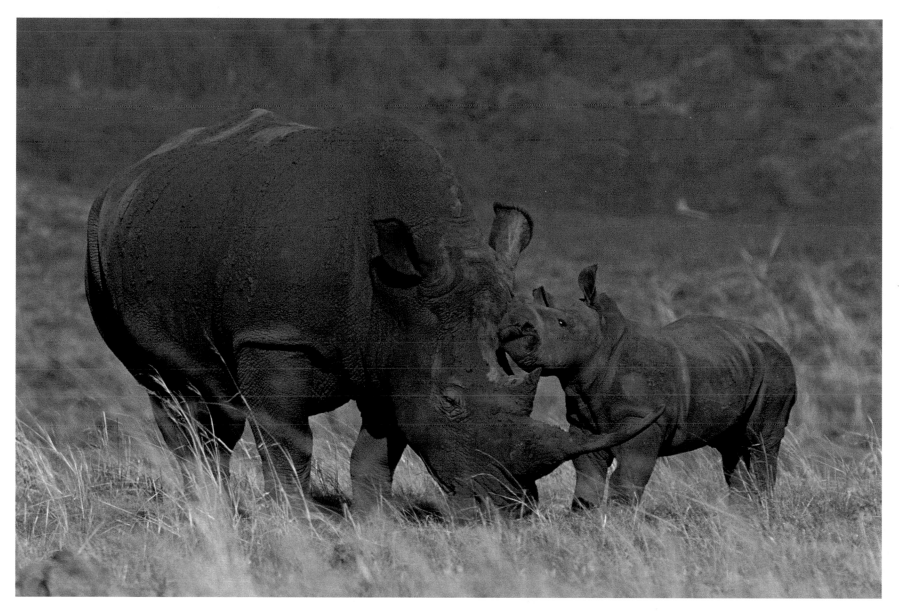

LEFT The young Masai giraffe delicately sniffs a member of the herd.

ABOVE A baby white rhinoceros stays with its mother until the age of two, enjoying the nourishment and protection she gives. As they wallow together, they blend seamlessly with their surroundings.

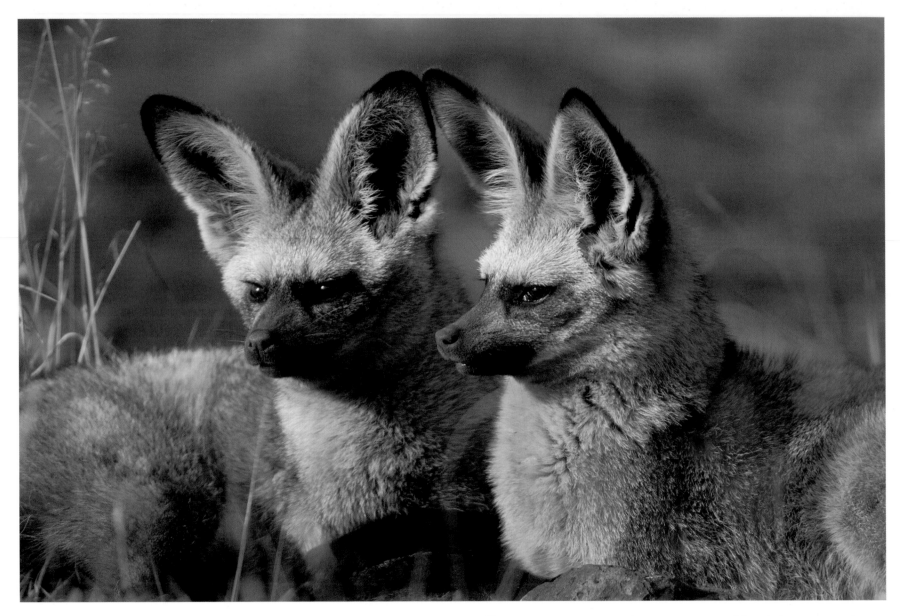

ABOVE Bat-eared fox couples are monogamous and raise their two to six cubs together. They spend a large amount of time devotedly grooming each other, and retain their playfulness as adults.

RIGHT Black-backed jackals are also monogamous, raising their young together with care and devotion.

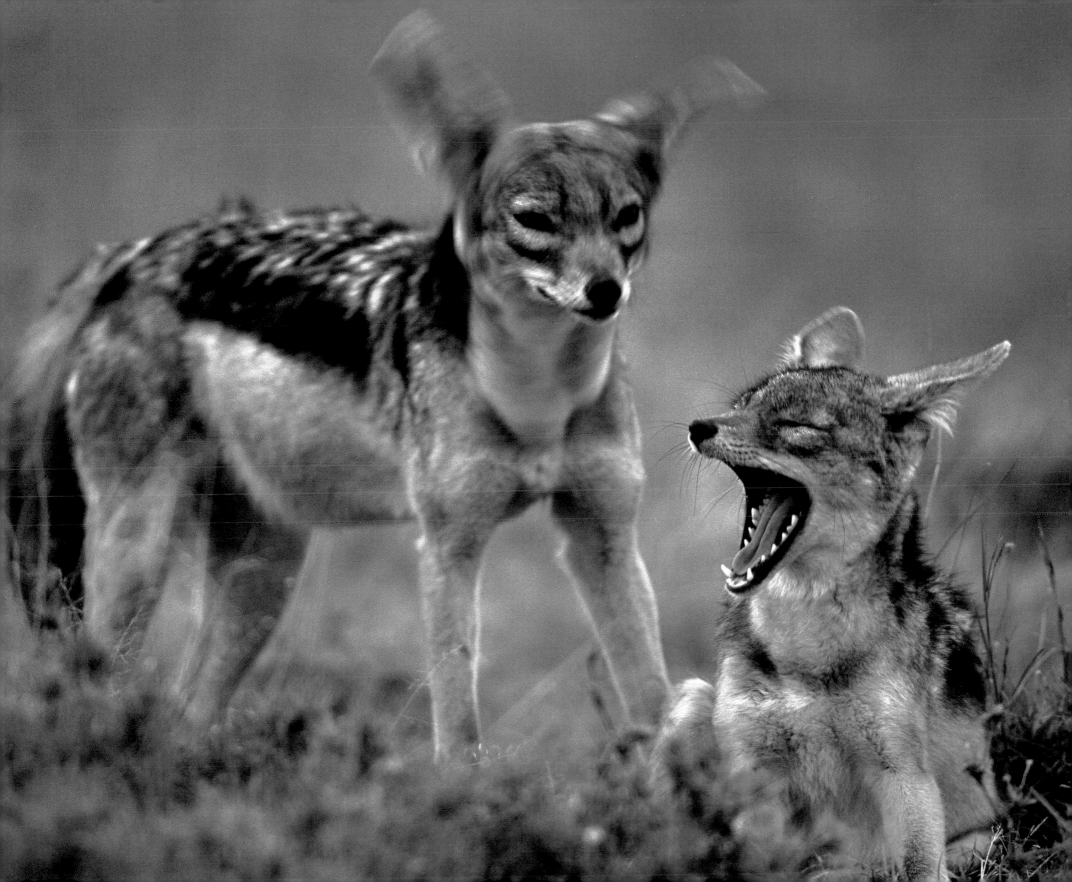

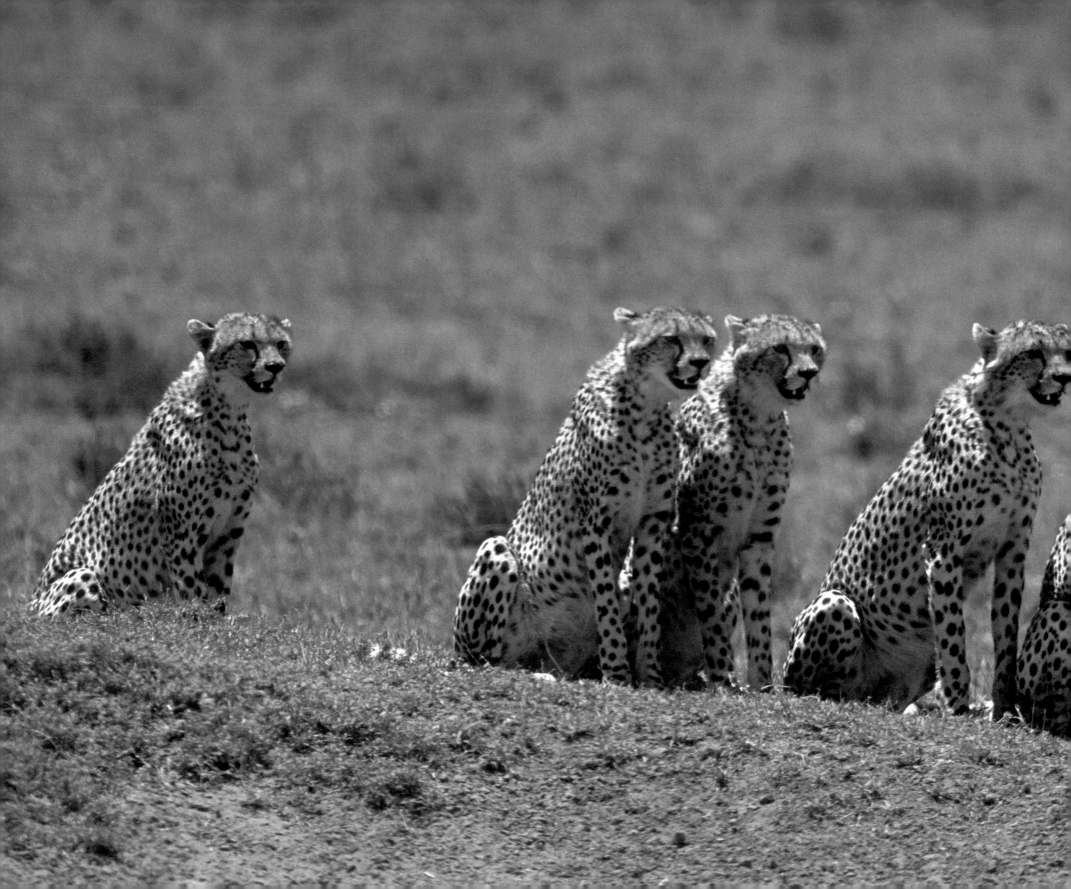

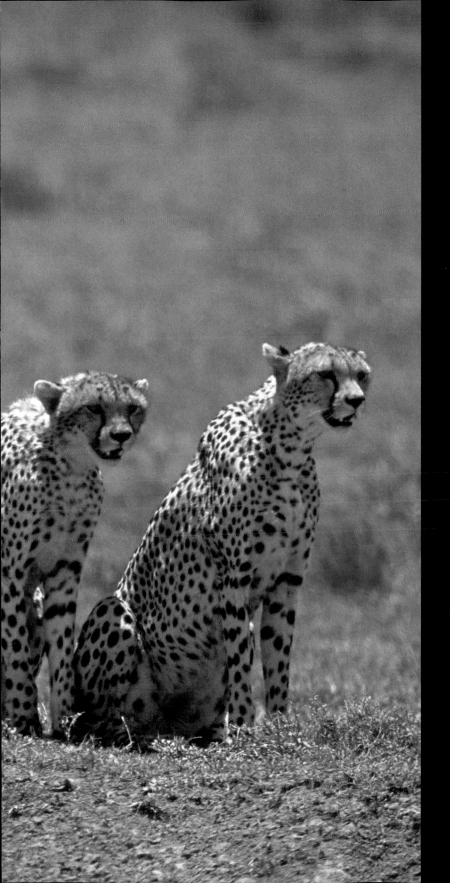

I always knew that animals have intelligence, emotions and personalities.

Jane Goodall, Ethologist and Primatologist

The five almost fully grown cheetahs
and their mother still hunt and spy
out potential prey as a group, bound
by a powerful feeling of togetherness.
The young cheetahs will not leave
their mother until they are 14 to 18
months old.

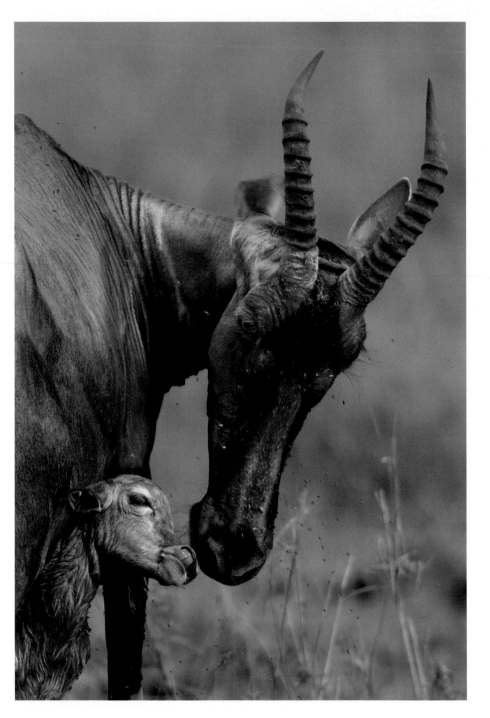

LEFT Only a few minutes after its birth, this baby topi antelope stands up to allow its mother to gently lick it all over. By doing so, mother and baby exchange their unique scents.

RIGHT The African buffalo calf is in particular need of its mother's special protection in the hours immediately after birth. While it is able to stand only ten minutes after being born, it is still unable to follow her in the event of danger.

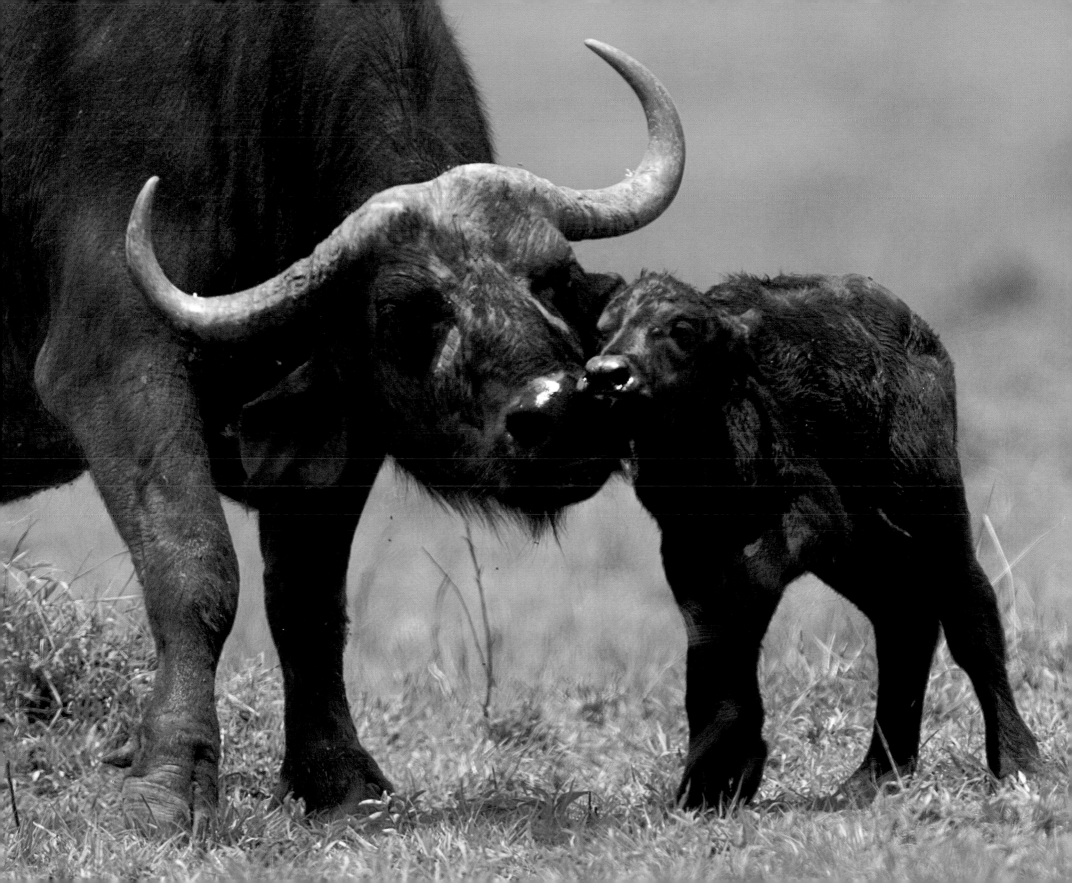

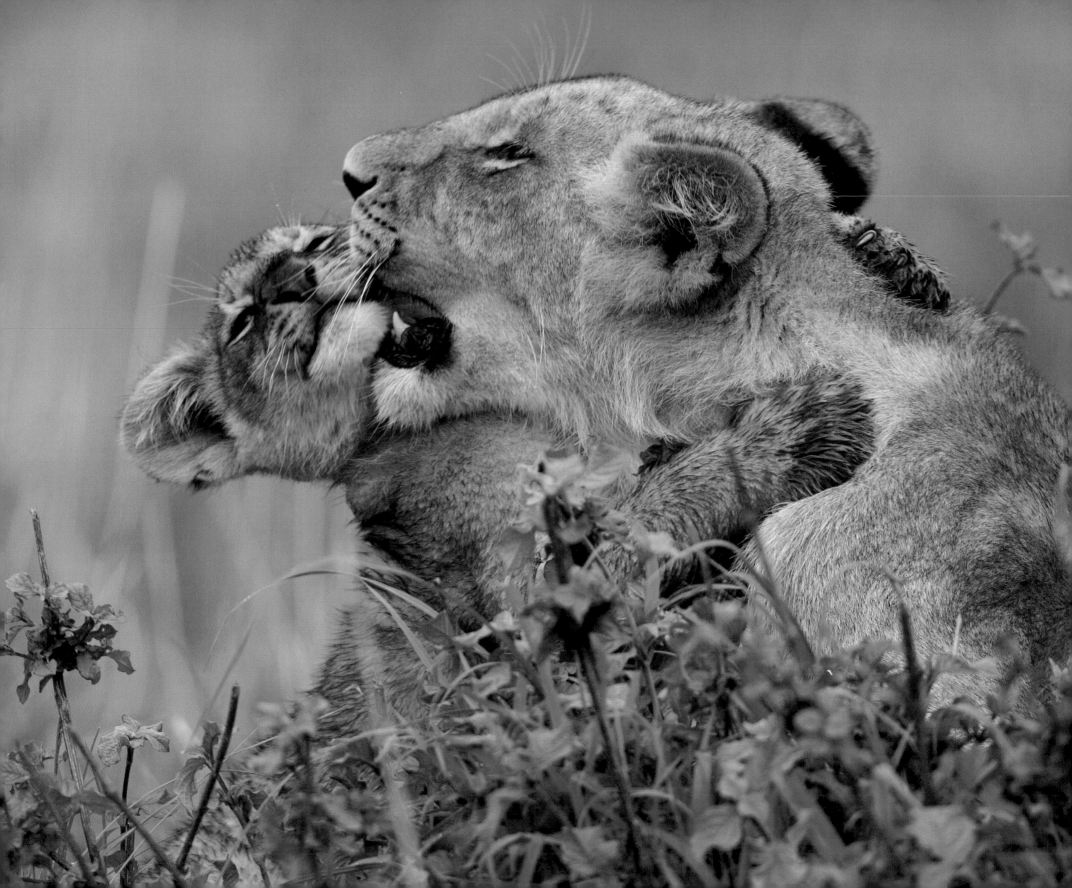

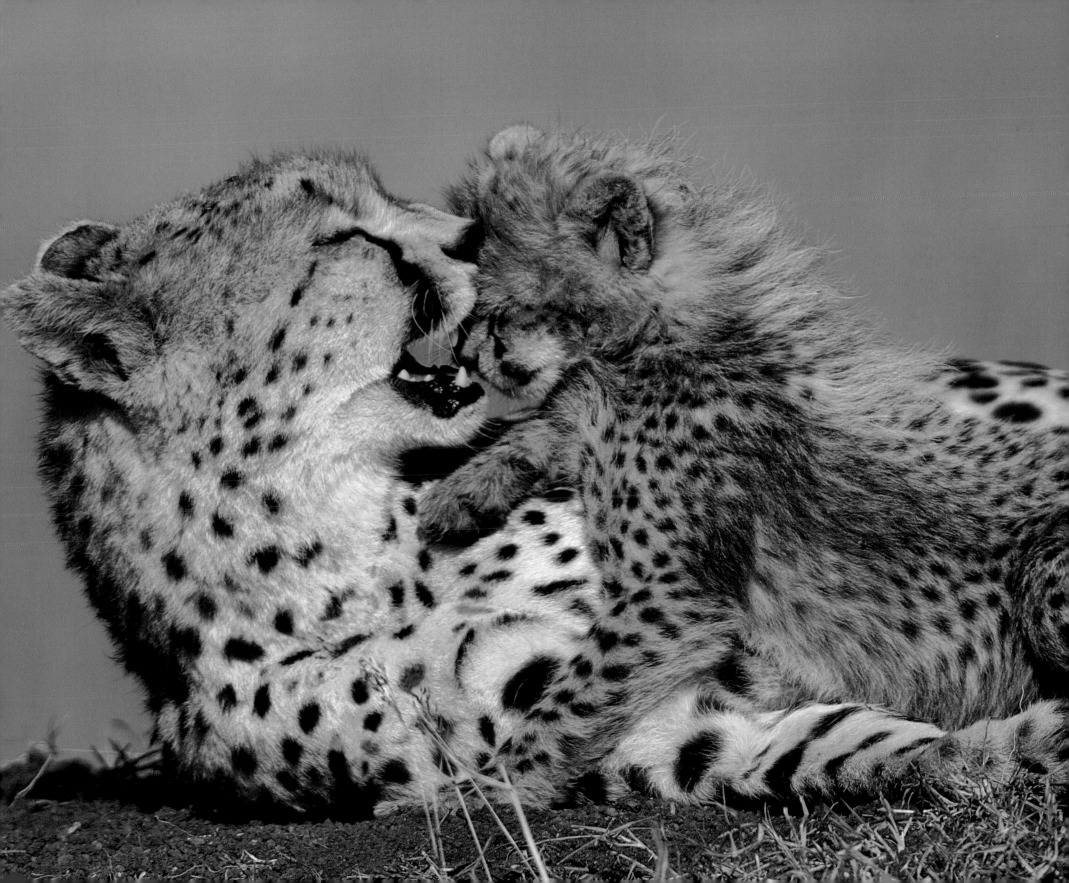

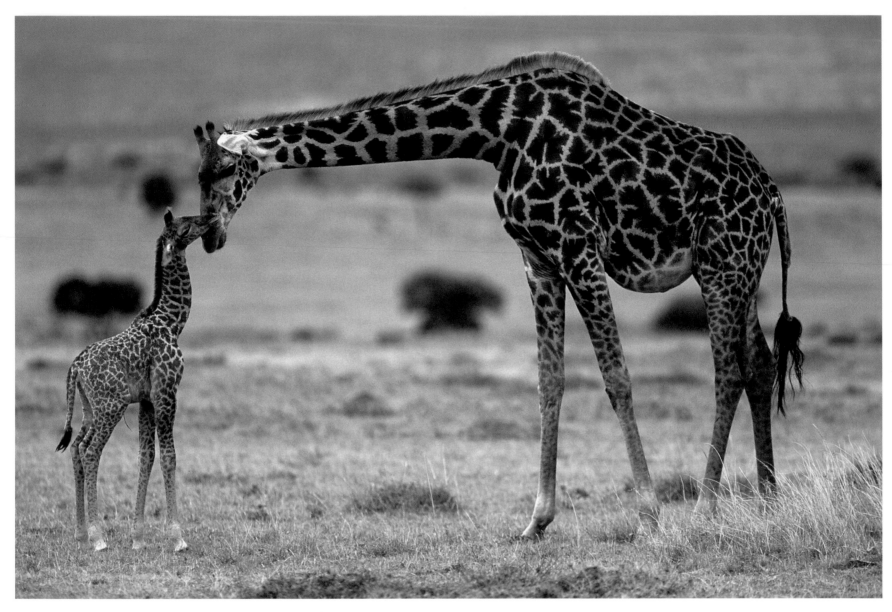

PAGES 40–41 Mother lions and cheetahs are patient and loving when playing with their young, communicating their maternal affection in close physical contact, licking and rubbing.

ABOVE When danger arises, mother giraffes courageously defend their new-born young, viciously kicking out at predators such as lions and hyenas. Mother and calf are inseparable in the first days after the birth.

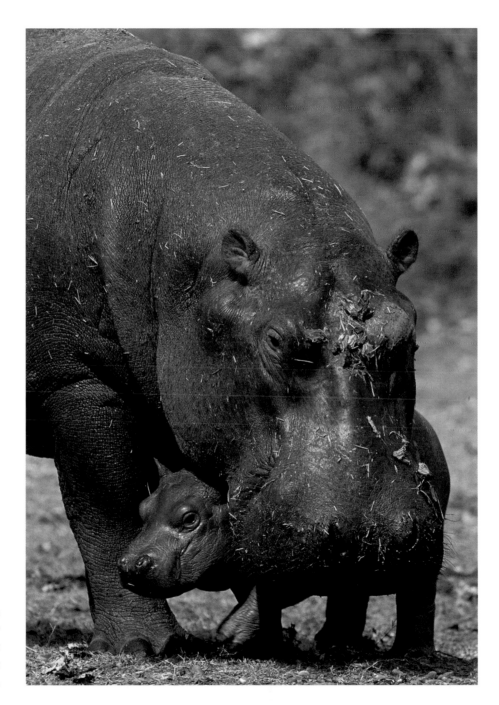

The mother hippo spends the first two weeks after giving birth alone with her calf. In this imprint phase, she withdraws from the herd to watch over and suckle her young.

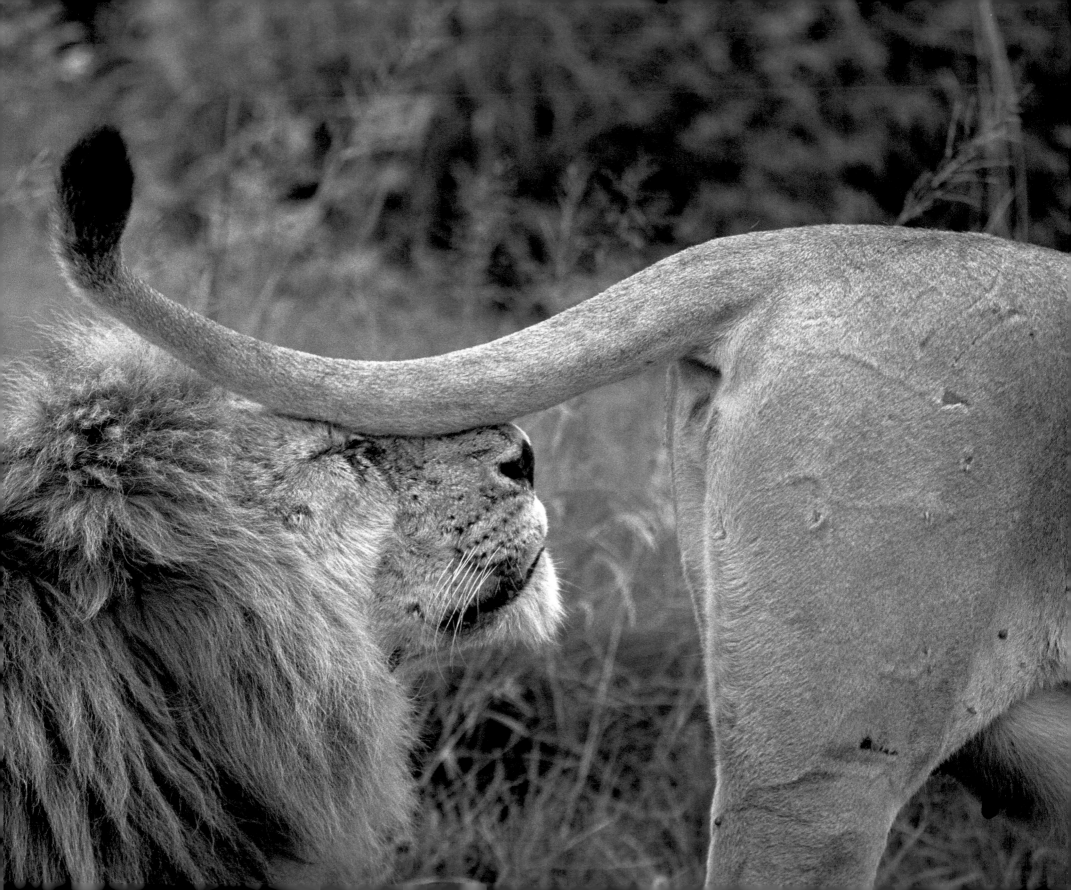

45

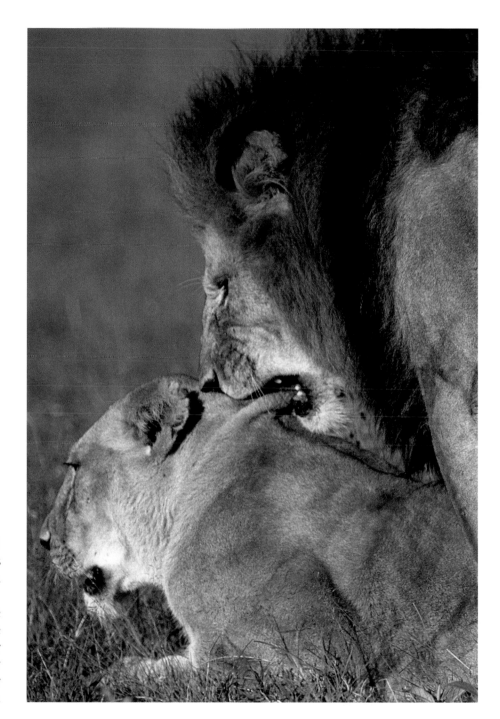

LEFT The lioness's scent and behavior tell the male she is ready to mate. He follows her closely, effectively repelling any rivals.

RIGHT During the mating period of three to six days the lions withdraw from the pride. Wholly fixated on each other, they neither hunt nor eat, but repeat their brief act of copulation almost every fifteen minutes.

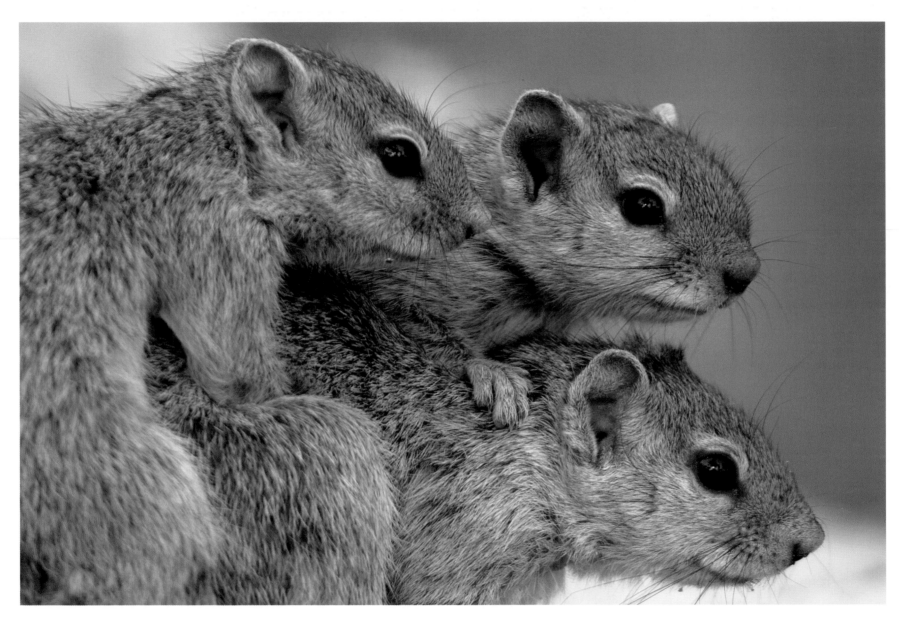

ABOVE These sociable bush squirrels form family groups and live in hollow trees. **RIGHT** The pride's strength is its solidarity. Its members hunt and feed together, also providing for the sick and for those unable to hunt.

PAGES 48–49 Herd animals such as impala, eland and giraffes feel secure and comfortable in large groups. Ostrich chicks are raised in nurseries of up to 30 animals.

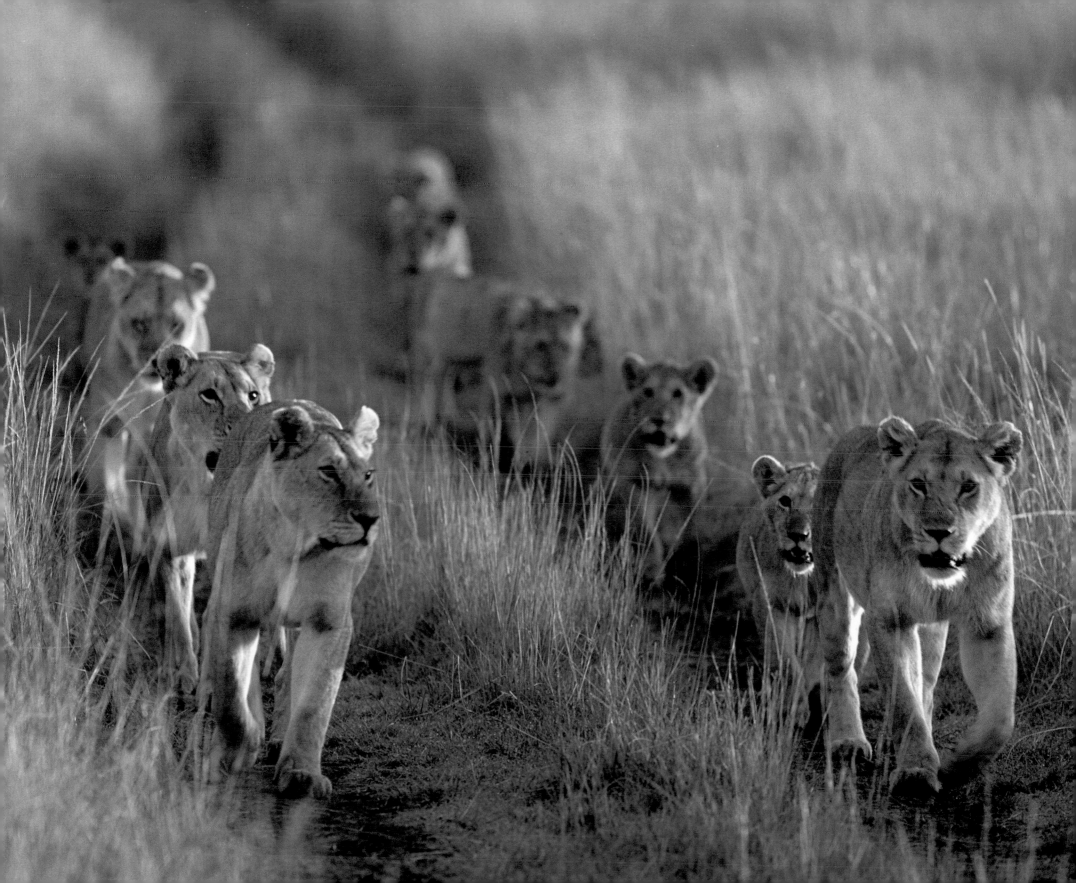

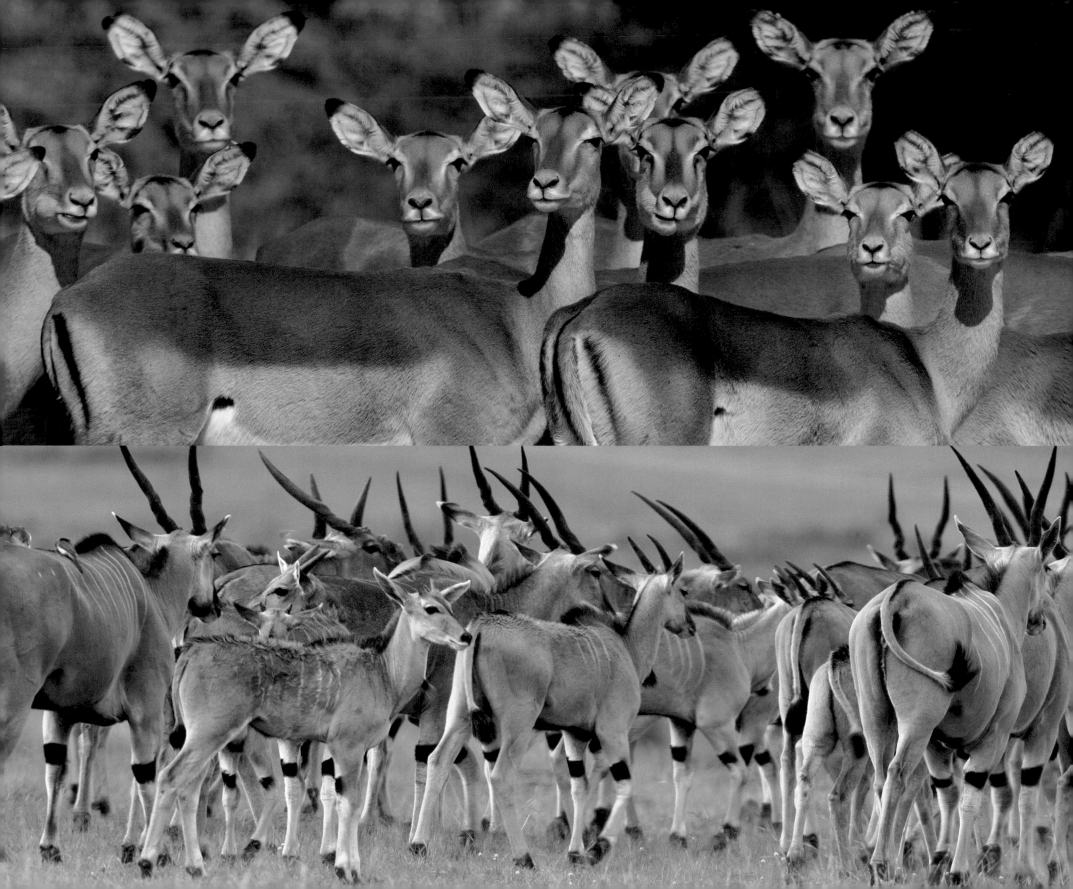

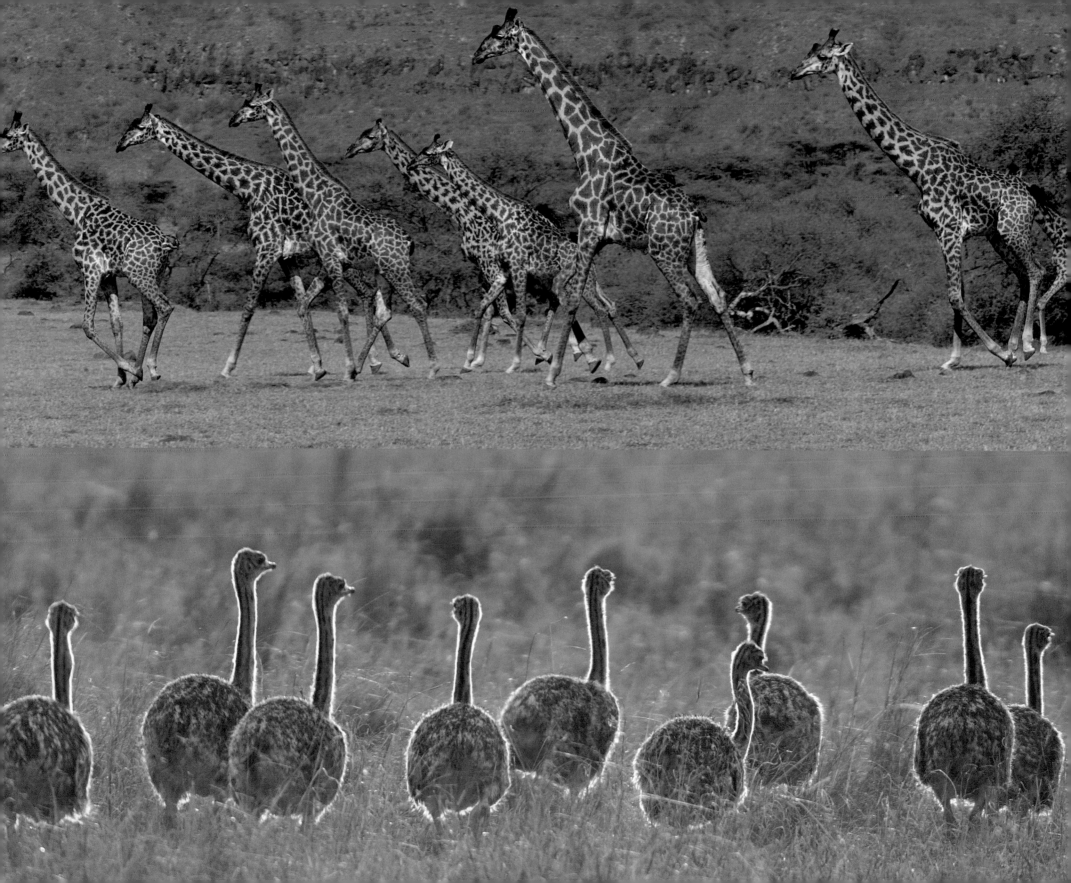

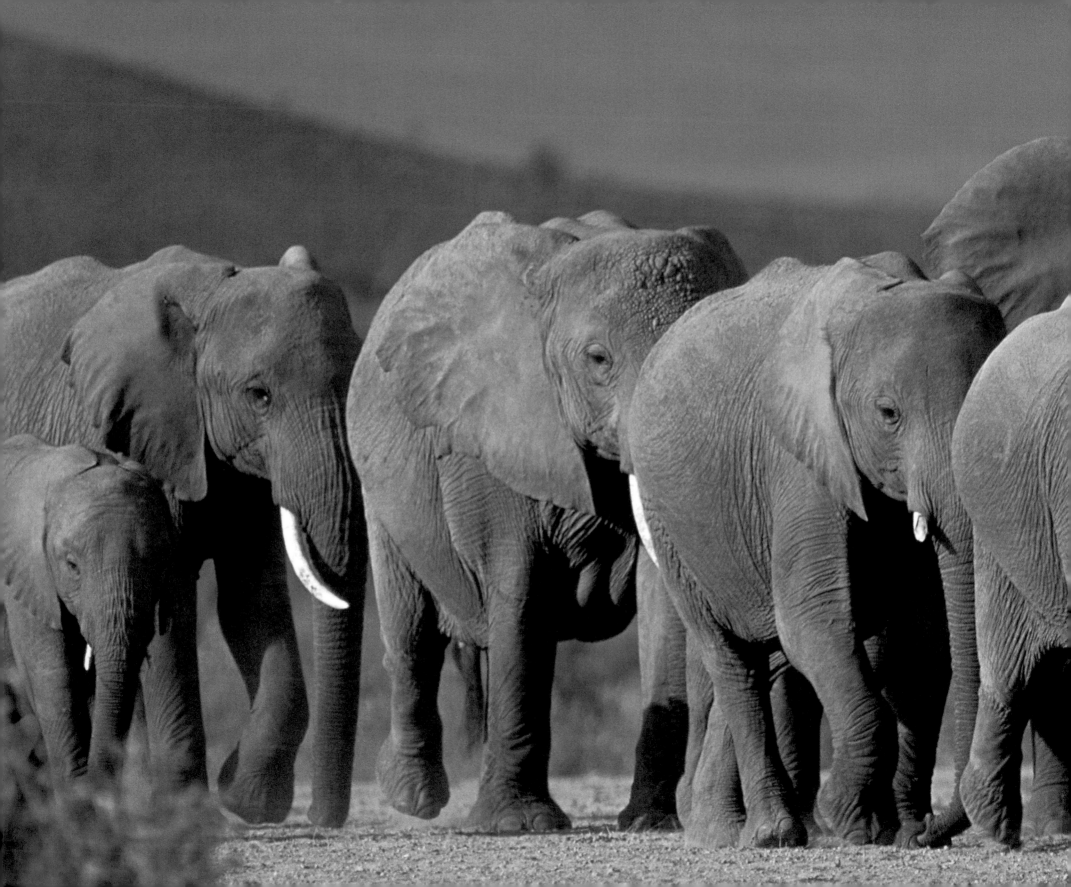

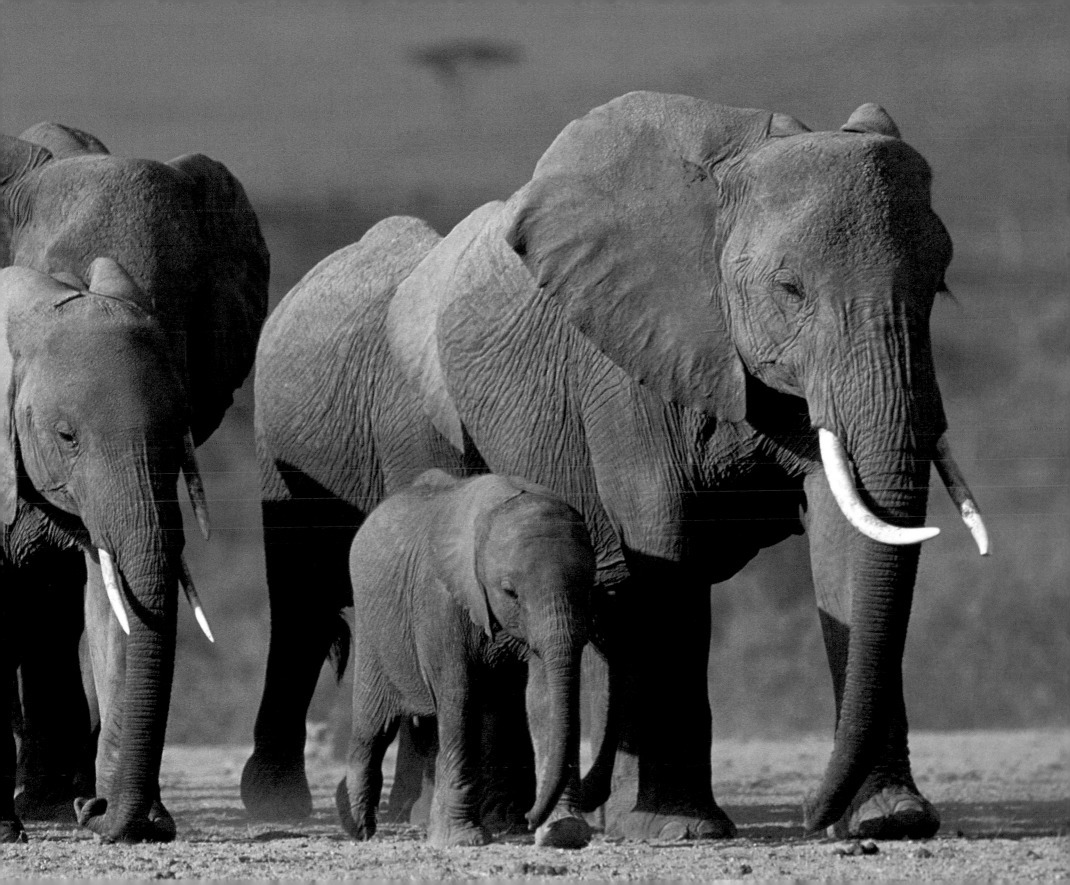

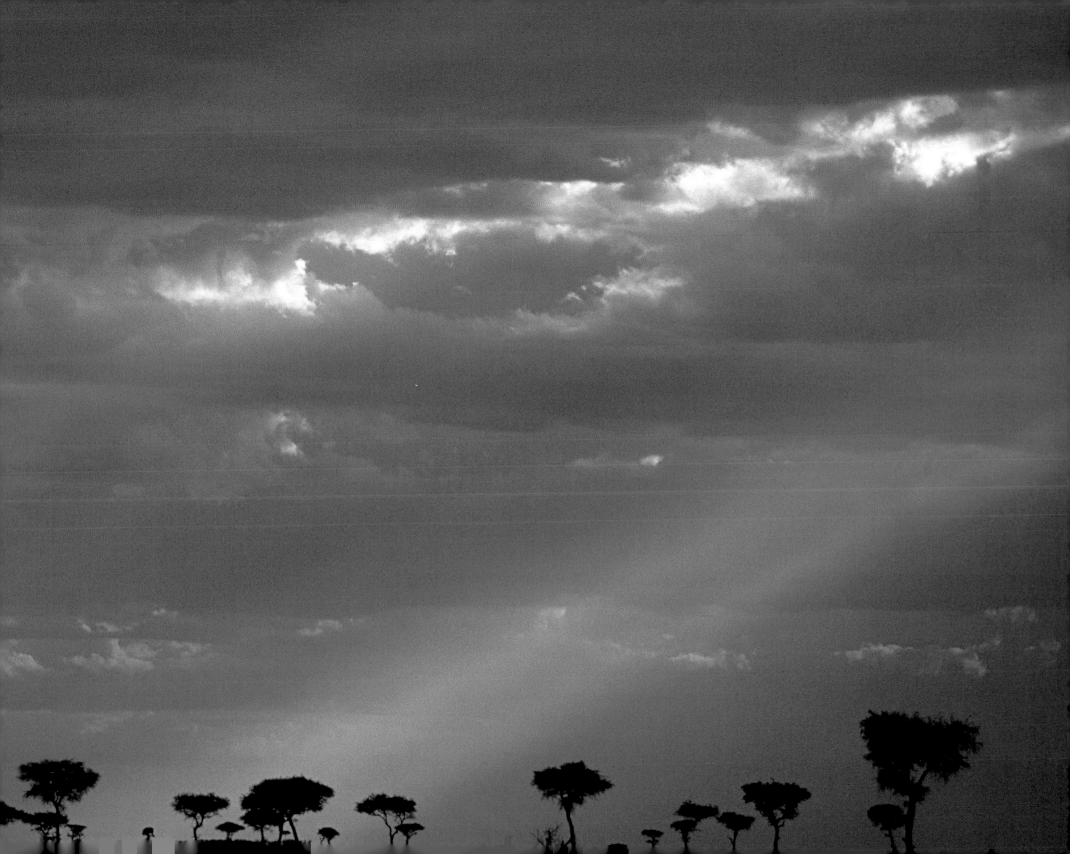

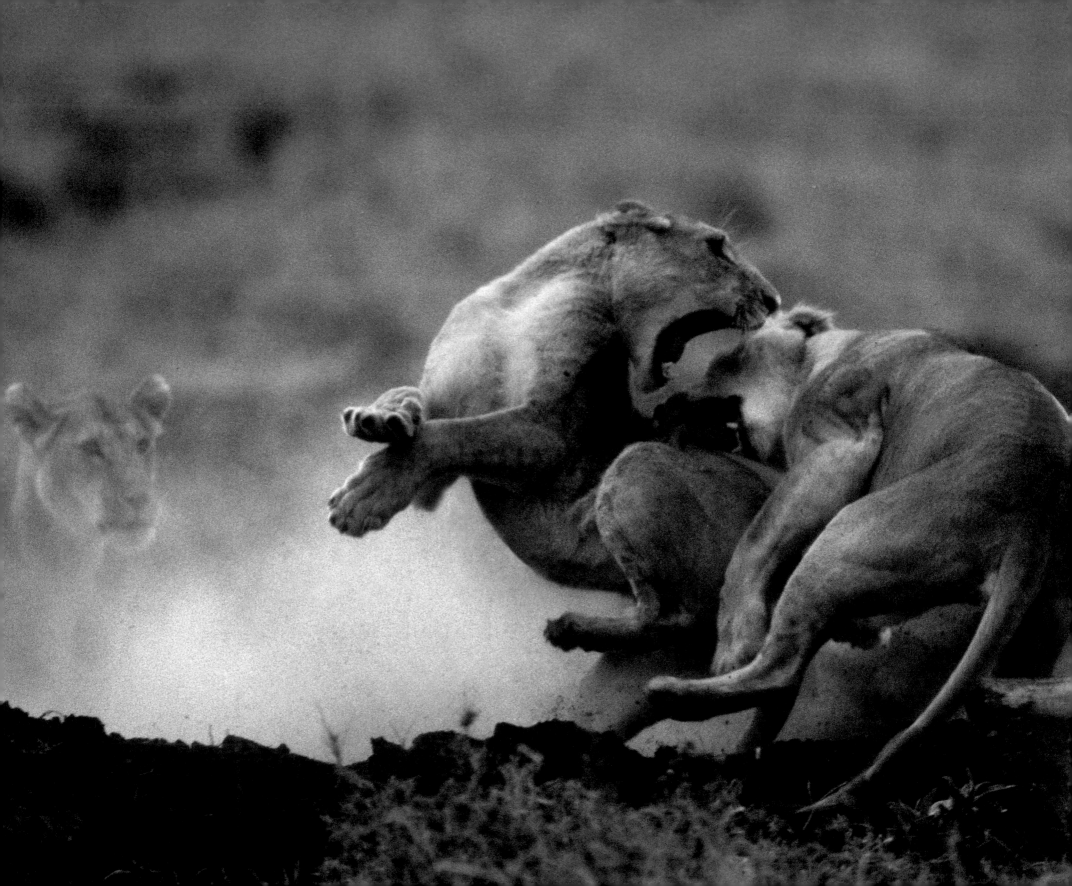

AGGRESSION

Dominance – Distrust – Attack – Enmity – Envy – Hunting and Killing

On the evolutionary scale, intra-species aggression is an attribute millions of years older than love and friendship, and a key survival mechanism. It serves as the motivation to defend territory; safeguard limited resources; ensure self-preservation and protect the family; determine the hierarchy within the group; and secure the propagation of the species.

Throughout the course of evolution, aggressive behavioral patterns have developed differently in different species, triggered by a variety of factors known as key stimuli. Hormonal levels may also affect aggressive behaviors. Sexually mature elephants undergo a periodic condition known as "musth" phase, for example, in which surging testosterone levels cause outbreaks of aggression against fellow elephants and other creatures. When food is scarce or the population is excessively large, aggression increases; the smaller the territory and the less food available for the herd, the higher the stress generated by the competitive environment.

In the case of animals that gather in prides, any disruption to the hierarchy triggers aggression. With big cats, fierce battles may erupt over prey if the hierarchy is not observed. The other members of the pride may only eat when the dominant male is sated, and the weakest and lowest-ranking must content themselves with the remains. If a young male baboon even attempts to mate, the dominant male in the group will respond with antagonism and nip his intentions in the bud. Dominant behavior engenders submission and respect in others. Rivalry in mating is one of the most powerful triggers of aggression; a zebra stallion, threatened with the loss of its mare to a rival, will brutally attack the interloper. On the other hand, female zebras also act with jealous aggression when their male partner shows interest in another female. For many animals, aggression is a response to pain; a swarm of mosquitos is enough to transform the normally peaceable lord of a pride of lions into an irascible bundle of nerves when dealing with his cubs.

Yet the majority of rivalries, among predators as well as herbivores, end peacefully. Bloody battles may often be forestalled with threatening behavior such as body language, facial expressions, roaring or hissing and scent signals, while specific placatory rituals are enacted by the loser. Many battles end with the weaker opponent's giving up and retreating in resignation: the submissive lion throws itself on its back and offers its most vulnerable parts – which the stronger lion graciously ignores (Lorenz speaks of "inhibition against killing").

In ethology, killing is not regarded as aggressive behavior where its purpose is to satisfy hunger. However, predatory animals have such a powerful killing reflex that when circumstances are favorable, they may also kill even when they are sated or have already killed sufficient prey. Predators from other species attempting to snatch prey are angrily routed or attacked: competition over food is often a reason for innate antipathy, such as that between lions and leopards or hyenas and big cats.

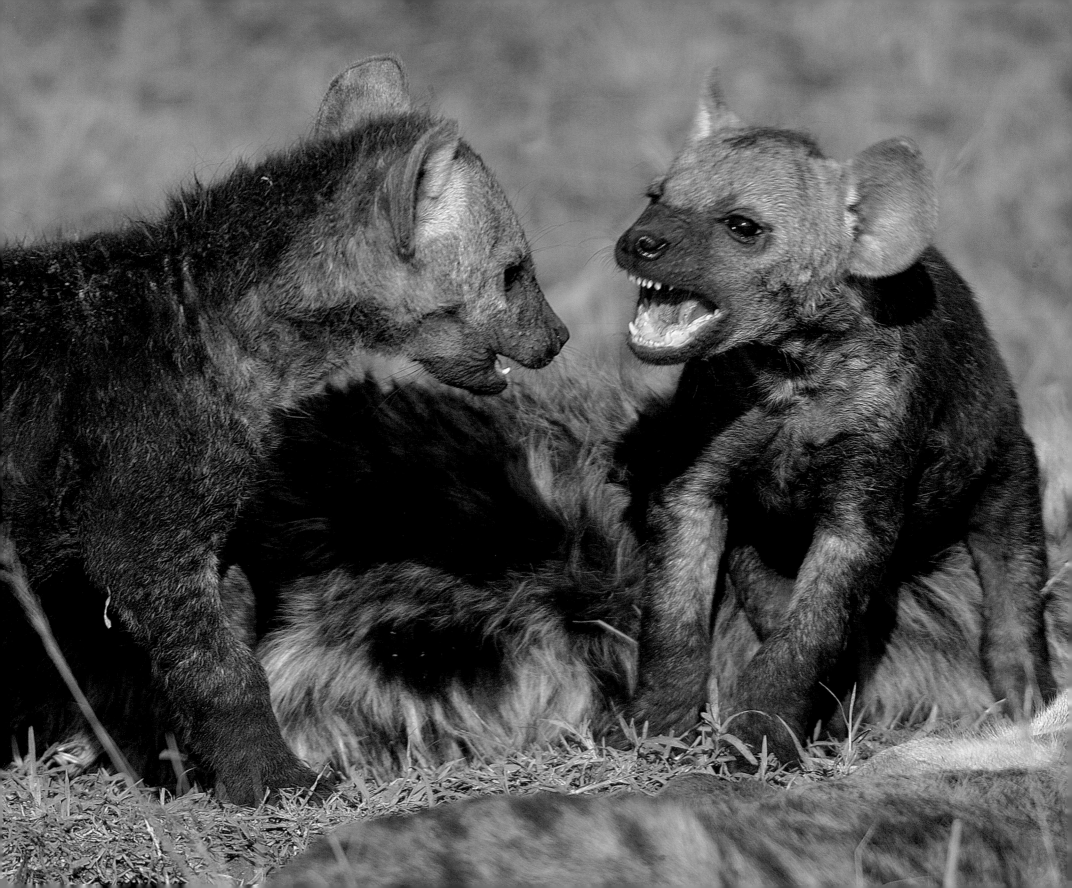

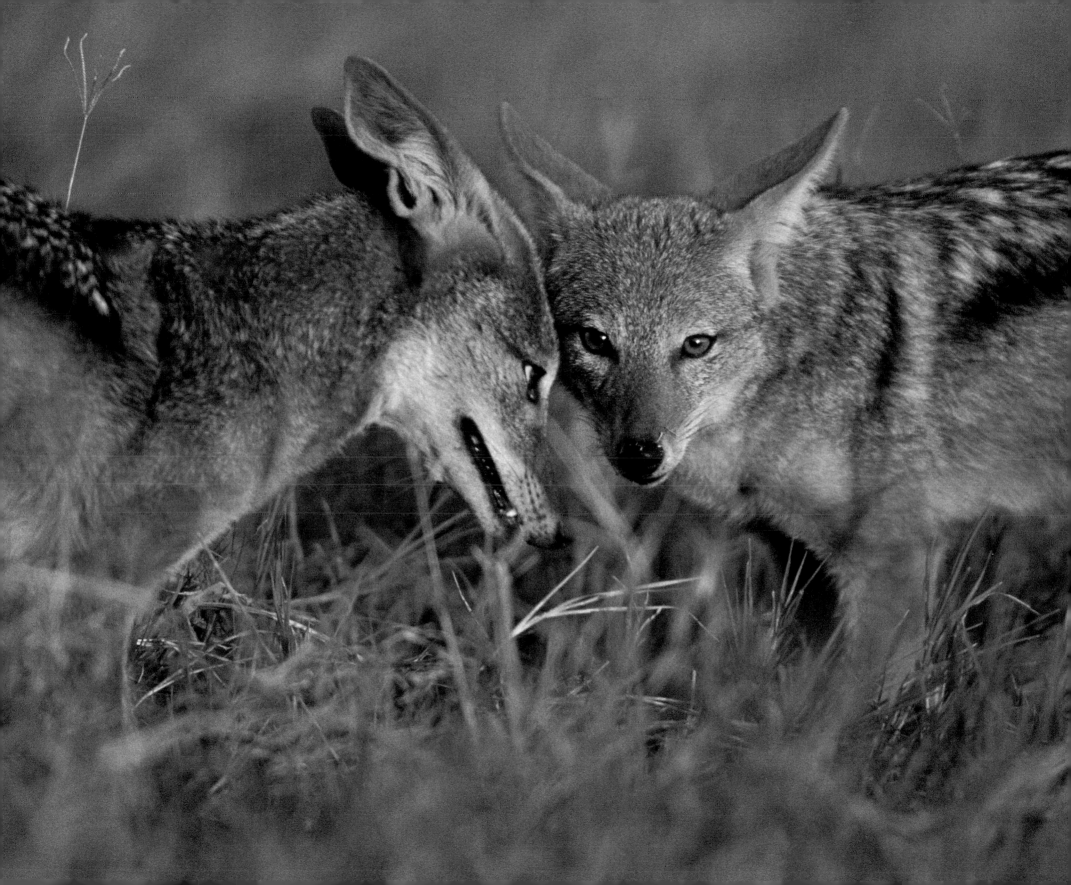

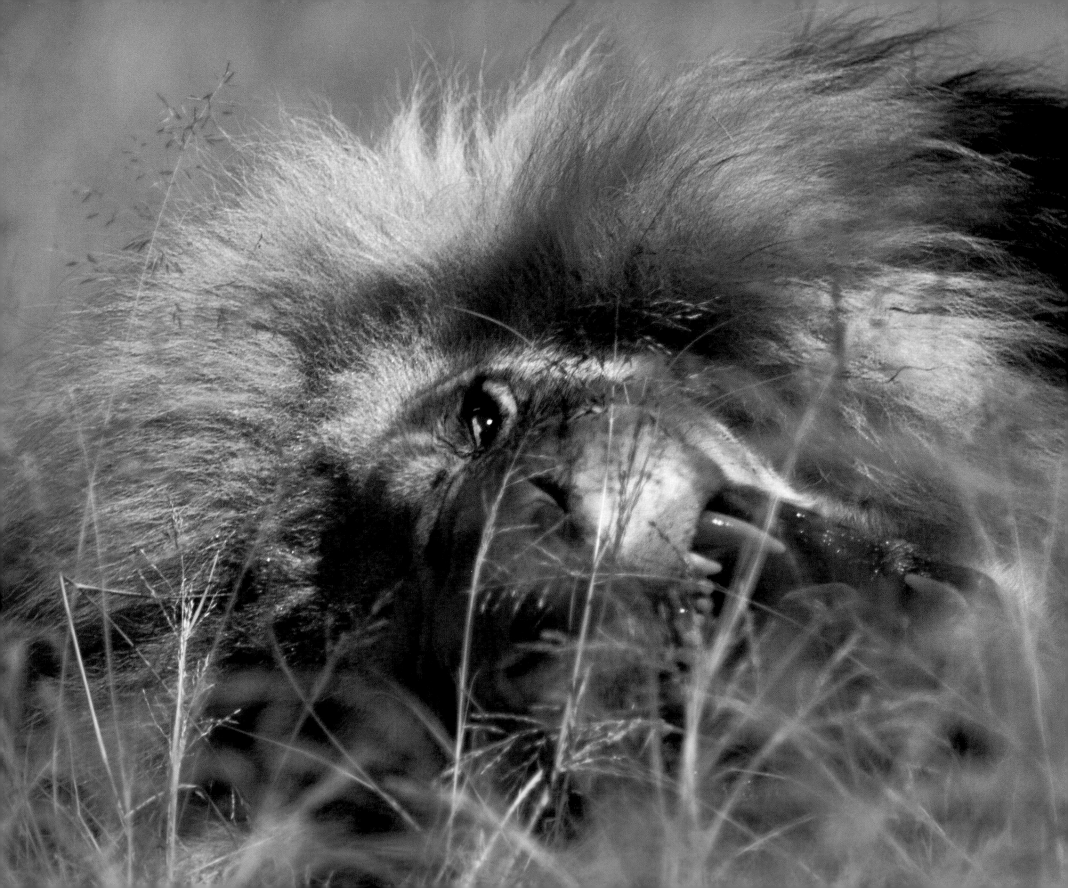

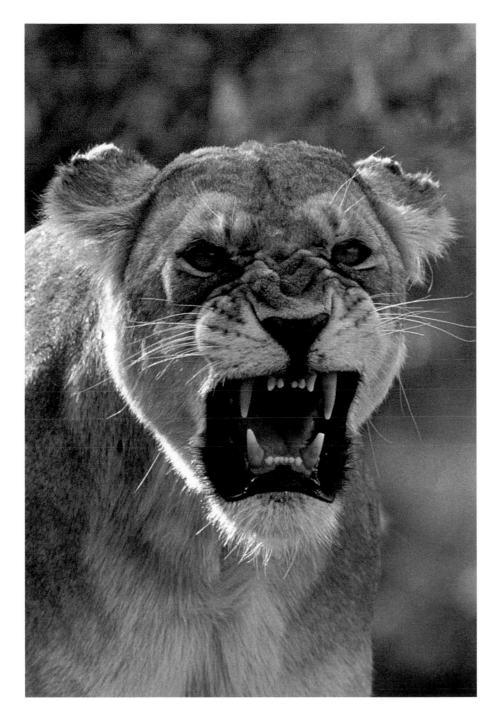

LEFT The lion brooks no disturbance during his siesta. Growling and baring his teeth is enough to warn off tiresome members of the pride.

RIGHT The lioness's unequivocally threatening behavior is aimed at her own sons. Now sexually mature, they must turn their backs on the pride for ever.

DOMINANCE

60

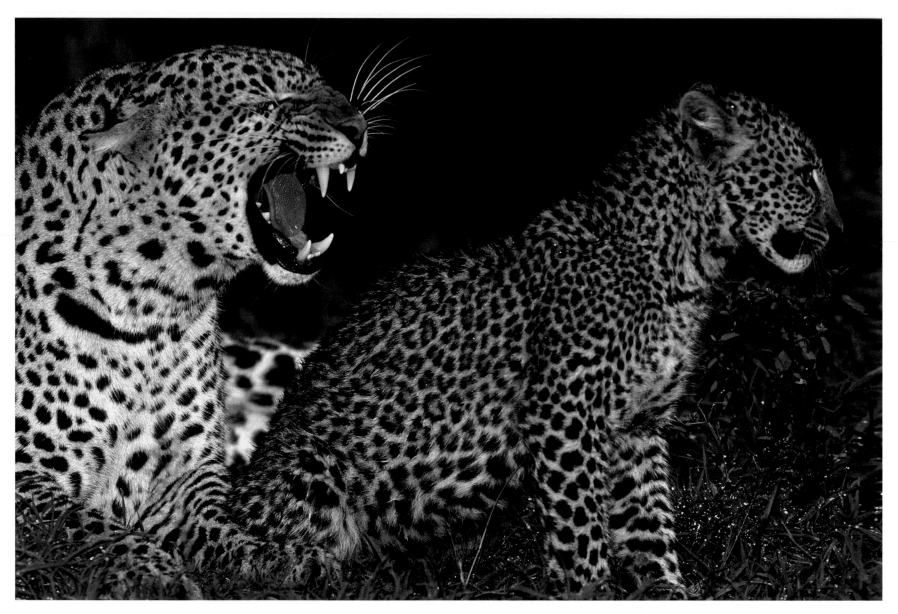

ABOVE The mother leopard has no interest in playing with her cubs and demonstrates her unwillingness by hissing and spitting.

RIGHT The enraged male impala drives off a rival. He tolerates no other adult males in his territory, where a large herd of females is grazing with their young.

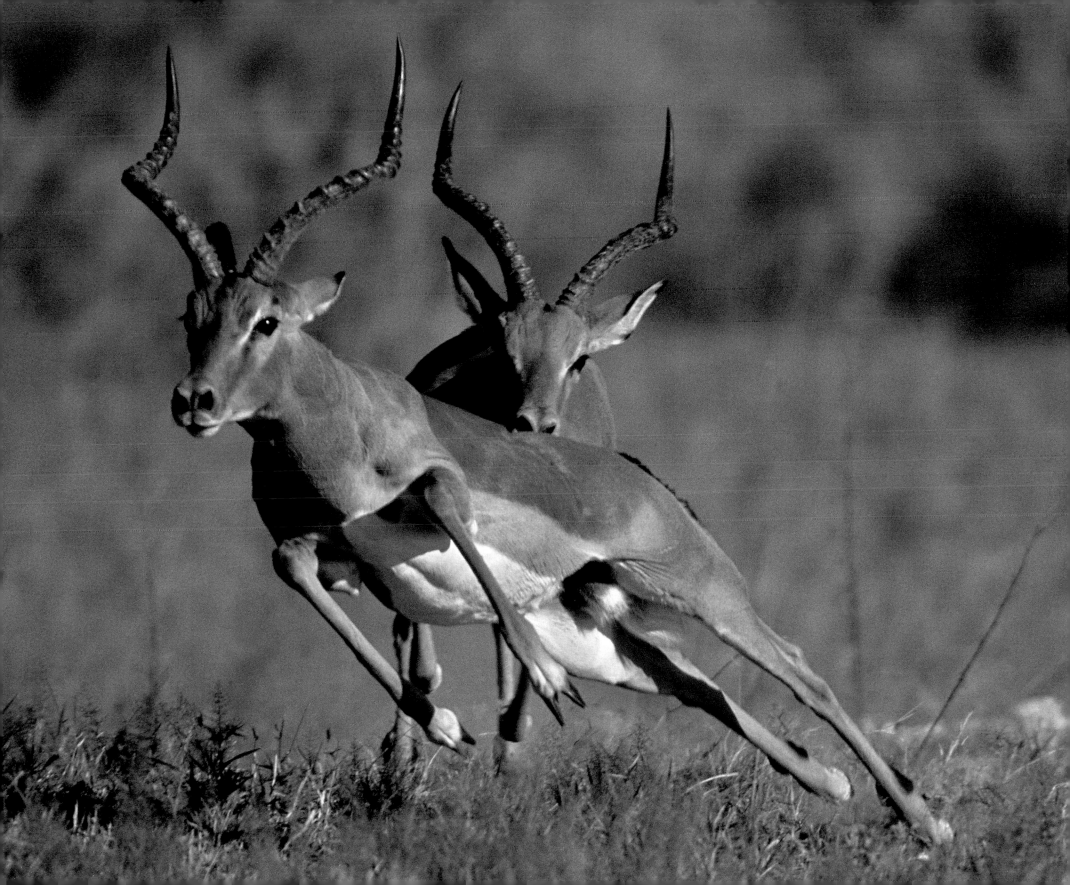

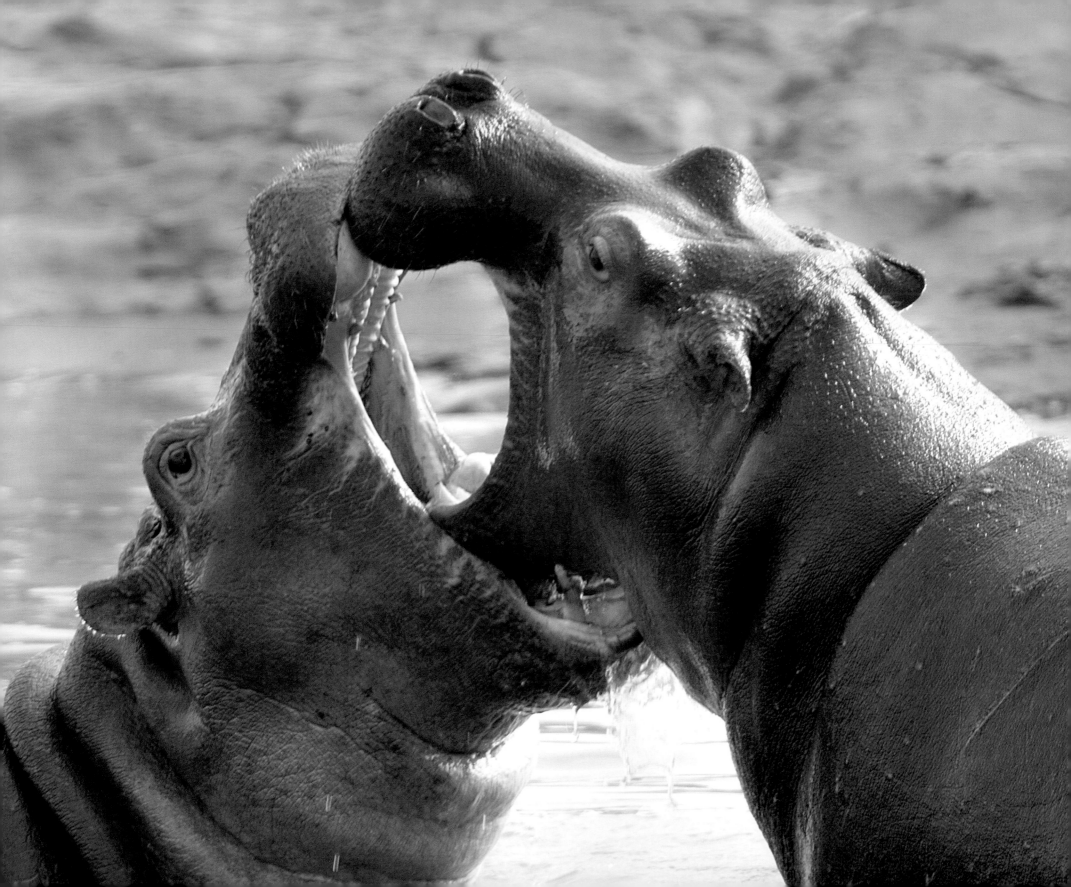

63

LEFT Yawning is part of the male hippopotamus' aggression ritual. Ritualized open-mouthed jousting contests may develop into bitter and bloody fighting, occasionally ending fatally.

RIGHT When a female rhinoceros is in estrus, males may engage in battle. Dominant behavior is used to intimidate potential rivals. The winner ostentatiously marks his territory by copiously urinating and defecating.

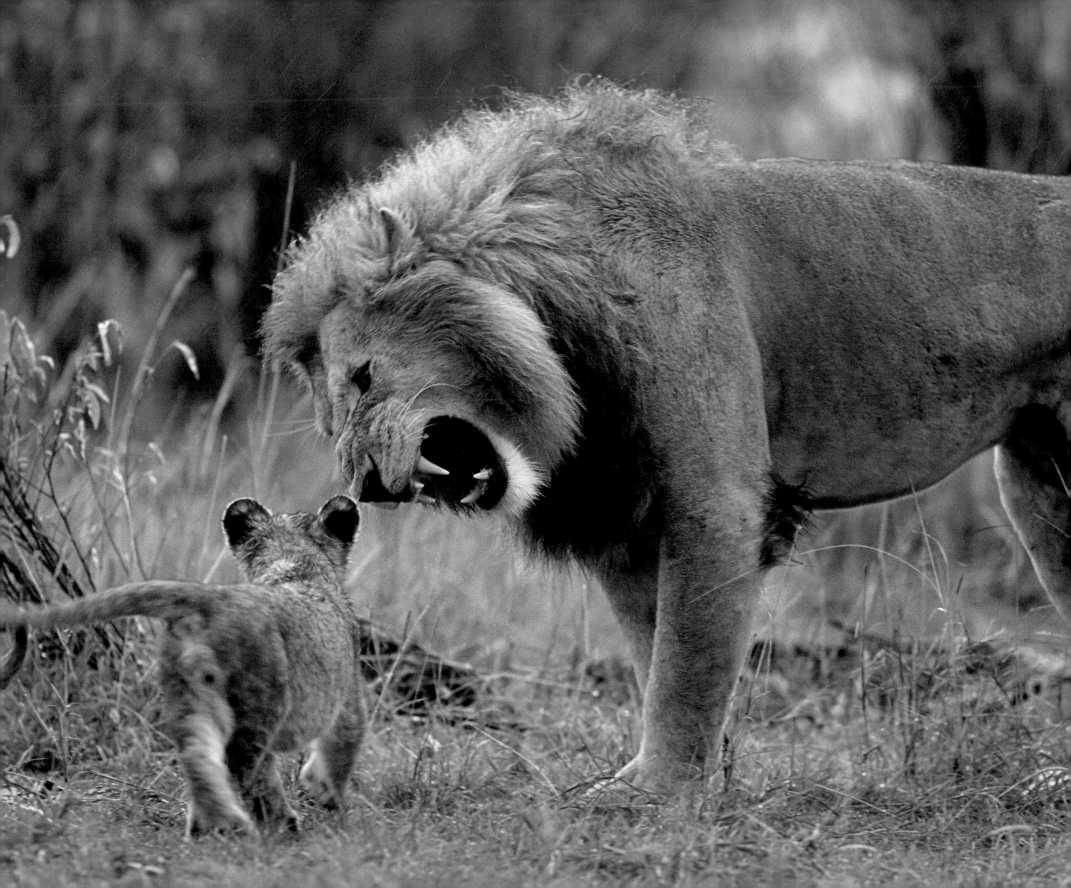

When denied the opportunity of an outlet, aggression in both animals and humans builds up and may trigger extremely powerful abreactions.

Irenäus Eibl-Eibesfeldt, Zoologist and Ethologist

The male lion lets his cub know that its overtures are unwelcome by hissing and growling unequivocally. The cub will not dare to repeat its attempt to play with the pasha of the pride. (A swipe of the paw could be a painful experience.) But not all males show aggression or irritation in dealings with their offspring. Depending on their temperament and mood, they may tolerate the cubs' riotous play or warn them with threatening gestures to keep their distance. Occasionally they simply retreat from the pride to seek a quiet spot.

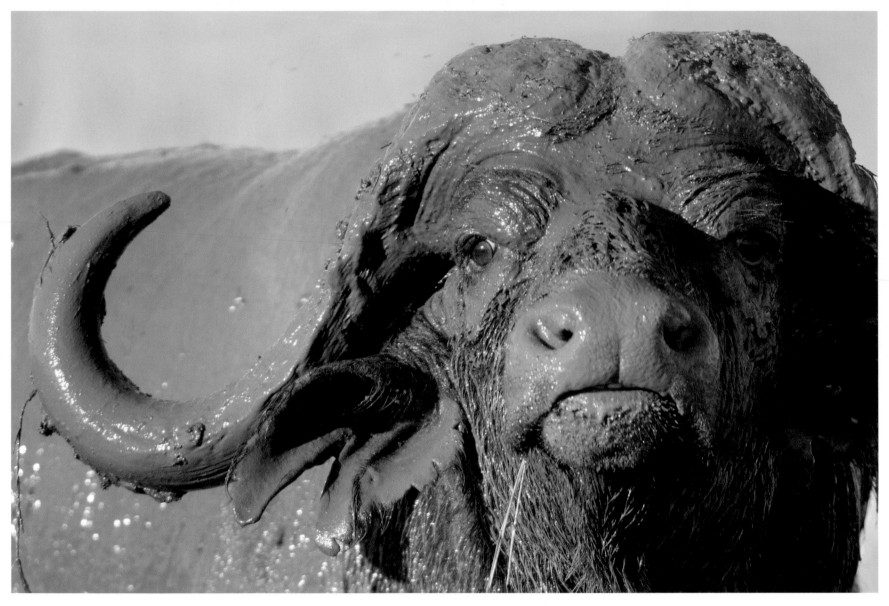

ABOVE Any danger? The African buffalo warily eyes the passing lions before resuming its wallowing in the mud.

RIGHT Hippos are known to be volatile and aggressive. More people are said to have been killed in attacks by hippos than by lions, buffalo or rhinoceros.

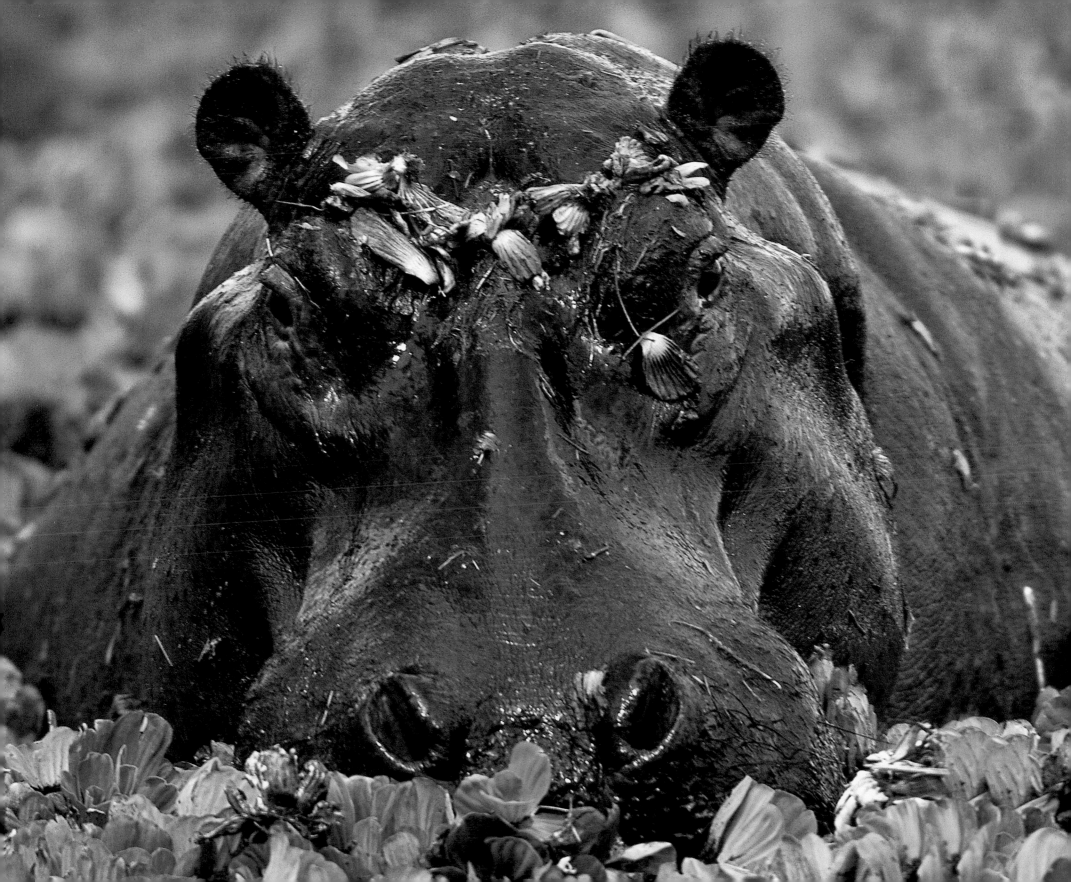

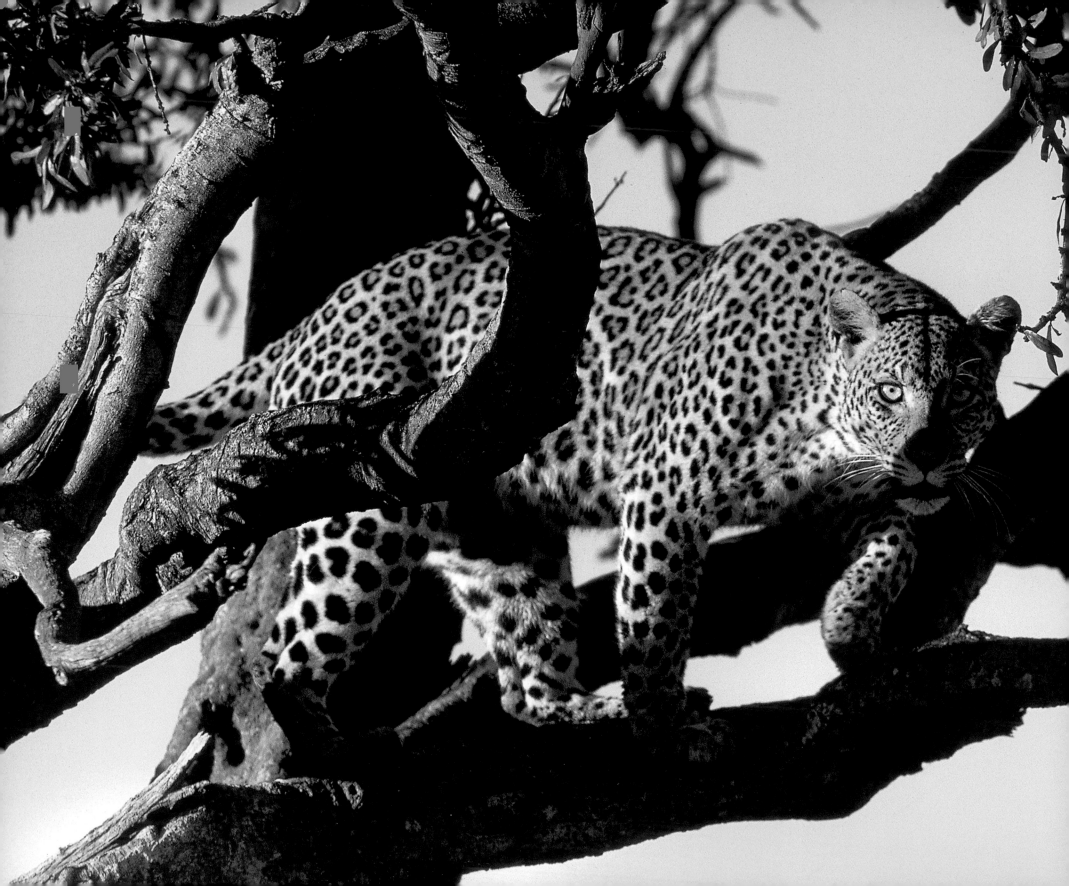

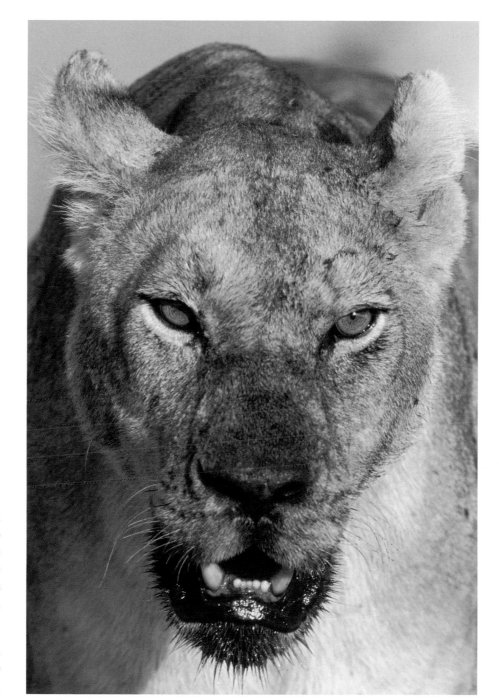

LEFT Leopards view lions with hostility. Not only do lions represent a danger to the leopards and their cubs; they also frequently steal the leopards' prey. The leopard keeps a suspicious eye on this potential rival for its food.

RIGHT The lioness has been successful in her hunting. Her look betrays her aggression. She has no intention of surrendering anything to the hyenas.

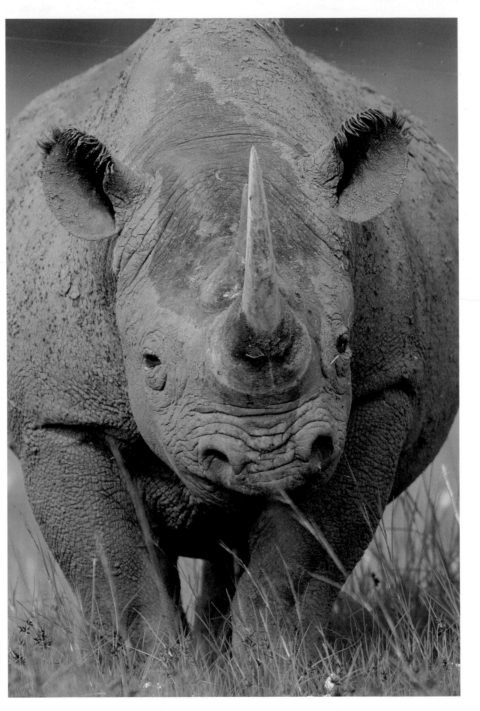

LEFT The rhinoceros protects itself and its young by using its horn to attack predators such as lions. Black rhinos are considerably more aggressive than white rhinos.

RIGHT It is not always a mock attack. In a serious attack, the male elephant charges at his enemy, preparing to trample him, fling him aside with his trunk, crush him with his skull and spear him with his tusks.

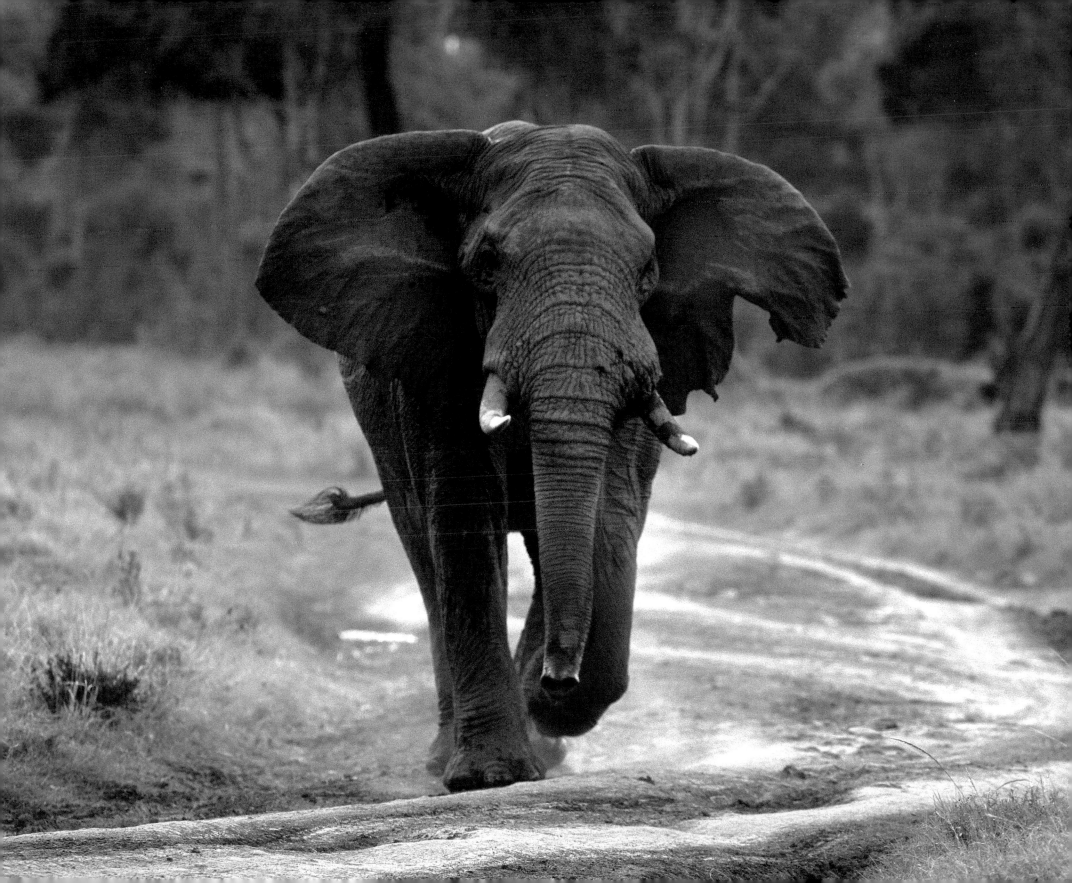

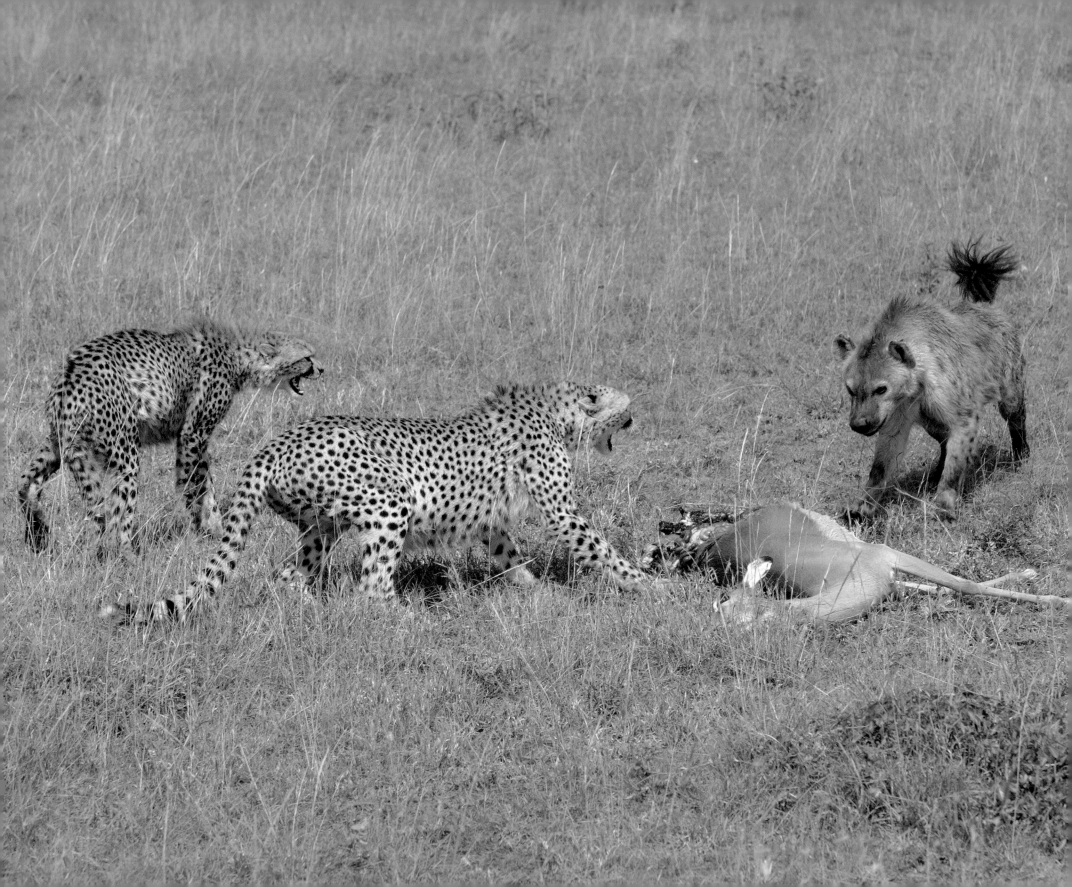

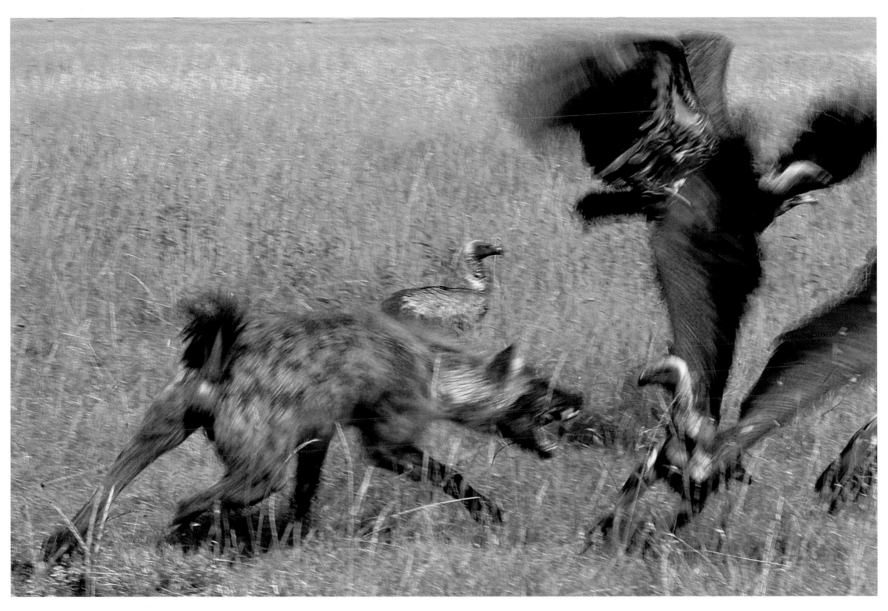

LEFT The cheetahs' agitated hissing and spitting is useless against even one hyena. The hyena is superior in strength to the fast cats and is about to steal their prey – a frequent occurrence.

ABOVE However, the hyena in turn must fight off the vultures that flock to the scene in the hope of finding leftover scraps of meat.

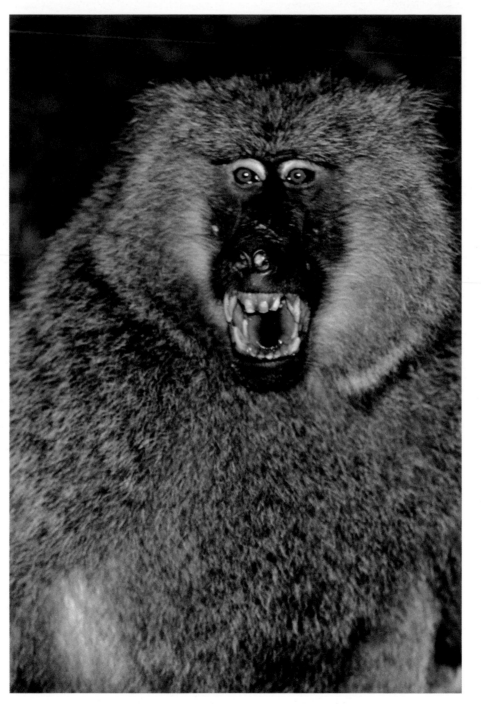

LEFT Open hostility and violence may also erupt when two animals of the same species come into conflict. The dominant male baboon bares his teeth as he challenges his subordinates to submit to him.

RIGHT Rival zebra stallions fight according to a specific ritual. When threatening and intimidating behavior is not sufficient to avoid a confrontation, bites and kicks are the order of the day. The loser can announce his defeat by showing submissive behavior or by retreating.

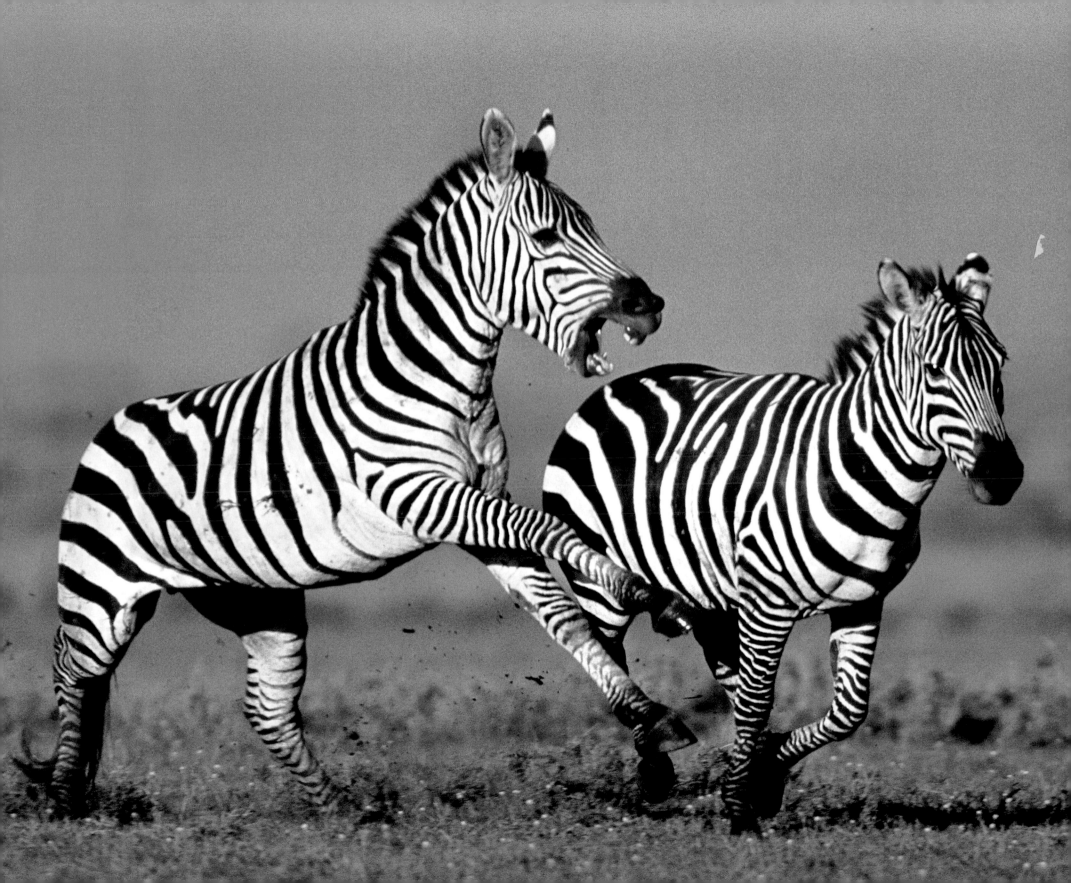

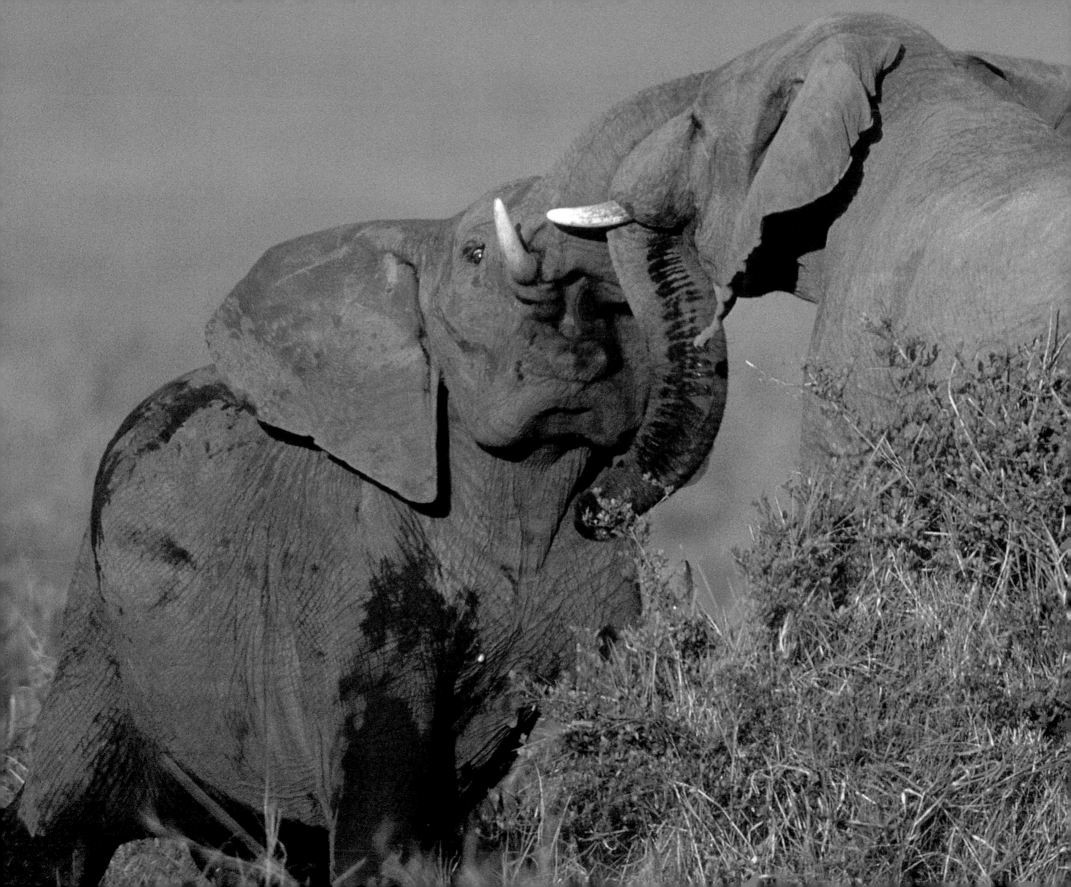

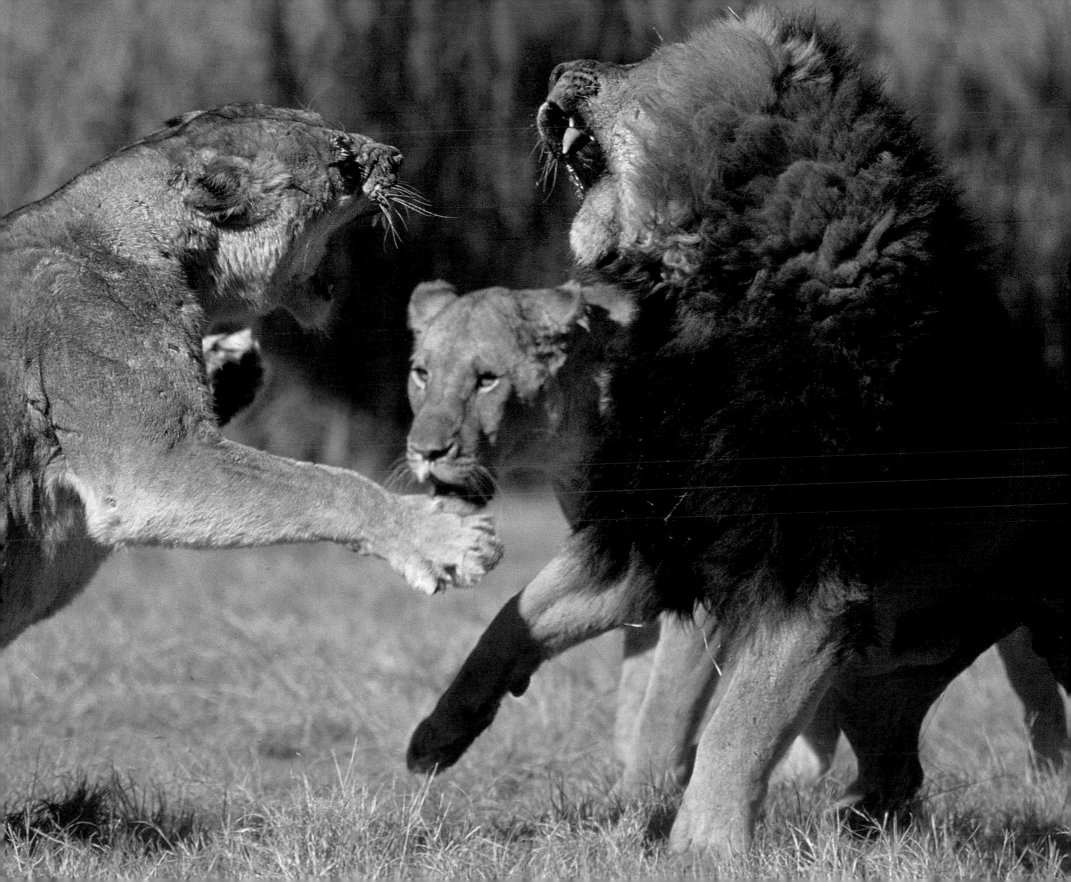

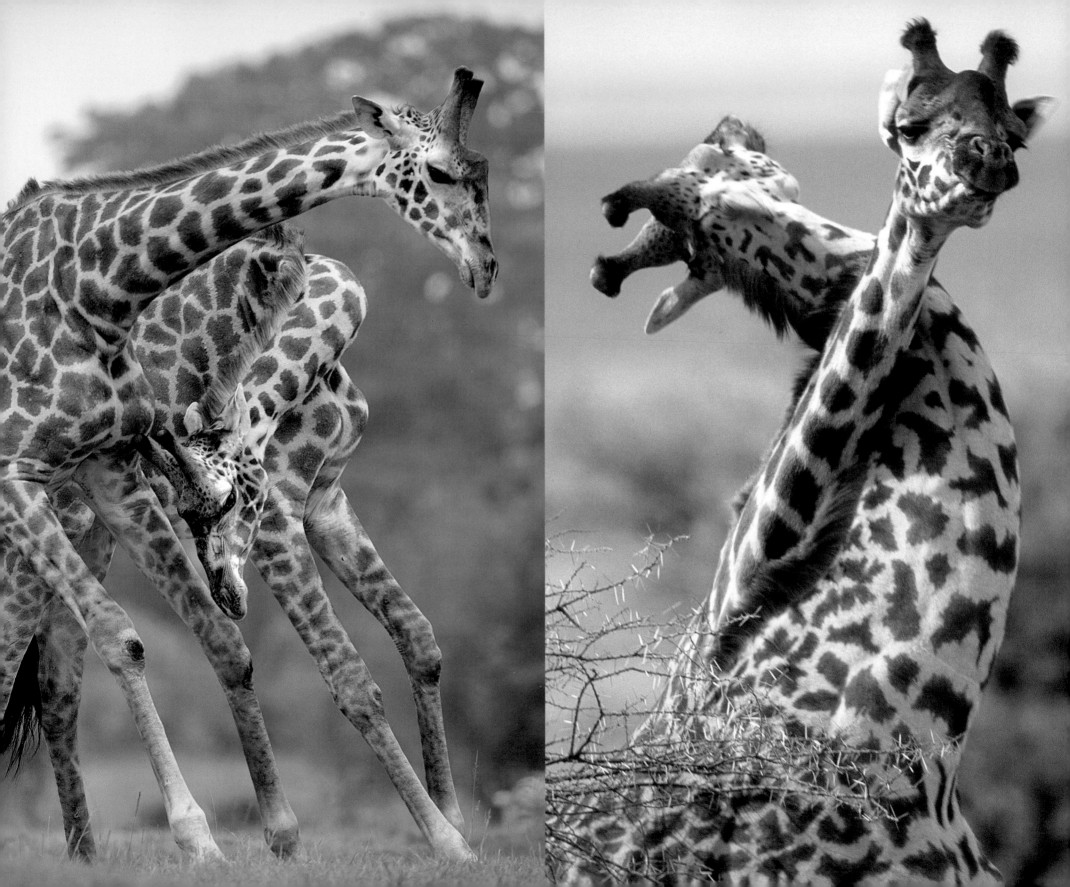

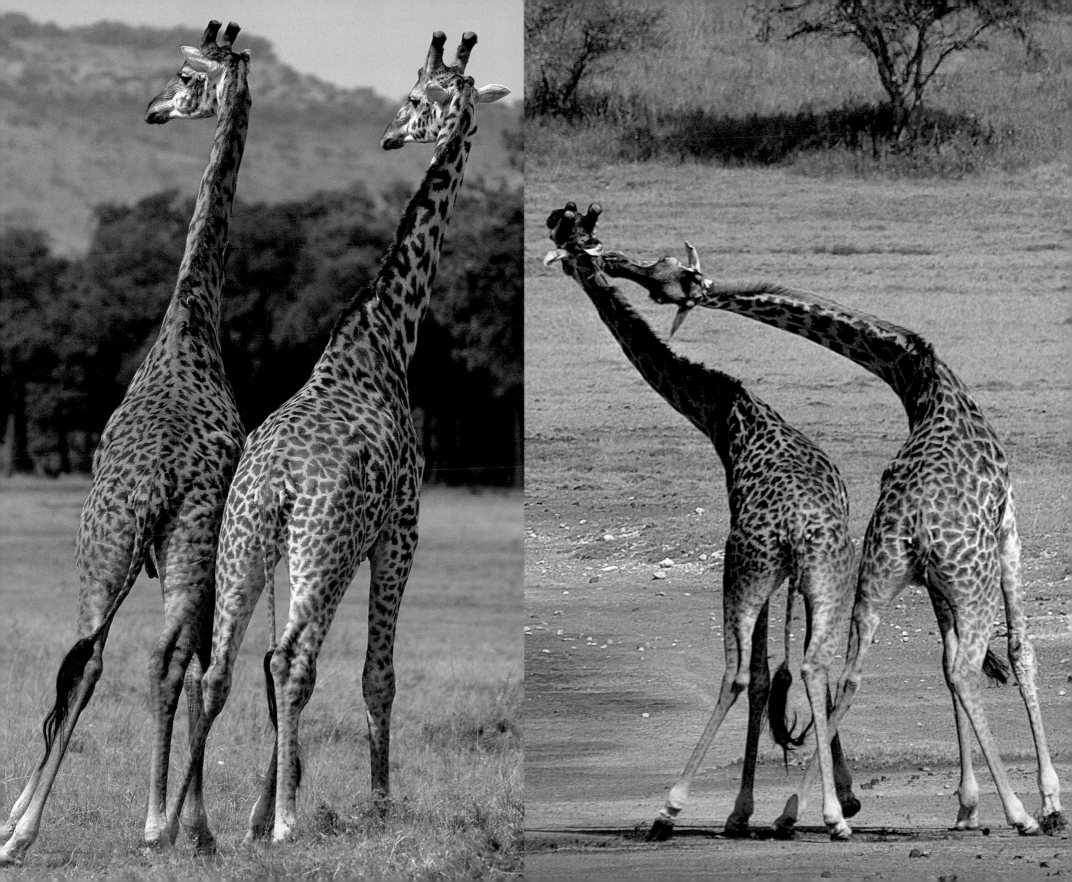

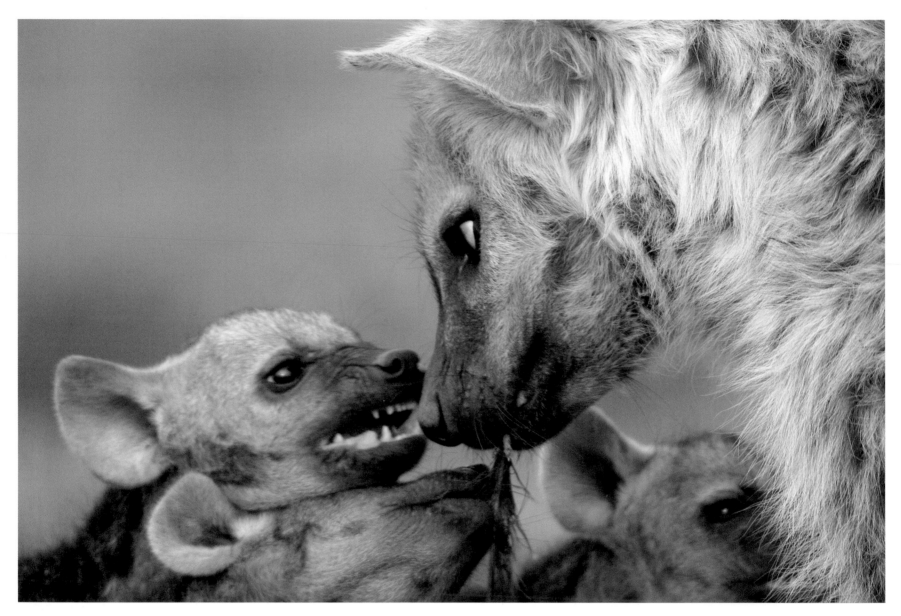

PAGES 78–79 Even adolescent male giraffes employ ritual fighting to establish a dominance hierarchy. Standing flank to flank, they swing their heads and necks against their opponents. Genuine fights are rare and generally concern females in estrus.

ABOVE The hyena has something that its younger siblings would like – a feather they want to play with.

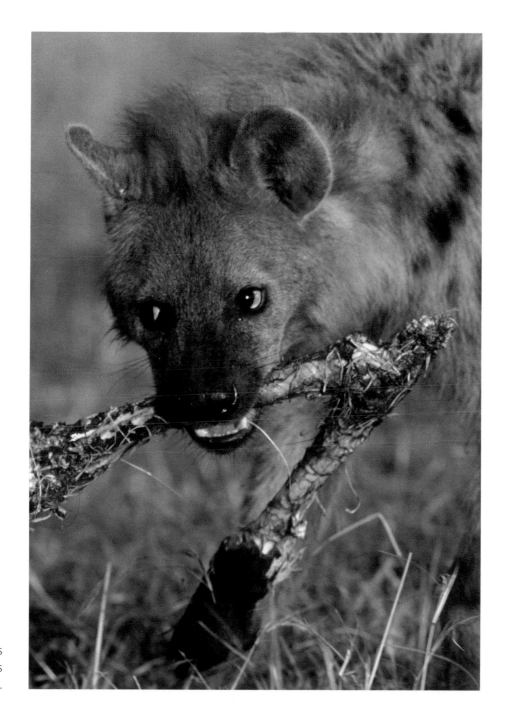

"This is my bone," the hyena's expression seems to boast to its envious clan.

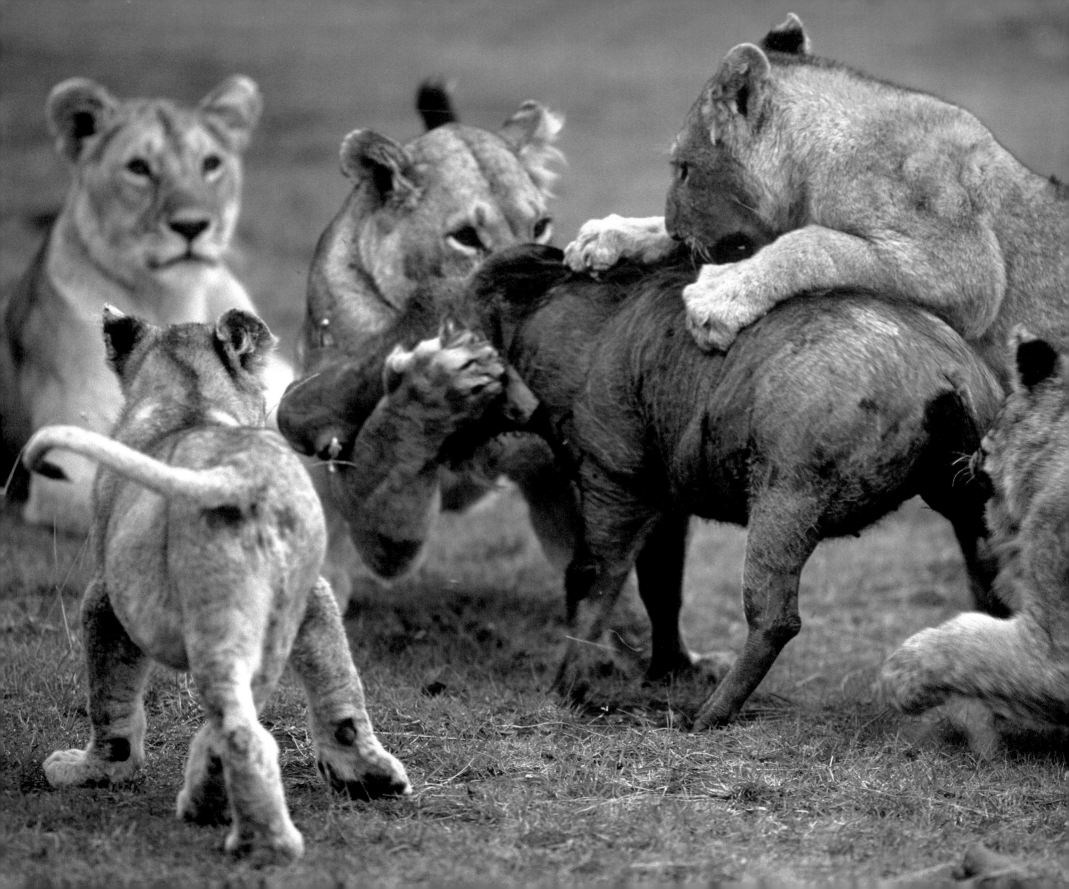

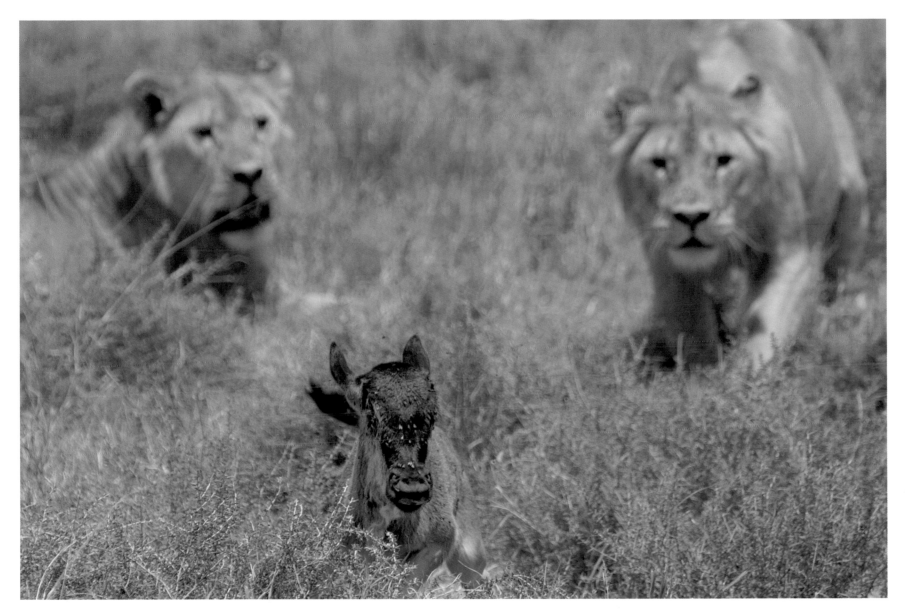

LEFT Killing a vigorous warthog is a matter of experience. It is done not out of aggression, but to get meat in order to avoid starvation.

ABOVE The hunting instinct in lions is generally so powerful that even when sated they will also take advantage of a favorable opportunity to kill a helpless wildebeest calf.

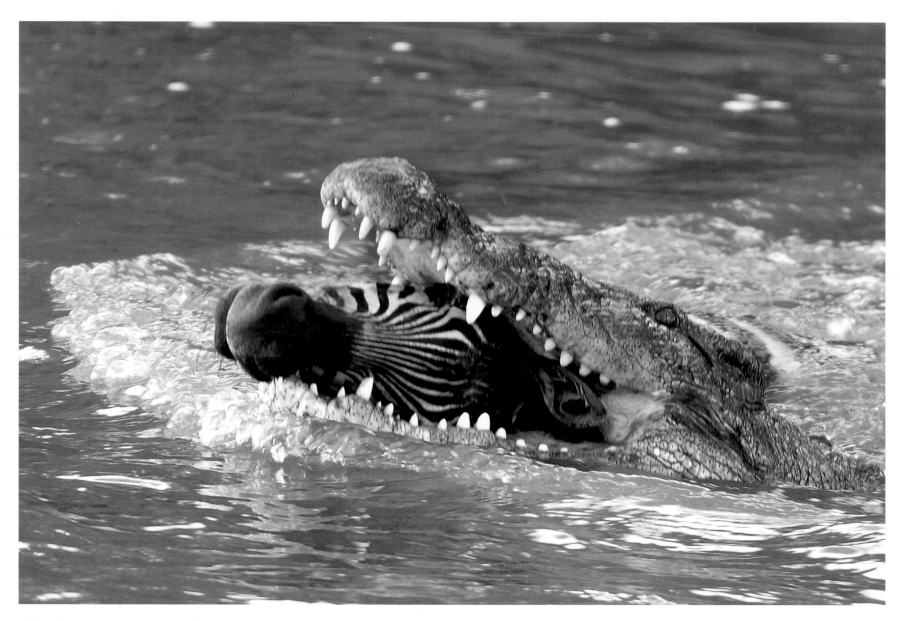

ABOVE, RIGHT AND PAGES 86–87 Like all hungry predators, the Nile crocodile kills its prey without feeling aggression. Crocodiles drag their prey under water to drown it. Several crocodiles generally share a kill, rolling around their own axis to tear out large chunks of flesh before swallowing them whole. However, fish is the main diet of these reptiles, which can grow up to 18 feet (6 meters) in length.

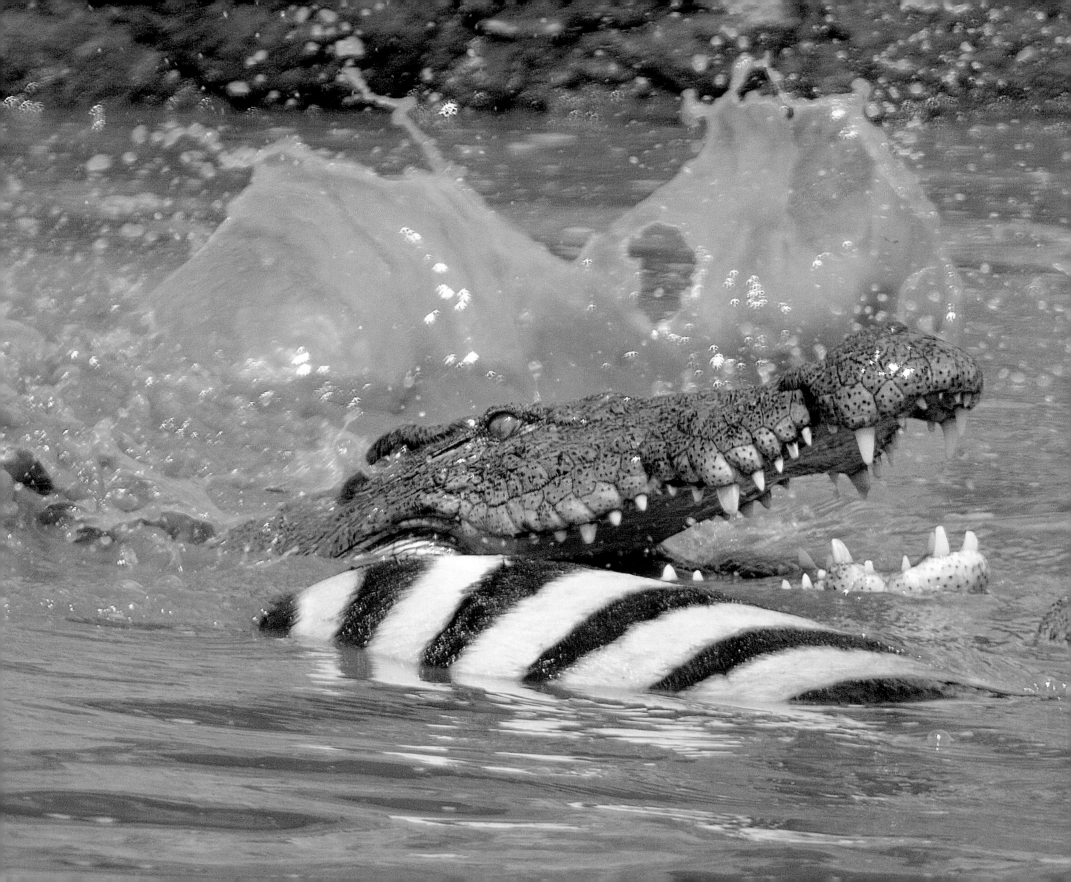

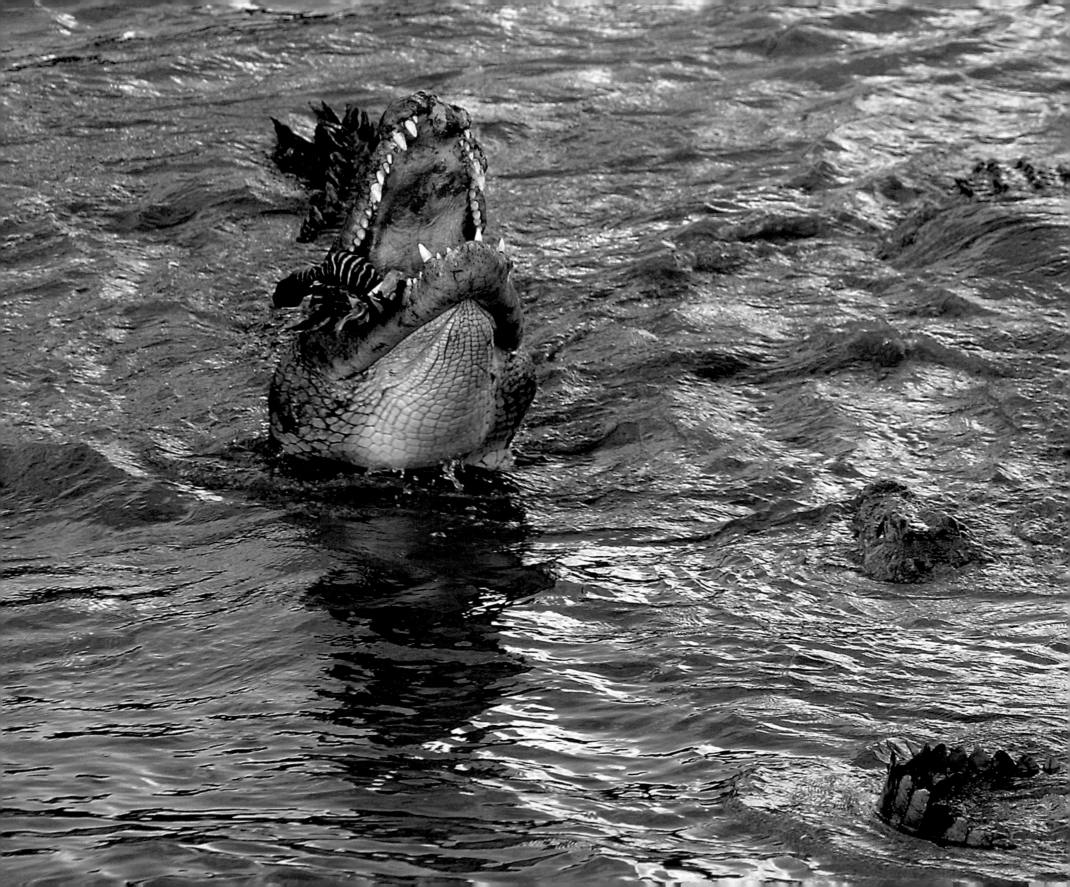

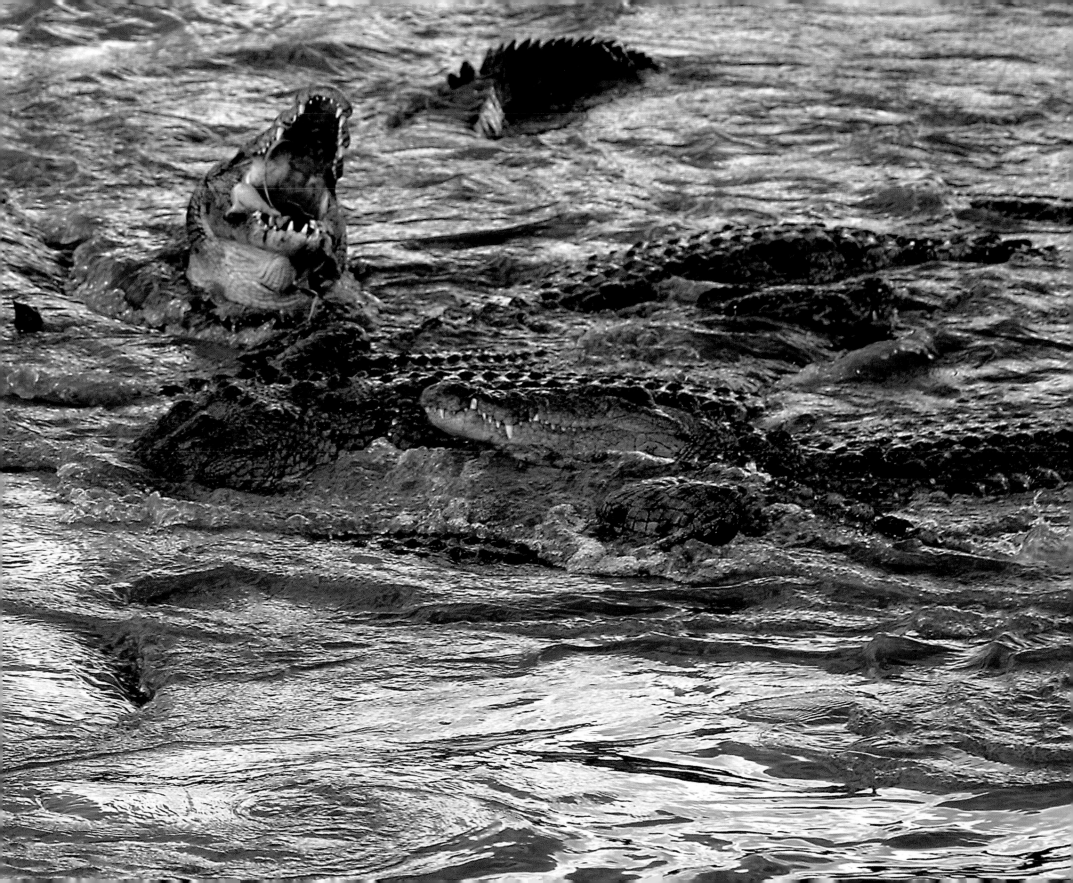

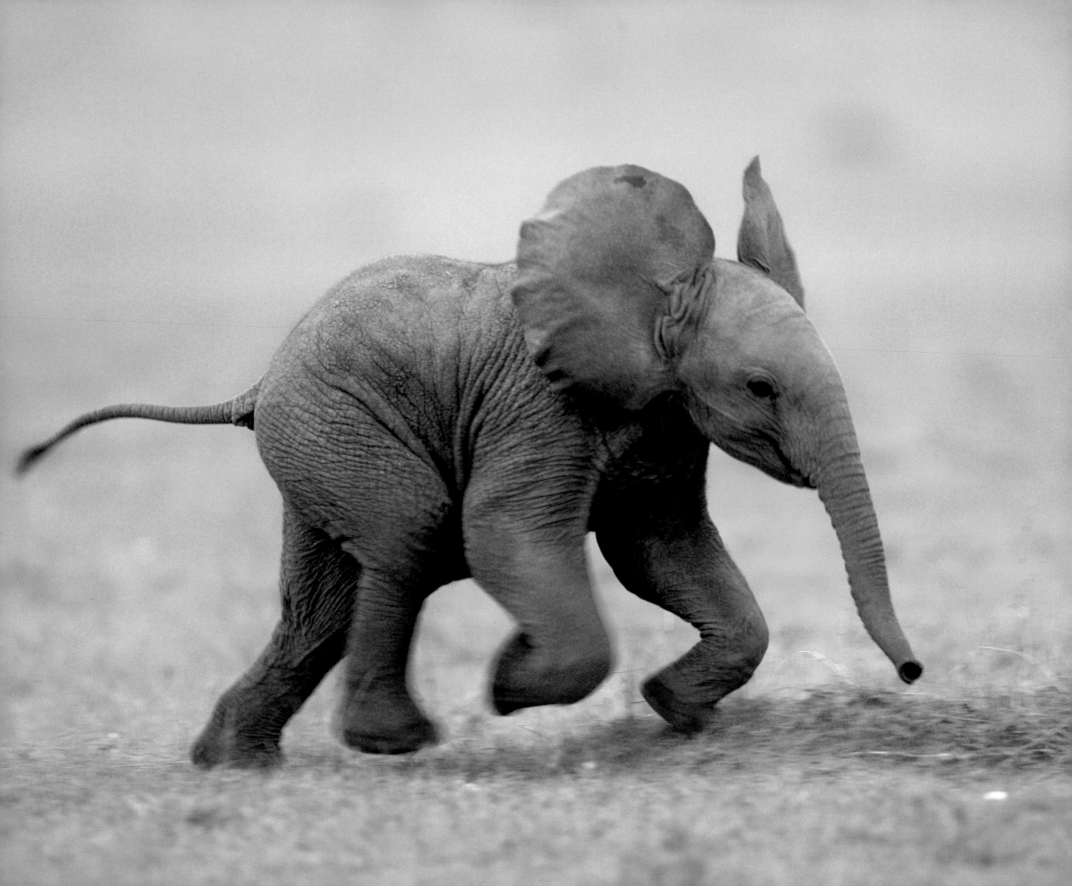

JOY

Security – Happiness – Curiosity – Playfulness – Contentment

I gain enormous pleasure from observing and photographing happy, exuberant wild animals in Africa. In humans, as in many species of animal, feelings and emotions are generated in the limbic system, the oldest part of the brain. When endorphins are produced, feelings of happiness are triggered – a physiological response also experienced by more highly developed animals, which are familiar with the sensations of joy, happiness and pleasure.

Life in the African wilderness is made up of more than the daily battle for survival; there is also plenty of fun and games. Cheetah cubs pursue each other on wild chases; young hyenas wrestle with bared teeth, yet without injuring each other. A young rhino charges through the savanna with no apparent purpose other than the sheer pleasure of motion. Adult animals also play, particularly when they are experiencing physical wellbeing. The river is a welcome source of refreshment to the elephants, and they splash happily in its waters. After a cooling storm, the lions – generally indolent by day – gambol through the pools and puddles of rainwater with visible glee.

In fact, play among wild animals is a type of survival training, training skills, honing reflexes and strengthening muscles. Herd and pack animals also practice rituals that strengthen their social ties and establish hierarchies, thus reducing tension in the group.

The biologist and ethologist Jonathan Balcombe, however, claims that "Animals play out of sheer fun, with no specific agenda; pleasure is the best motivation to perform actions which will be useful for survival."

Happiness is many-faceted: The feeling of security experienced by all young animals in close physical contact with their mothers. The elation when a member of the family returns. Contentment and comfort when hunger and thirst are sated or a shady spot is found to sleep. Pleasure in sex, and the satisfying feeling of superiority over a fellow.

When animals experience an underlying positive feeling they show vivid interest in their environment. Young big cats embark zestfully on journeys of discovery. Everything unknown is investigated playfully; even creatures that do not fall into the category of food are spotted and observed at length with lively curiosity.

In the case of primates, which have facial expressions similar to our own, we can easily read their happiness in their faces. Other highly developed vertebrates generally reveal whether they feel good-humored and relaxed by employing specific body language or by emitting sounds or scents.

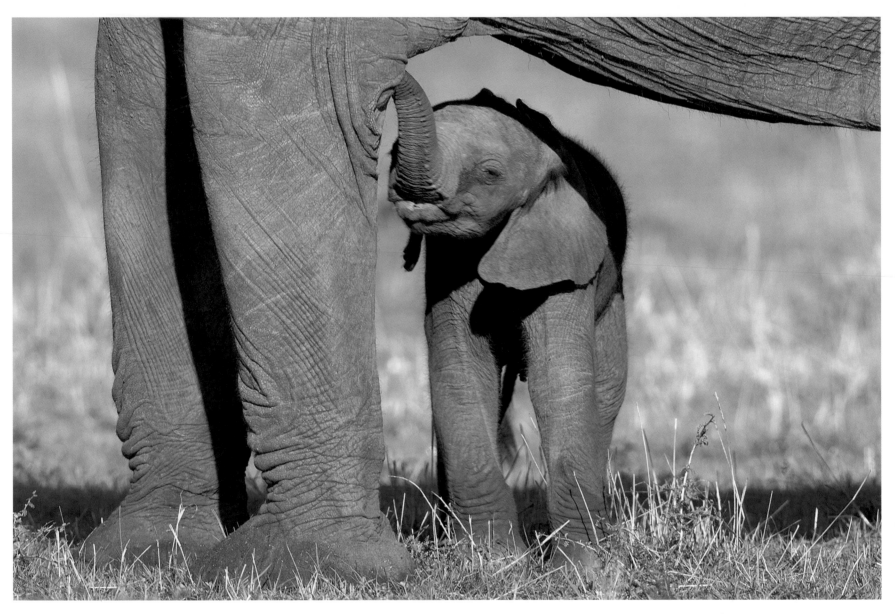

ABOVE The youngest elephants feel secure amid the herd. If danger approaches, the adult animals form a protective wall around the smallest. Each mother would defend her calf to the death if need be.

RIGHT Until its first birthday, an elephant calf fits neatly under its mother's belly, a haven of safety that also provides shade on hot days.

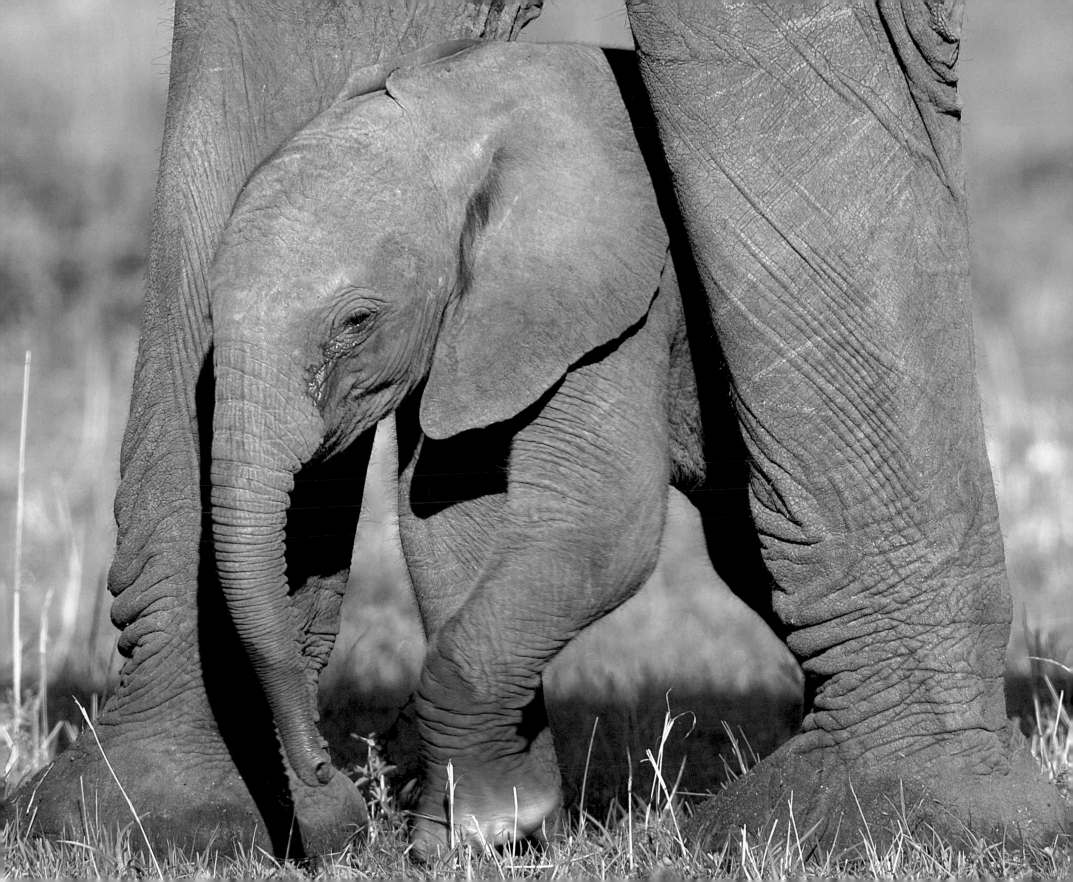

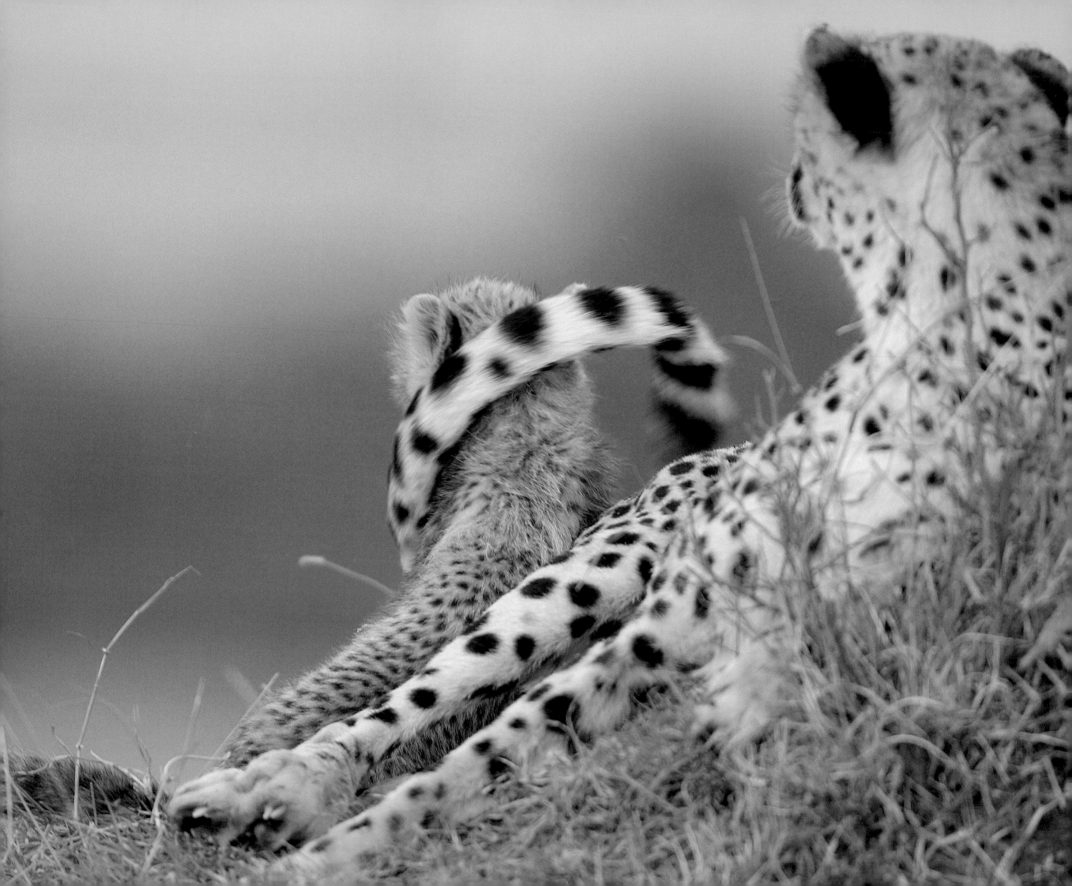

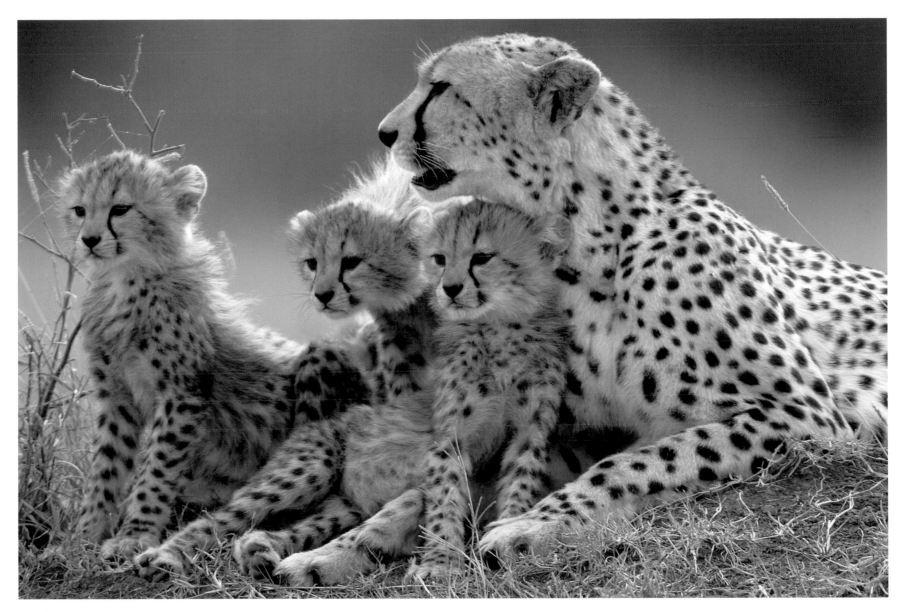

ABOVE AND LEFT Female cheetahs are single mothers. The swift cat attentively keeps watch for danger on all sides. Her cubs feel safe and secure in her presence. They would be helpless without their mother; as yet unable to hunt on their own, they would simply starve.

PAGE 96 When not searching for food, the spotted hyena spends much time with her cubs. Hyenas are not only feared predators, but also loving mothers.
PAGE 97 The baby olive baboon trustingly clutches its mother's fur. It will remain with her until it is eighteen months old.

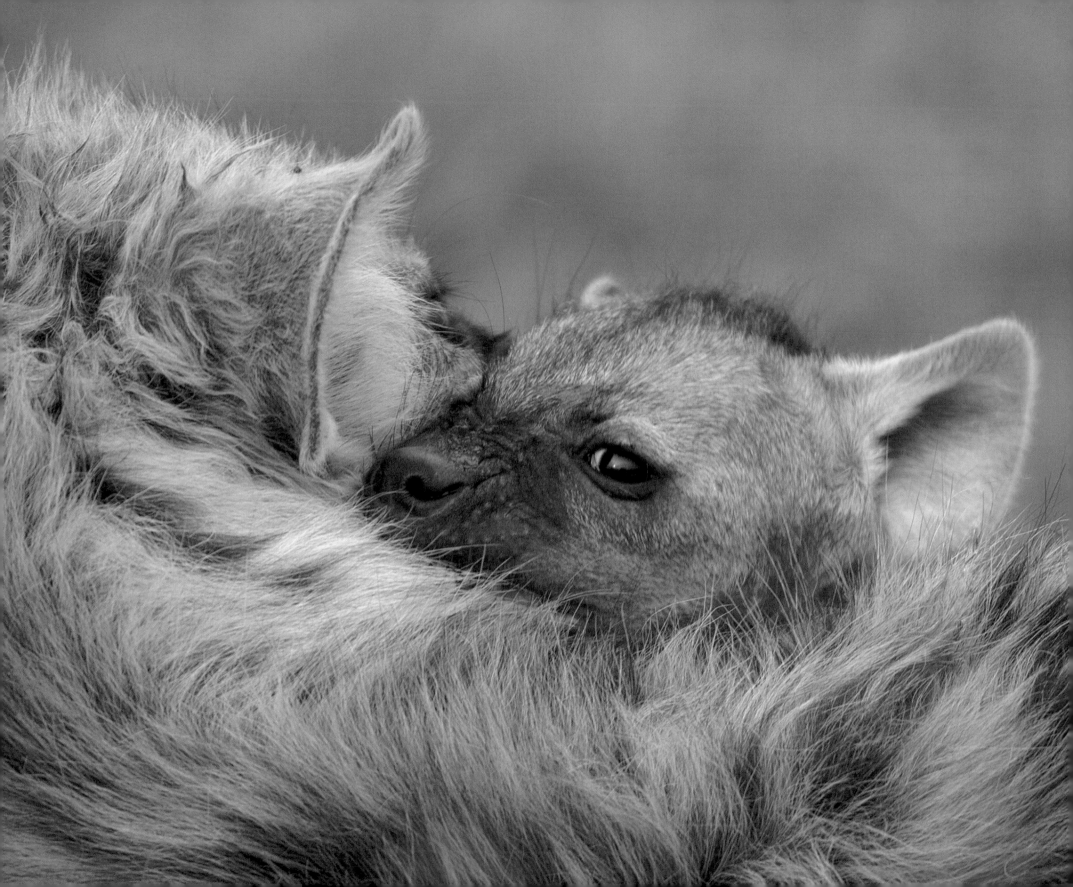

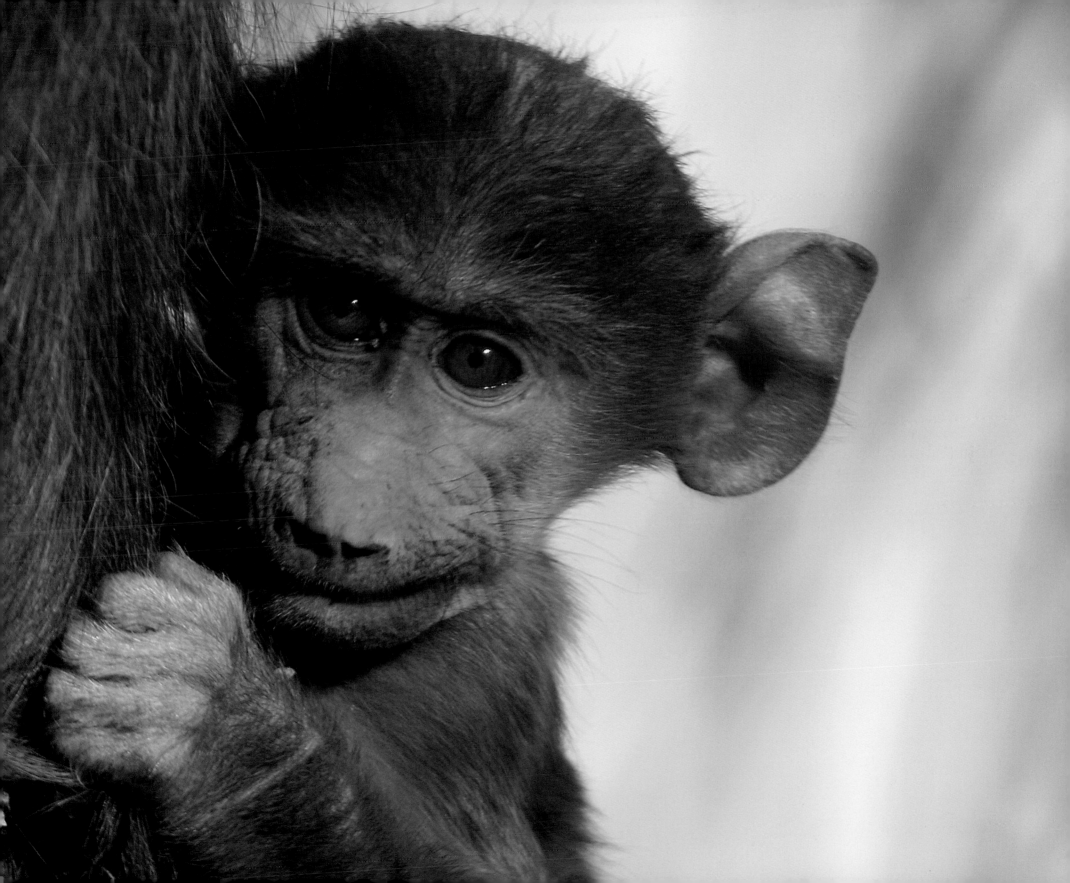

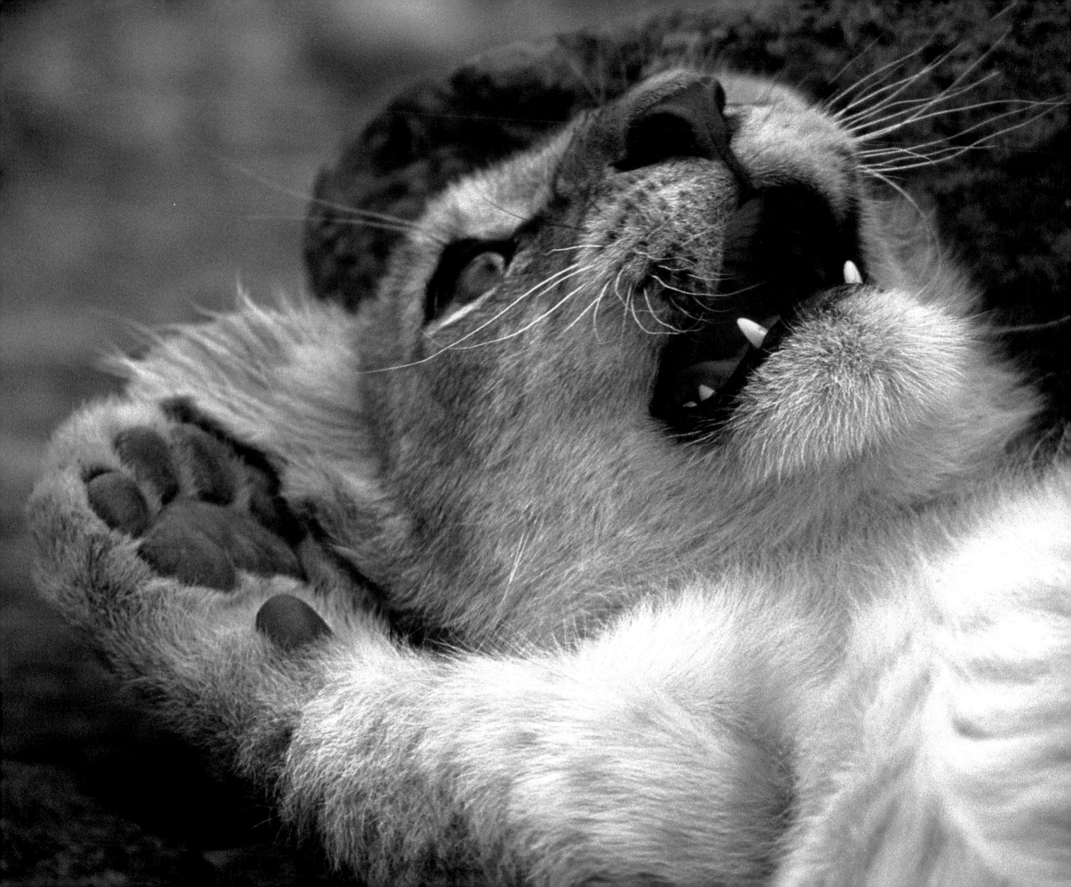

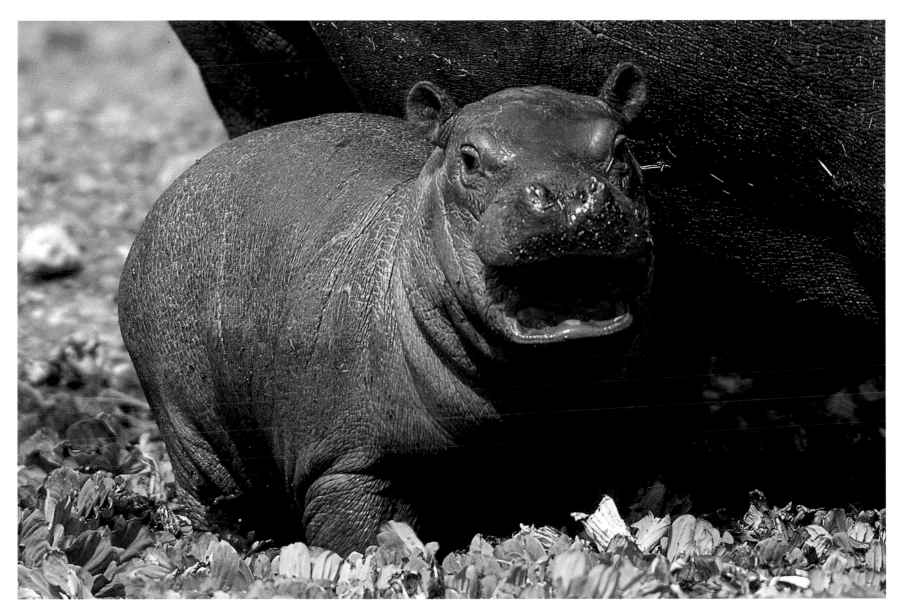

LEFT It's a wonderful life! The lion cub spends an untroubled childhood in a kind of lion kindergarten, surrounded by playmates and receiving milk, care and protection from all the mother lions in the group.

ABOVE The baby hippopotamus feels happy and secure at the side of its watchful mother, even when on land. Although the little one already eats vegetation, it continues to drink its mother's milk until it is one year old.

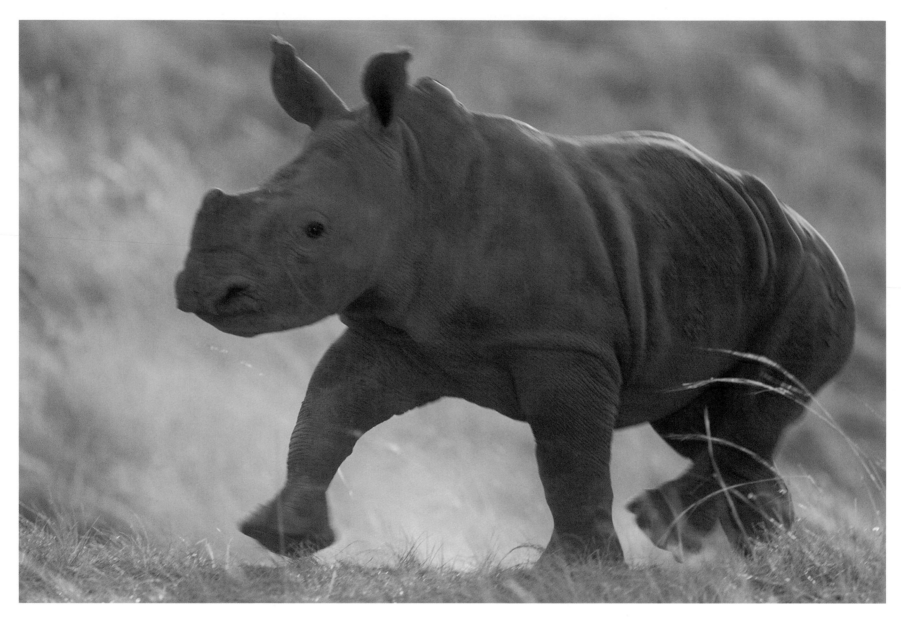

ABOVE The young white rhinoceros basks in the cool morning air, galloping glee-fully through the savanna.

RIGHT In the mating season, the male ostrich attracts females for its harem by emitting low-pitched cries.

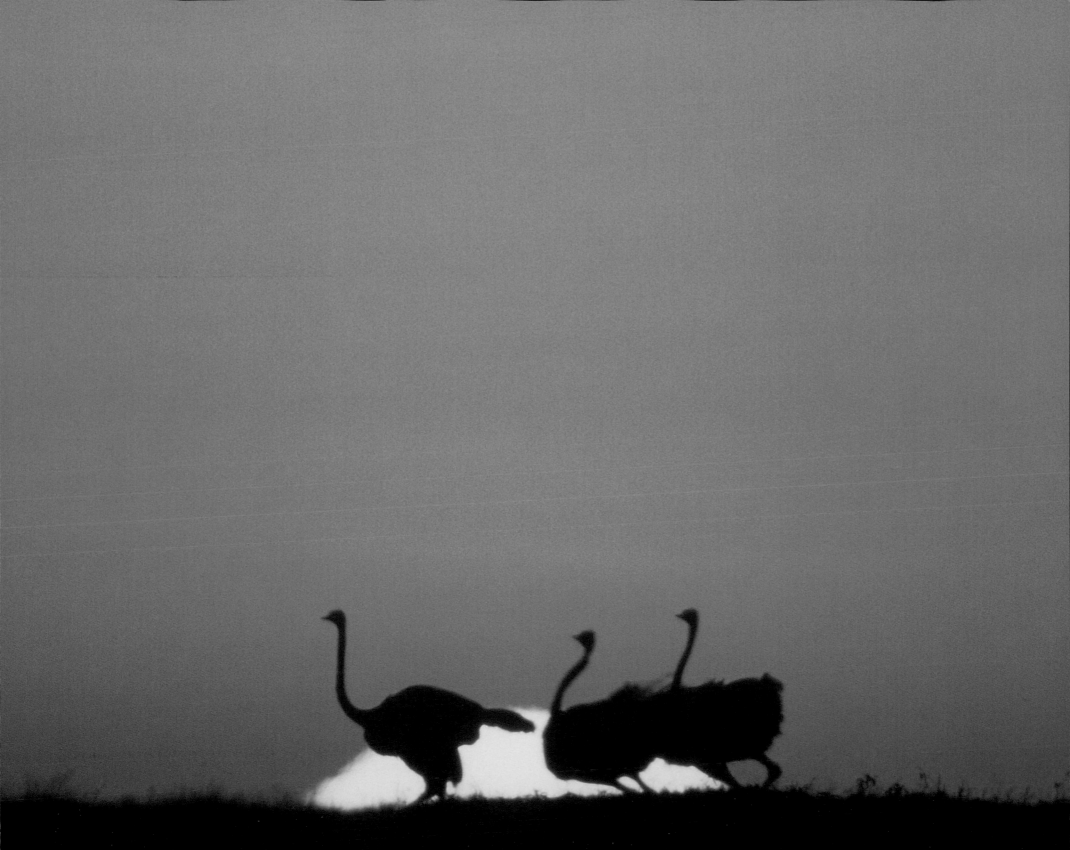

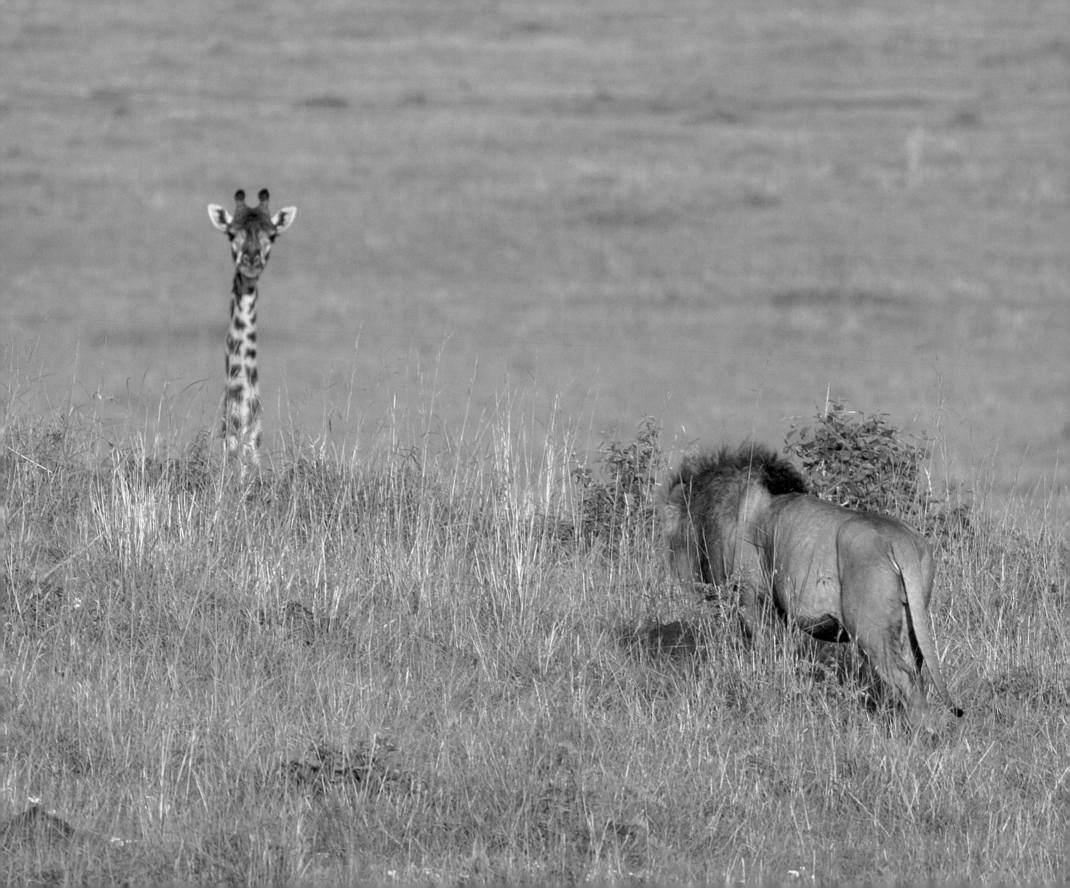

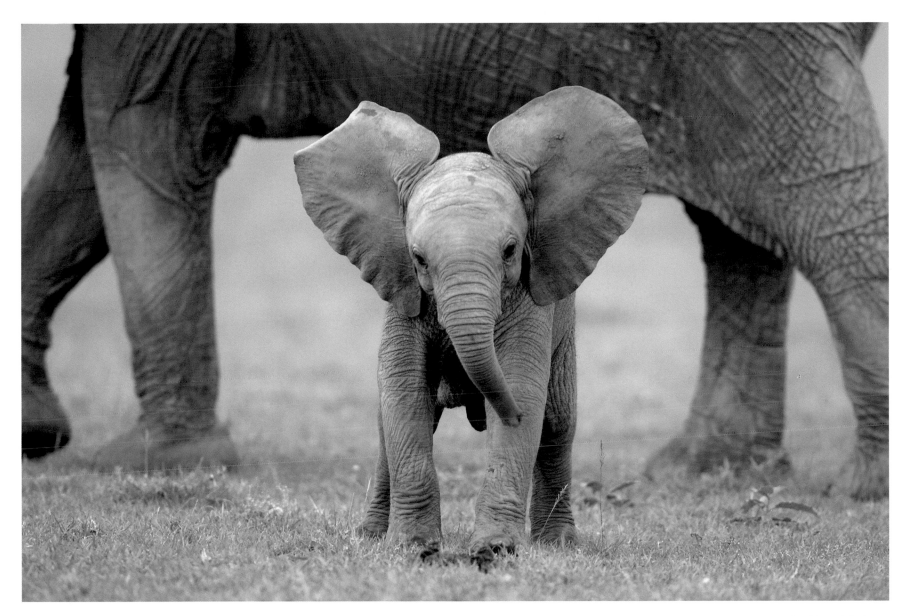

LEFT The unusual sight of a giraffe awakens the curiosity of the male lion; he cautiously approaches to investigate, but has no intention of attacking.

ABOVE The inquisitive elephant calf is attracted by anything unfamiliar while its mother calmly continues to graze. As a precaution, the calf adopts a threatening pose before excitedly approaching.

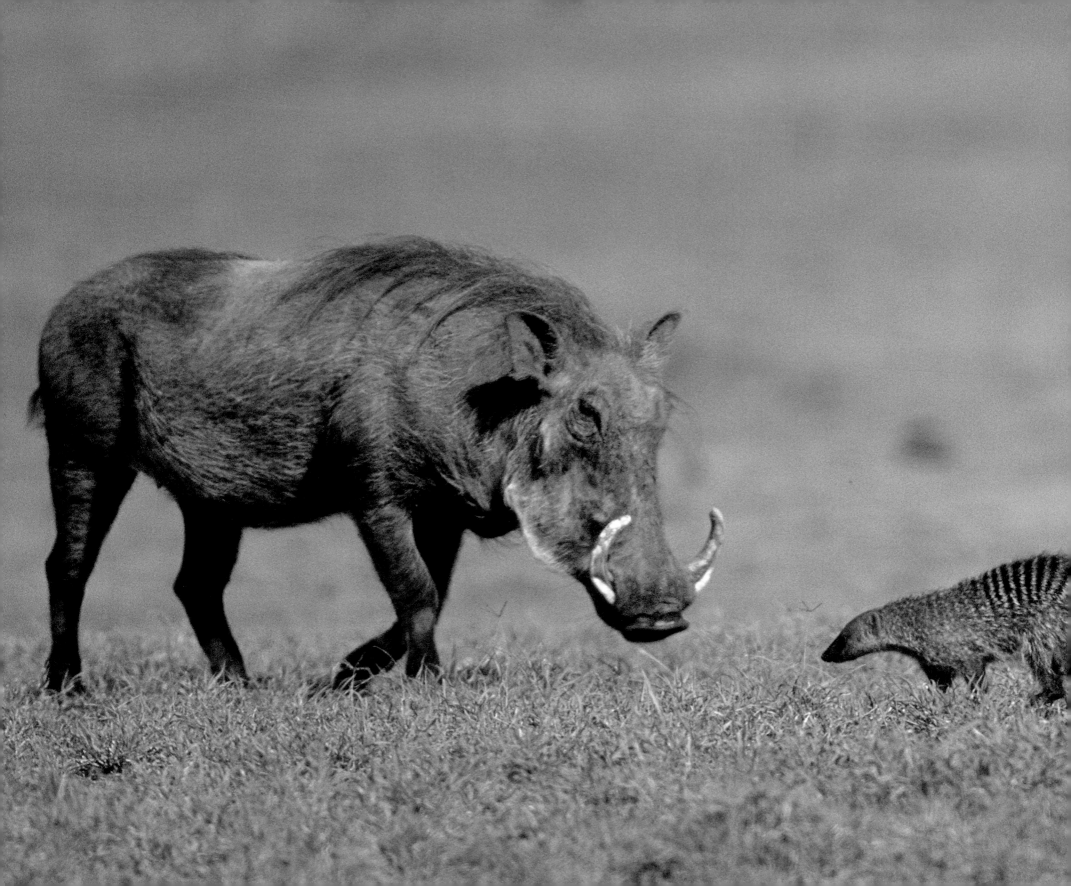

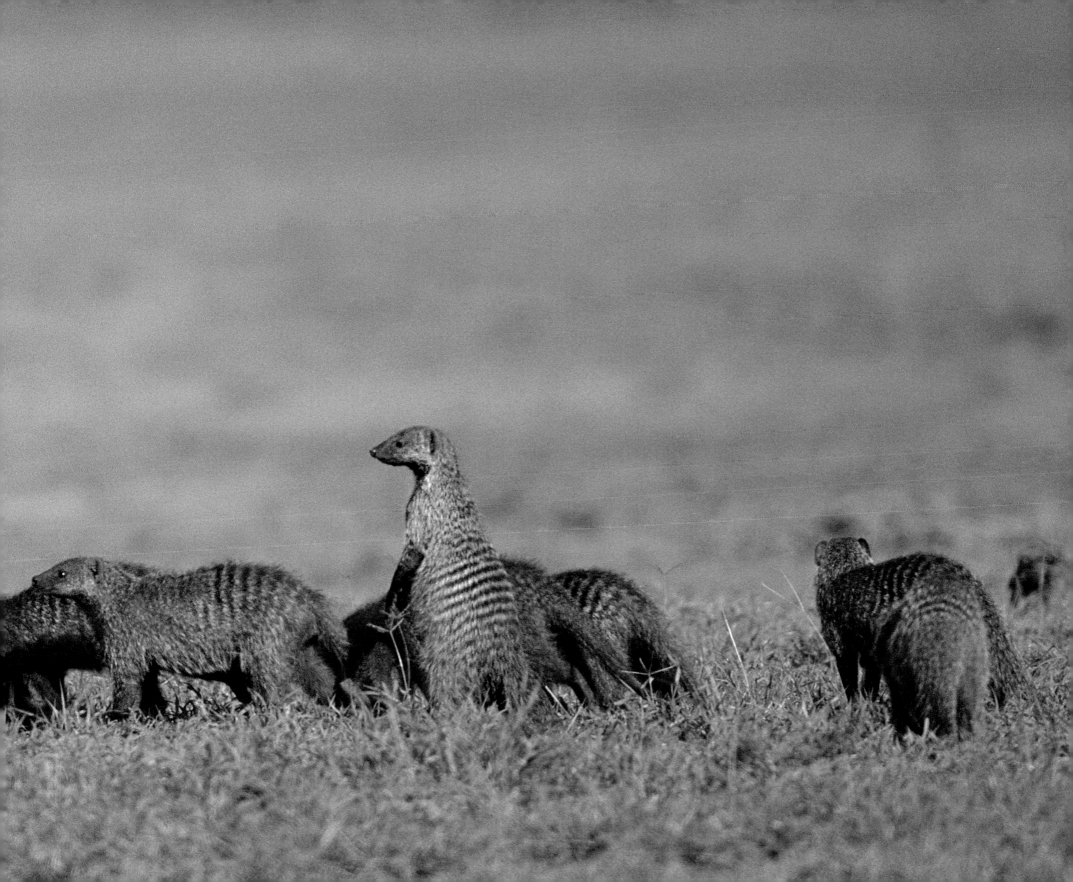

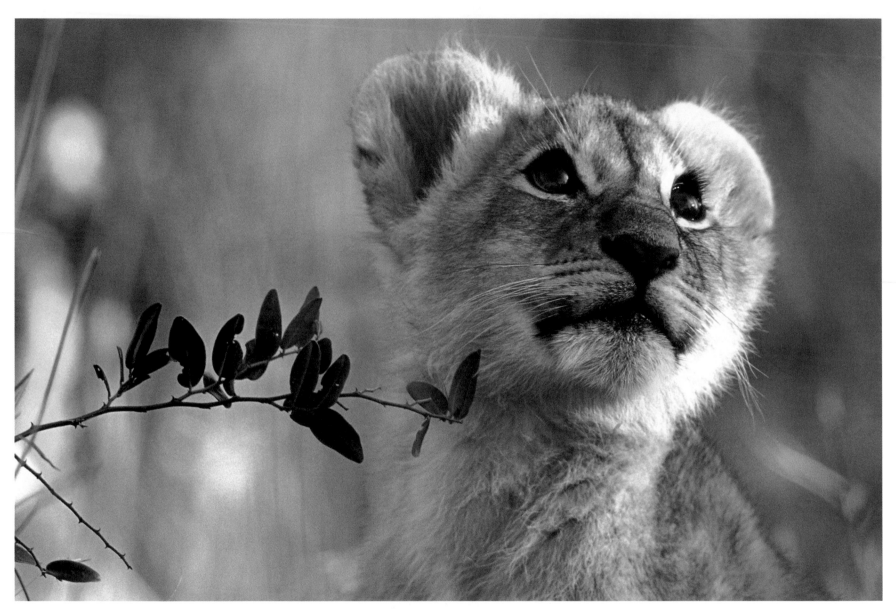

PAGES 104–105 Banded mongoose and warthogs share the same habitat; when they chance to meet, they eye each other with curiosity, but without hostility.

ABOVE Isn't life exciting? The lion cub is fascinated by the vulture in flight.

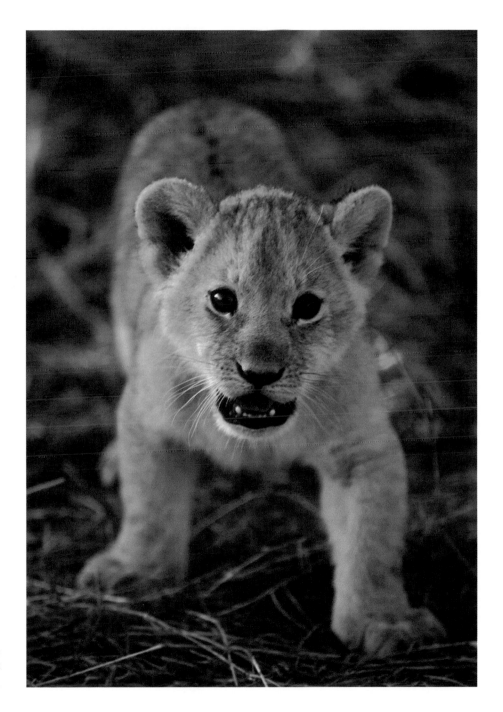

Like all kittens, lion cubs are inquisitive, and love to explore their surroundings and any creatures they find there.

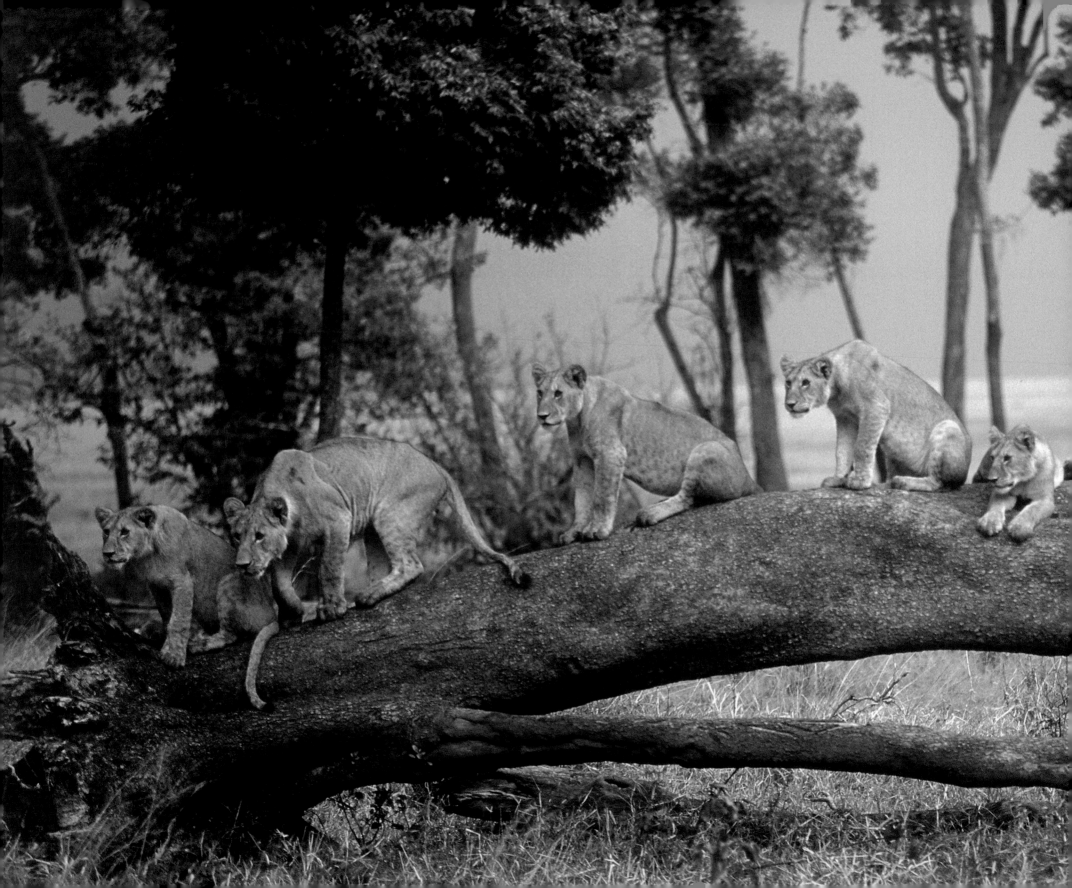

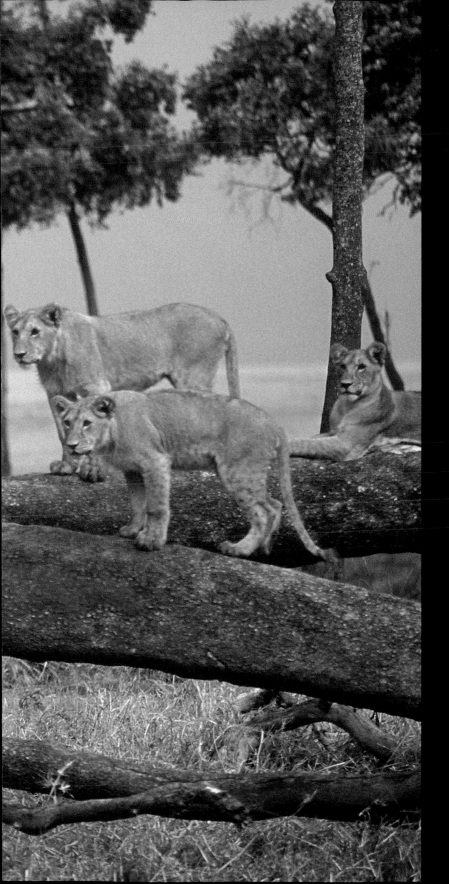

Animals' pain and pleasure are akin to yours and mine, and their will to live is just as strong.

Jonathan Balcombe, Biologist and Ethologist

LEFT Up in the trees, the young have a grandstand view of one of the adult females as she hunts. Fascinated, they follow events without joining in.

PAGES 110–111 The downpour has slaked the heat of the day, leaving vast sheets of water. The young lions are delighted and frolic in the water, ecstatically scattering spray over each other.

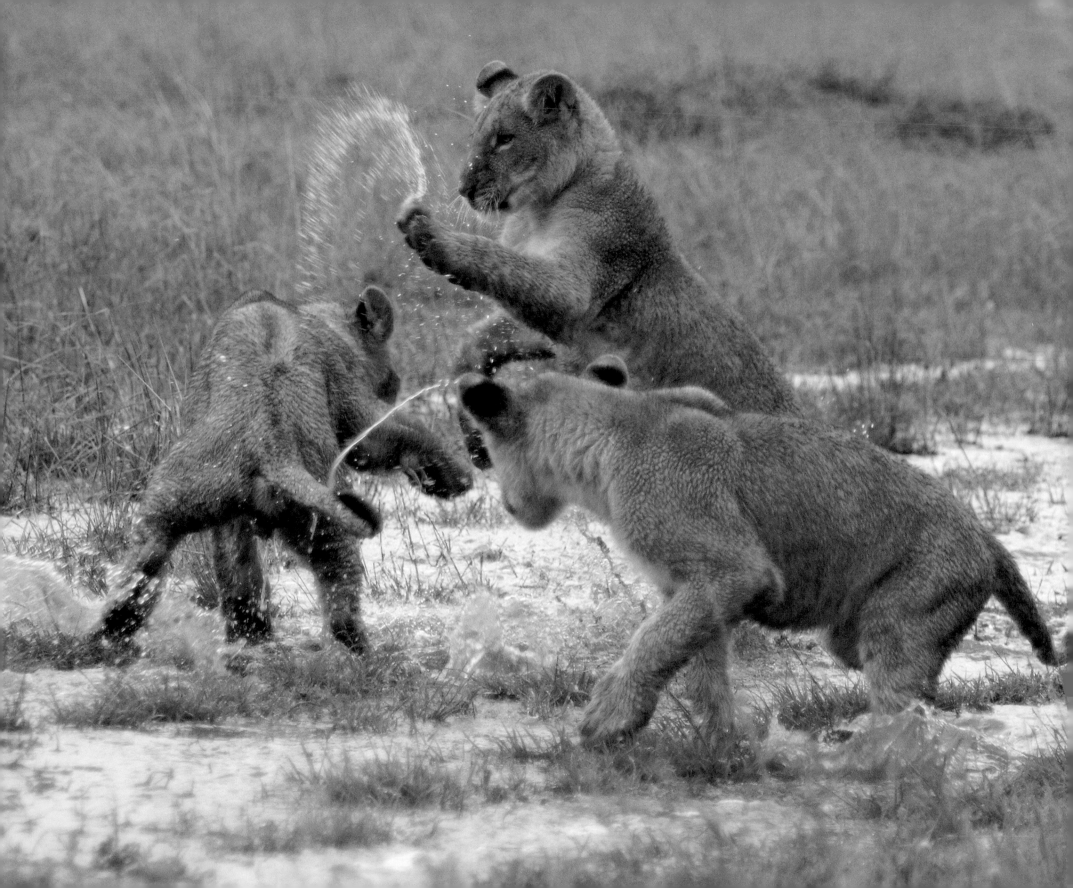

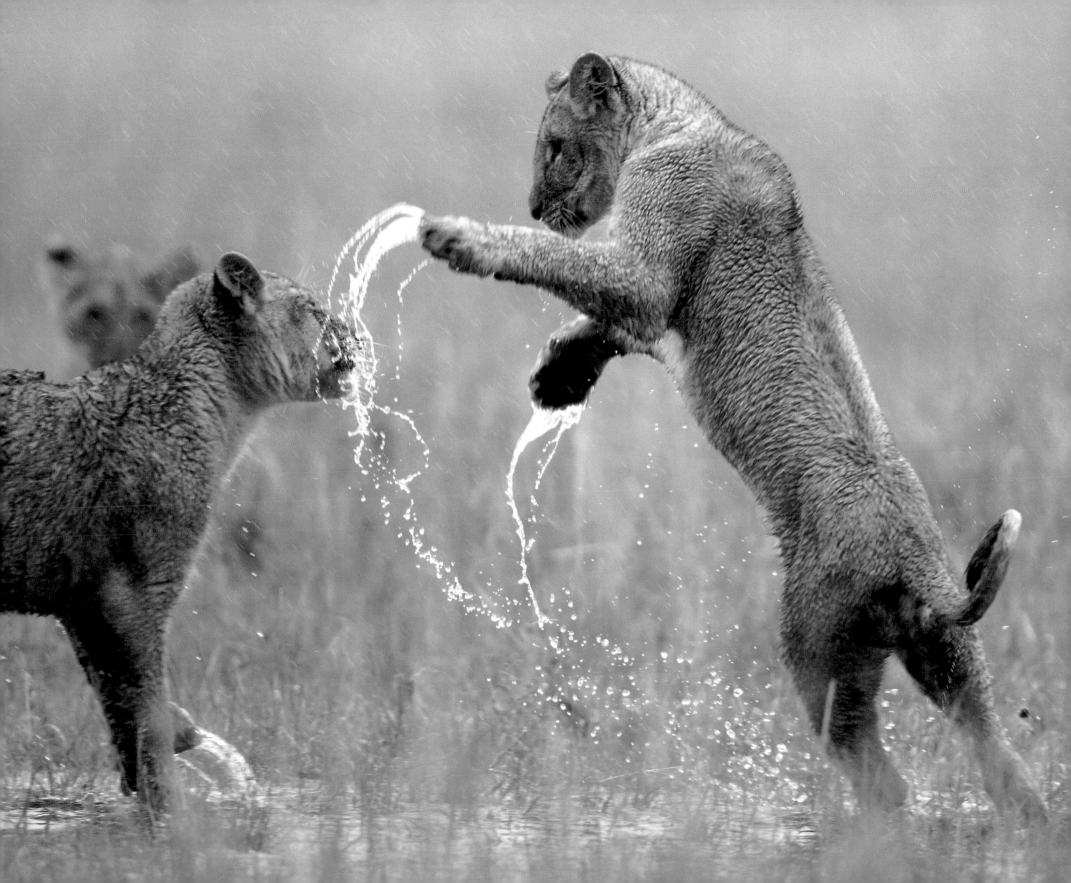

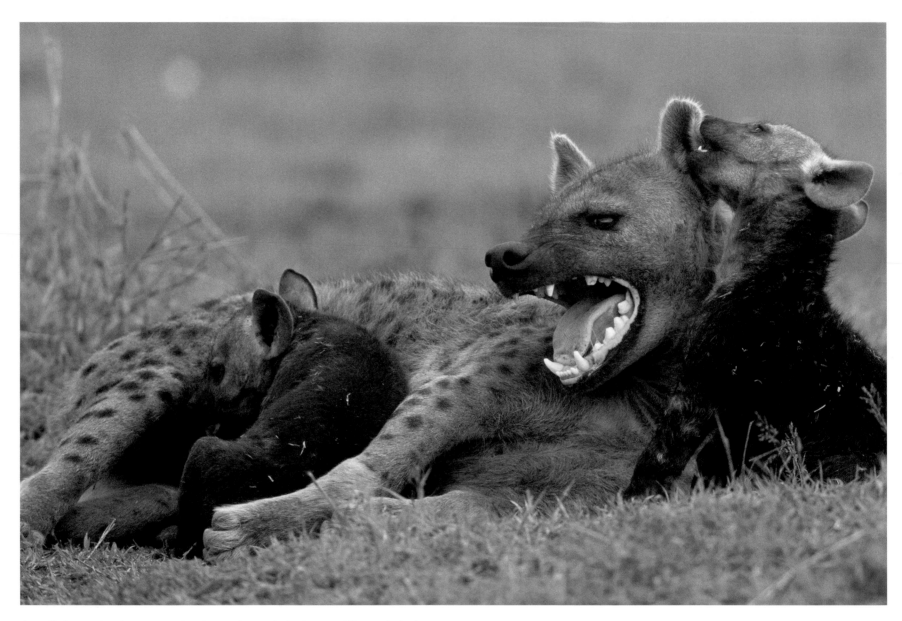

At twilight, mother hyenas can be observed near their dens, suckling and playing
with their young. They patiently endure the little teasers' rambunctious play.

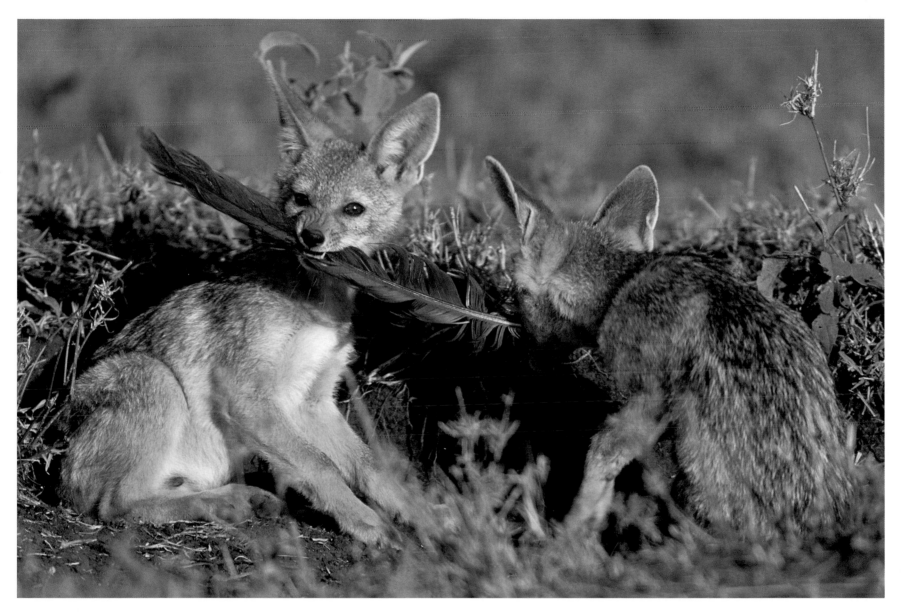

The vulture's feather is a welcome toy for these young black-backed jackals.
Three to five in number, the siblings generally romp together.

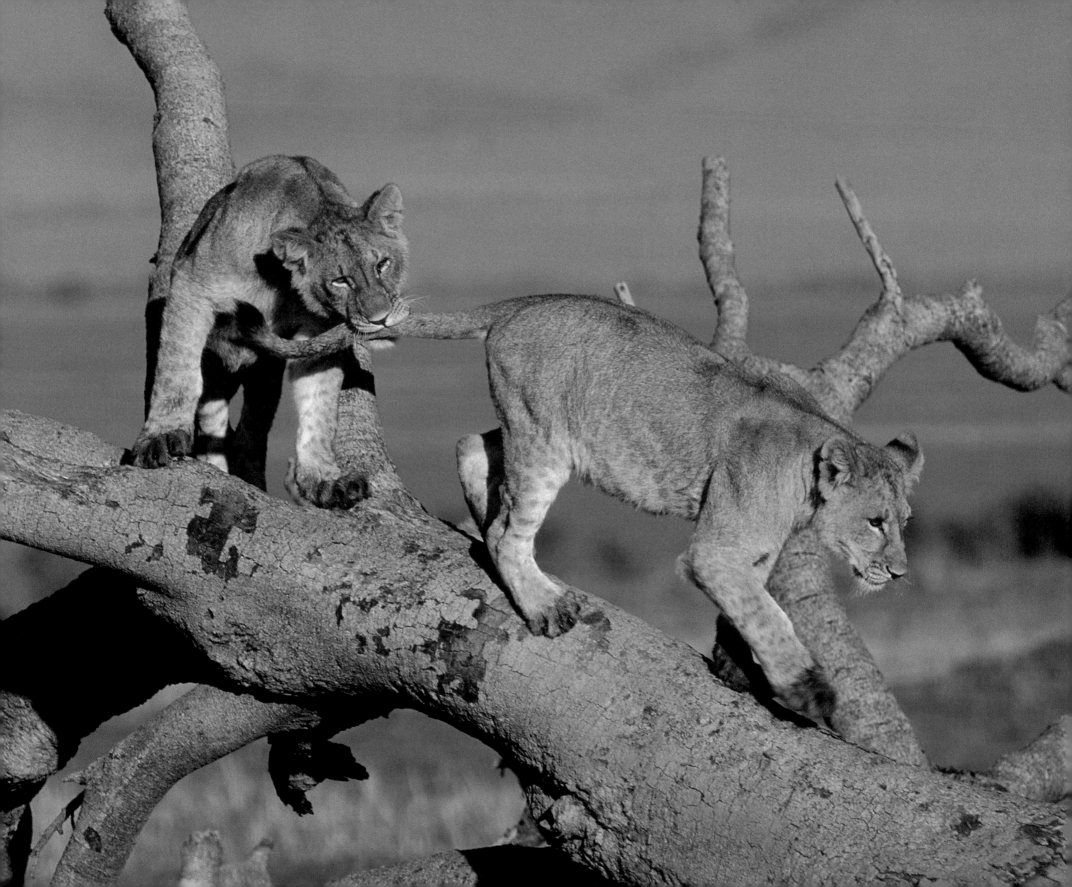

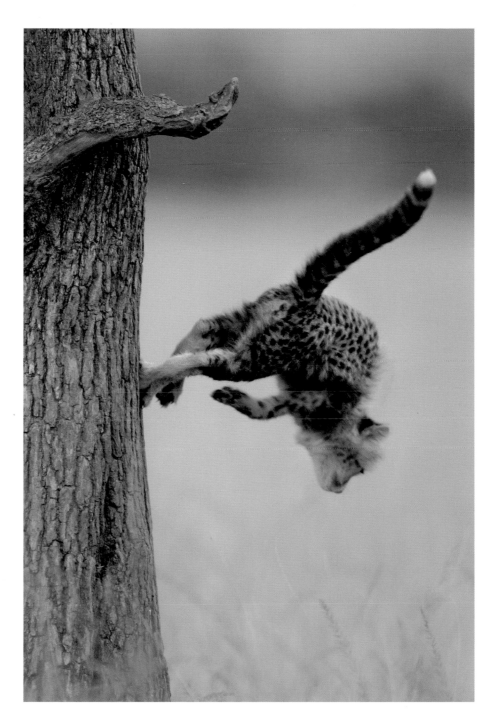

LEFT Biting, climbing over fallen trees and hunting each other are the favorite pastimes of these adolescent lions.

RIGHT The young cheetah boldly leaps from its vantage point into the high savanna grass. Now, as in later life during hunting, its long tail acts as a stabilizer.

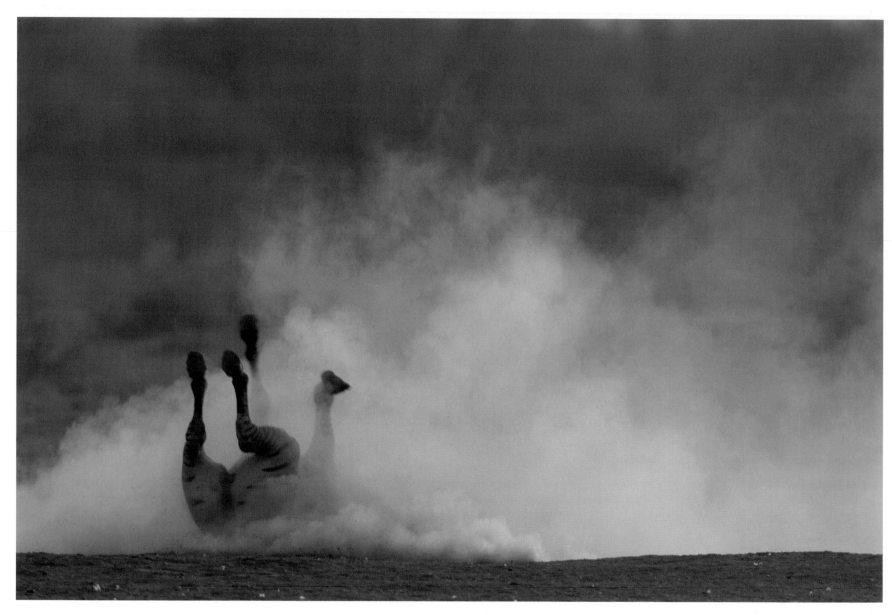

ABOVE Zebras regularly luxuriate in dust baths, which keep their coat in good condition; the dust also acts as a protective layer against the sun.

RIGHT Hippos generally spend their time lazing enjoyably in the water, where their body weight of up to three tonnes is irrelevant. They can also snooze under water for up to five minutes, resurfacing to take in air and spraying fountains of water over their heads.

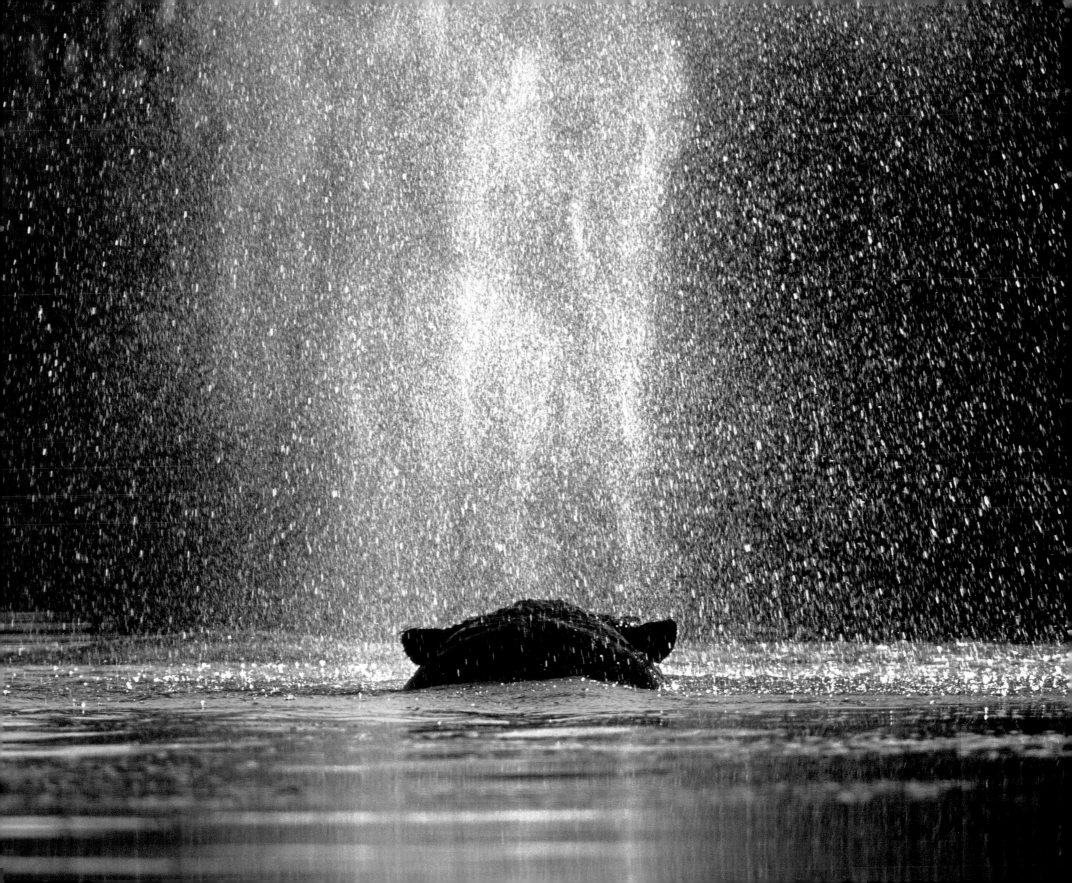

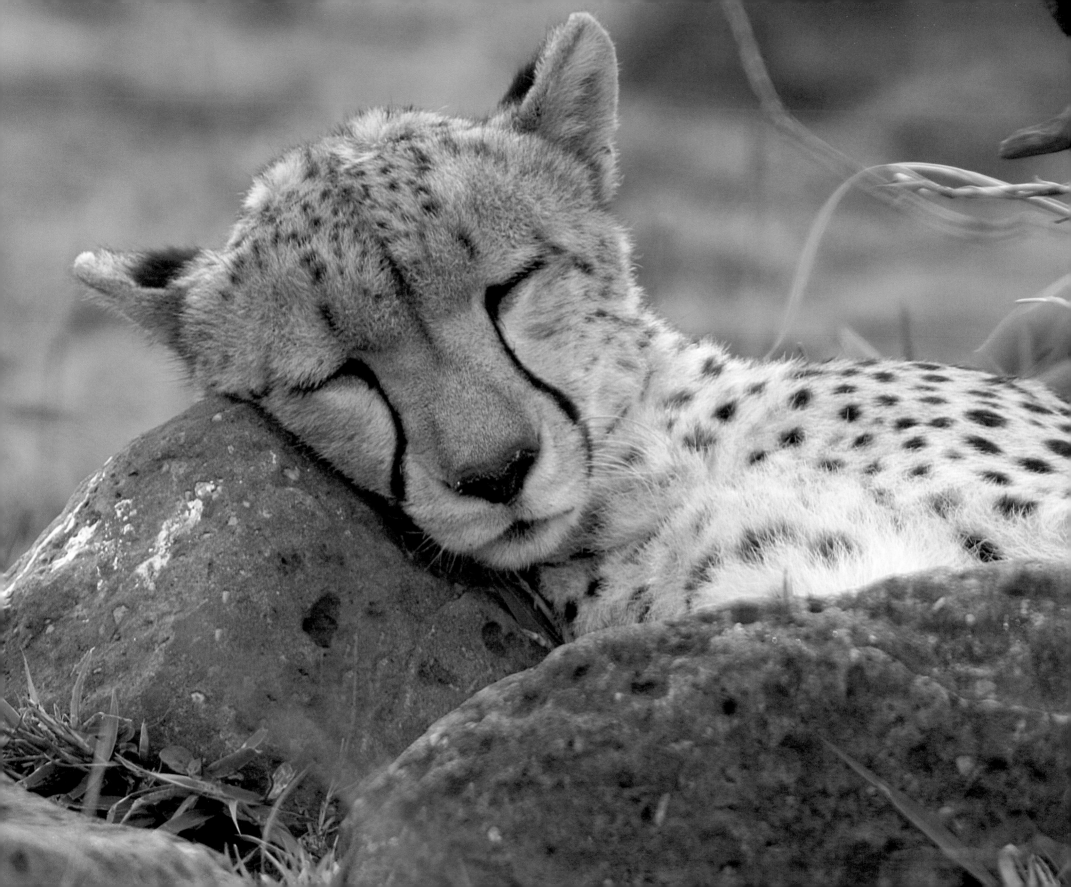

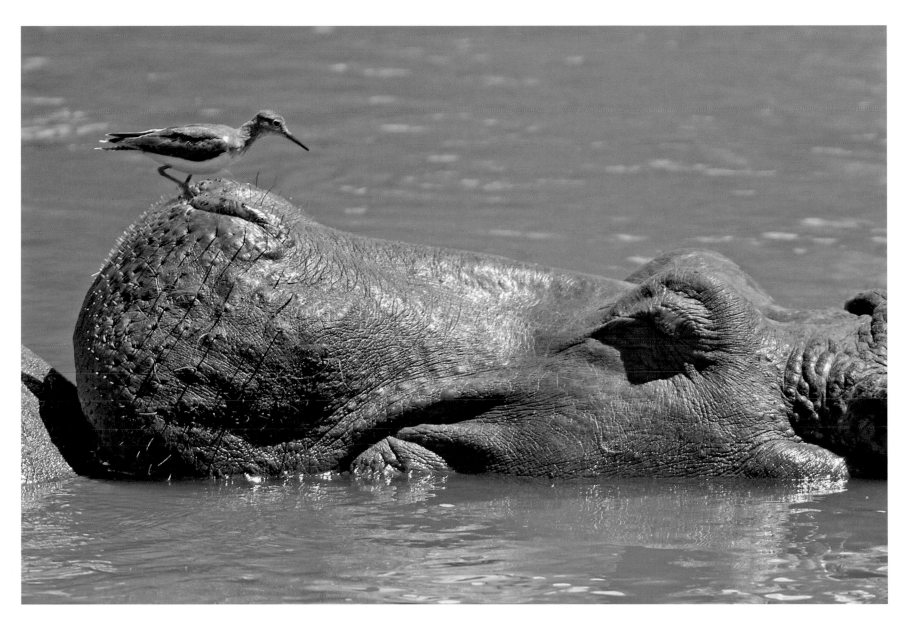

LEFT Like all cats, cheetahs spend most of their lives asleep or dozing. They partic-
ularly enjoy a well-earned rest in the shade of a tree after a successful hunt.

ABOVE The sleepy hippopotamus luxuriates in the body care it receives as the bird
picks insects out of its thick skin.

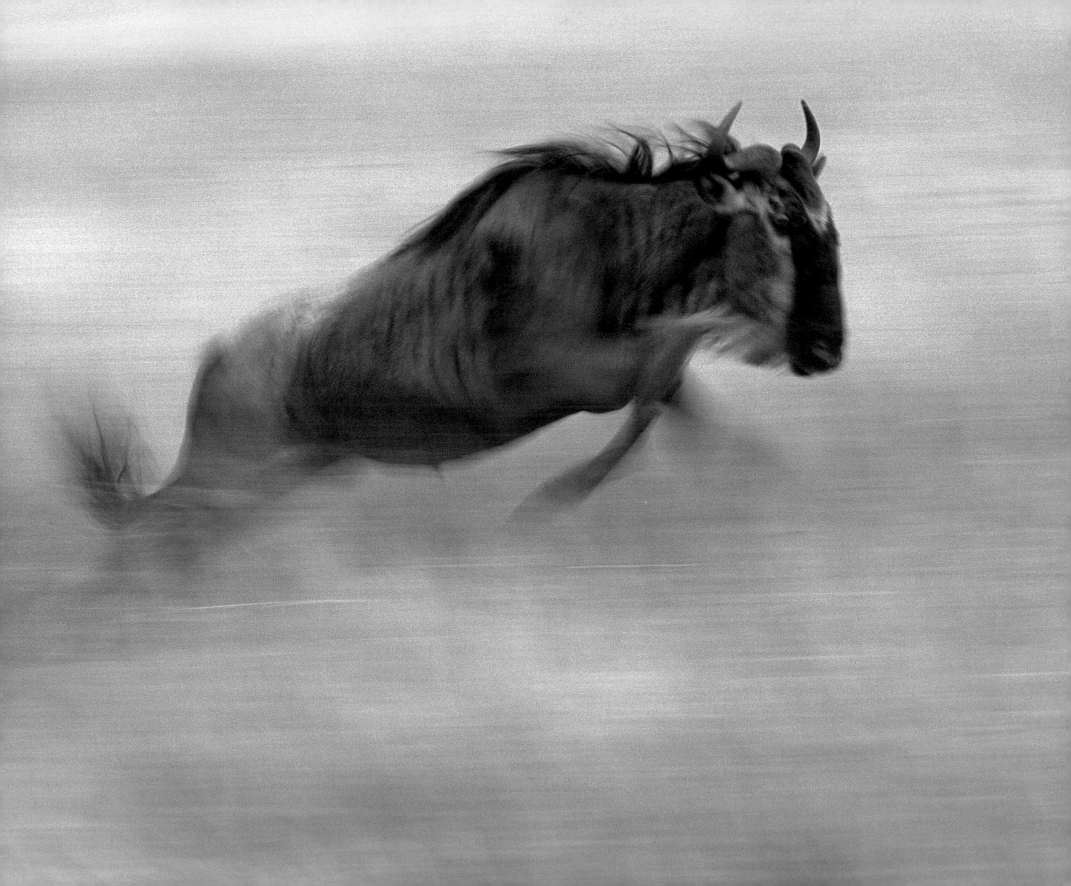

FEAR

Fright – Panic and Mortal Fear – Vigilance

Fear is vital for humans and animals, warning us of concrete dangers and allowing us to take survival action – such as the flight instinct, when a herd of antelopes flees before a pride of attacking lions. The type of fear known as anxiety, on the other hand, is a largely indefinite feeling of being threatened. The roaring torrent that the herds of wildebeest must cross contains myriad perils. Through instinct and experience, animals are able to recognize points of danger, sensing an impending threat without seeing it. They respond by becoming tense and agitated.

For wild animals, vigilance and caution are fundamental survival strategies. No herd of zebra will sleep without having appointed a "sentry." No herd animals graze without regularly inspecting their environment. Cheetahs devour their prey in record time, continuously raising their heads and surveying their surroundings for predators such as lions or hyenas. Their razor-sharp senses enable them to react immediately. Even when apparently in a deep sleep, a big cat misses neither the unsuspecting buffalo passing by nor the herd of elephants that may drive it from its place.

Acute danger causes stress levels to soar. The body produces the adrenal-cortical hormone adrenaline, driving up blood pressure, blood sugar and heart rate – physical reactions that prepare the body for fight or flight. Surprisingly, herd animals will actually approach a predator within their flight distance, to test the extent of the danger he represents. The enemy is kept under close surveillance; all animals in the herd are alerted by warning snorts until the predator has moved on or they see the need for rapid retreat. In encounters between members of the same species that are unrelated to one another, distrust is the order of the day; the animals sniff each other and enact rituals designed to find out whether the interloper is friend or foe.

Occasionally fear may also trigger aggression, which is expressed as enragement: for example, when a mother predator perceives a threat to her young and turns to attack.

Sudden, intensive fear triggers panic, an extreme and uncontrollable condition. When panic grips an entire herd, the resulting stampede enables herbivores to evade their predators. Panic is a frequent occurrence in annual wildebeest migrations, as thousands of animals cross rivers inhabited by crocodiles. Amid the overpowering, irrepressible urge to take flight, weaker animals of the herd's own species are trampled or drowned.

No-one knows whether animals experience mortal fear – the fear of death. What goes through the mind of a gazelle fawn, dragged alive by the mother cheetah to her cubs to allow them to practice the art of hunting and killing? Does the fawn know it is about to die? And the animal confronted with the yawning jaws of a crocodile as it crosses the river – what does it know? In the best case, it is paralyzed with fear. And yet I will never be able to forget the bone-chilling scream of the gazelle as the crocodile's jaws snapped shut.

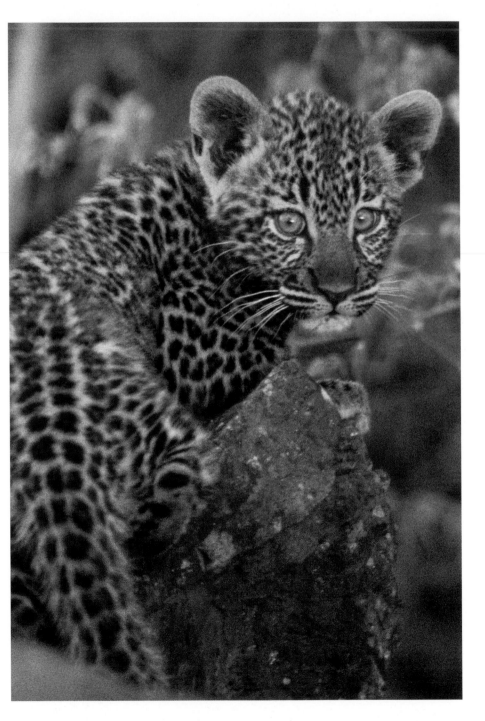

LEFT The mother is hunting. Feeling defenseless and alone, the baby leopard anxiously awaits her return in its hiding-place among the rocks.

RIGHT Enormous, unfamiliar animals are passing. The leopard cub, only a few months old, decides to remain in hiding.

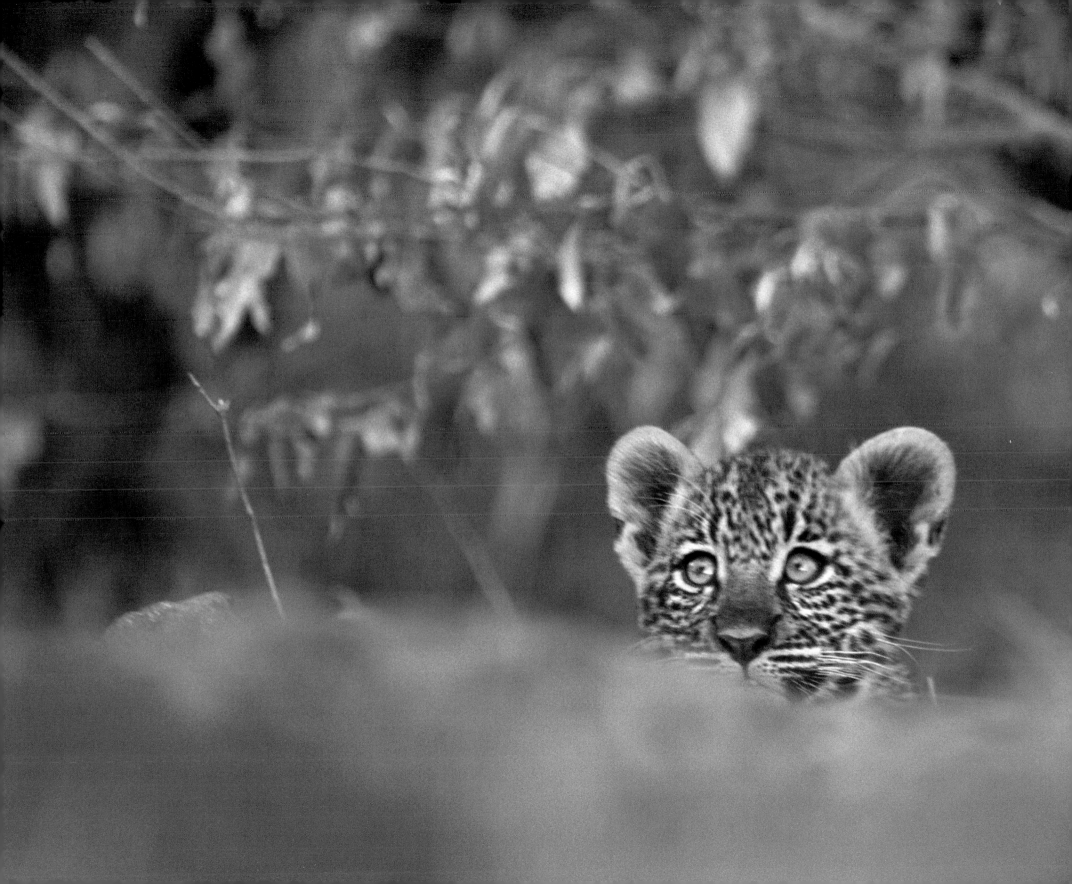

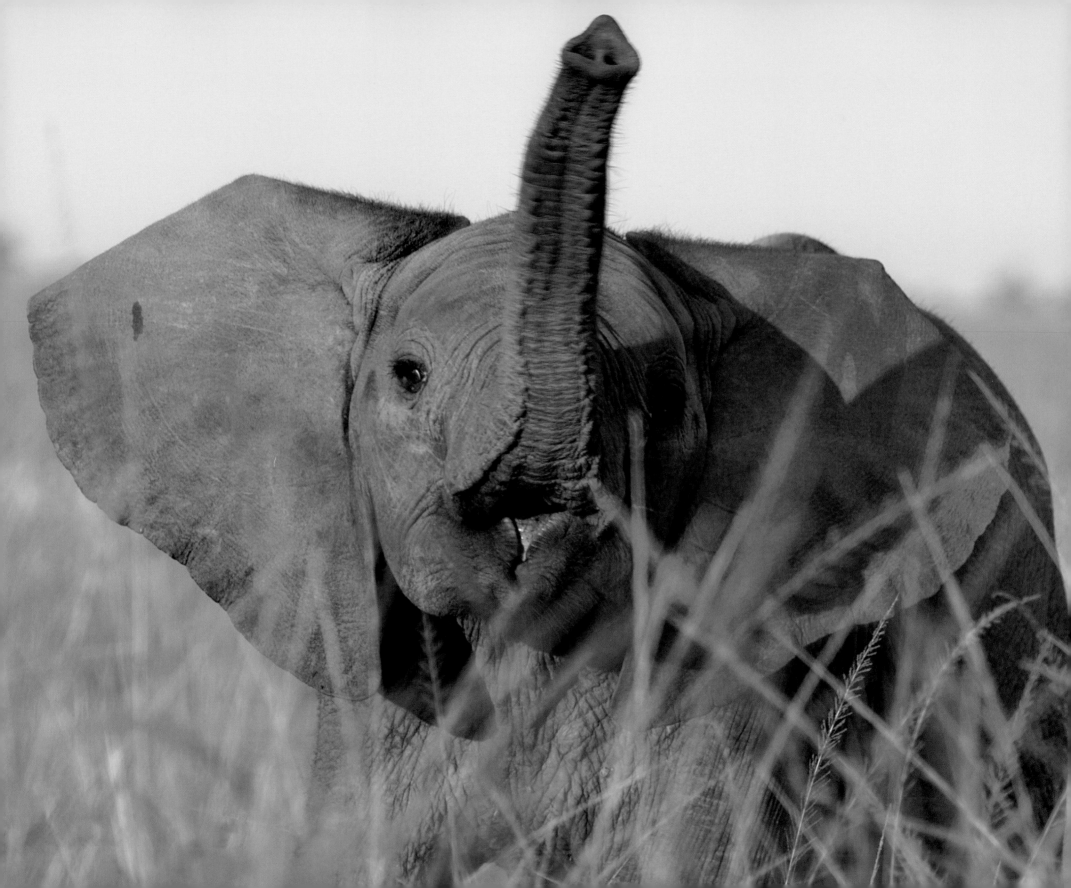

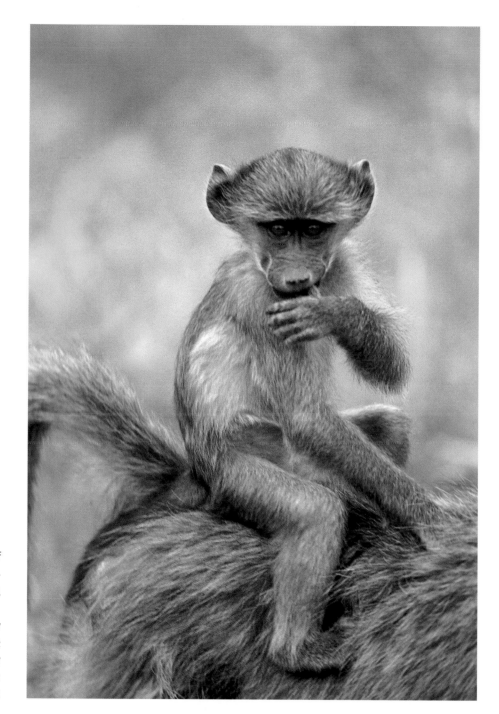

LEFT Scenting a lion, the elephant calf trumpets in agitation and runs panic-stricken to its mother.

RIGHT At the age of six weeks, baby baboons ride on their mothers' backs like jockeys. Although the baby is perfectly safe, it responds to unfamiliar sights with a mixture of fear and curiosity.

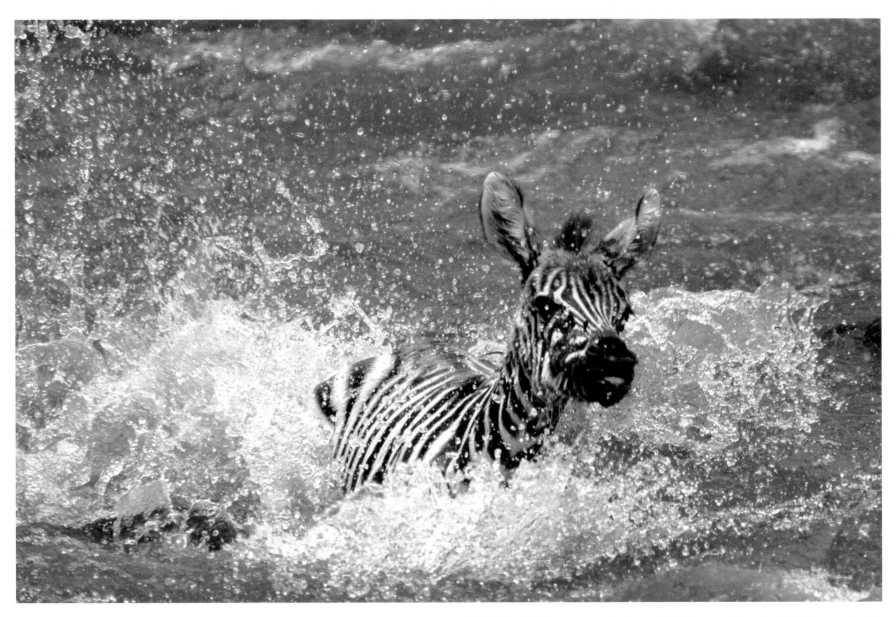

ABOVE AND RIGHT Swimming across a torrential river is enormously stressful for these zebras. Spurred by fear, they battle through the rapids to reach the opposite bank. The river is boiling with crocodiles, and jagged rocks lurk under the water.

PAGES 130–133 On their travels through the Serengeti, hundreds of thousands of zebra and wildebeest must cross mighty rivers in their search for new, juicy pastures. The animals are nervous and tense, sensing the deadly hazards before them.

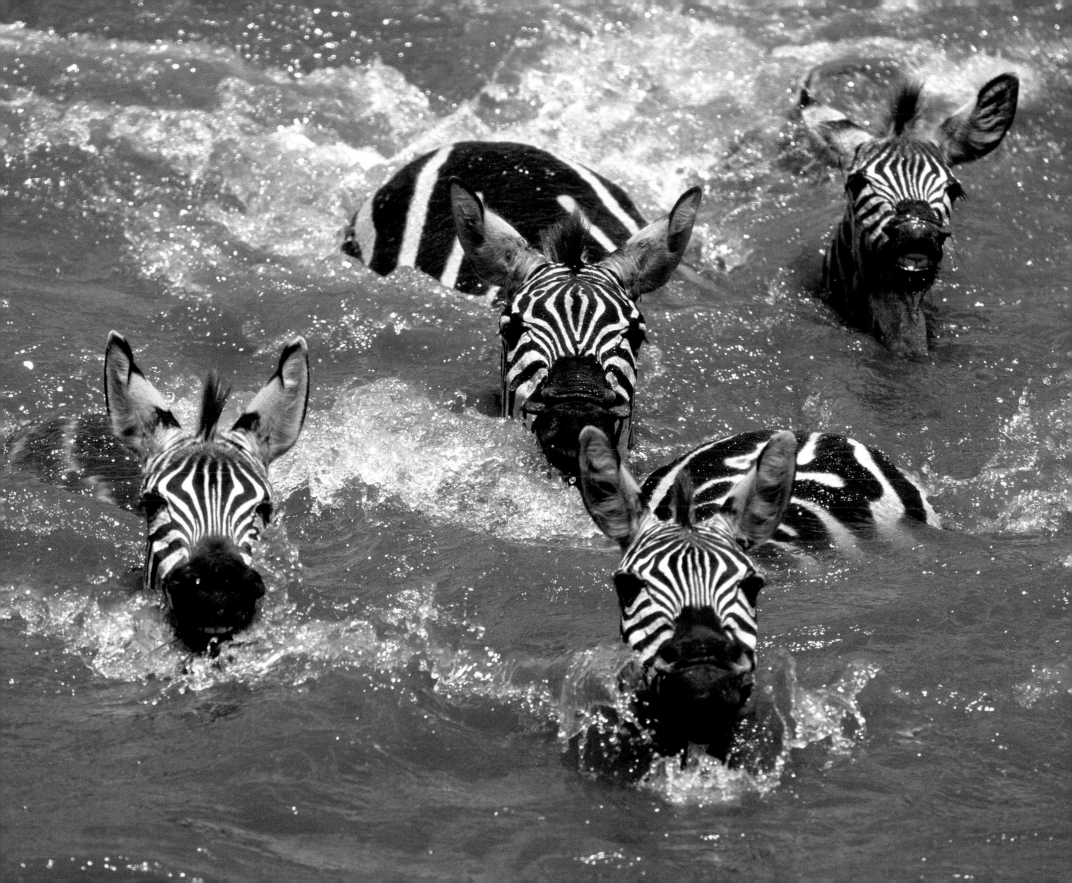

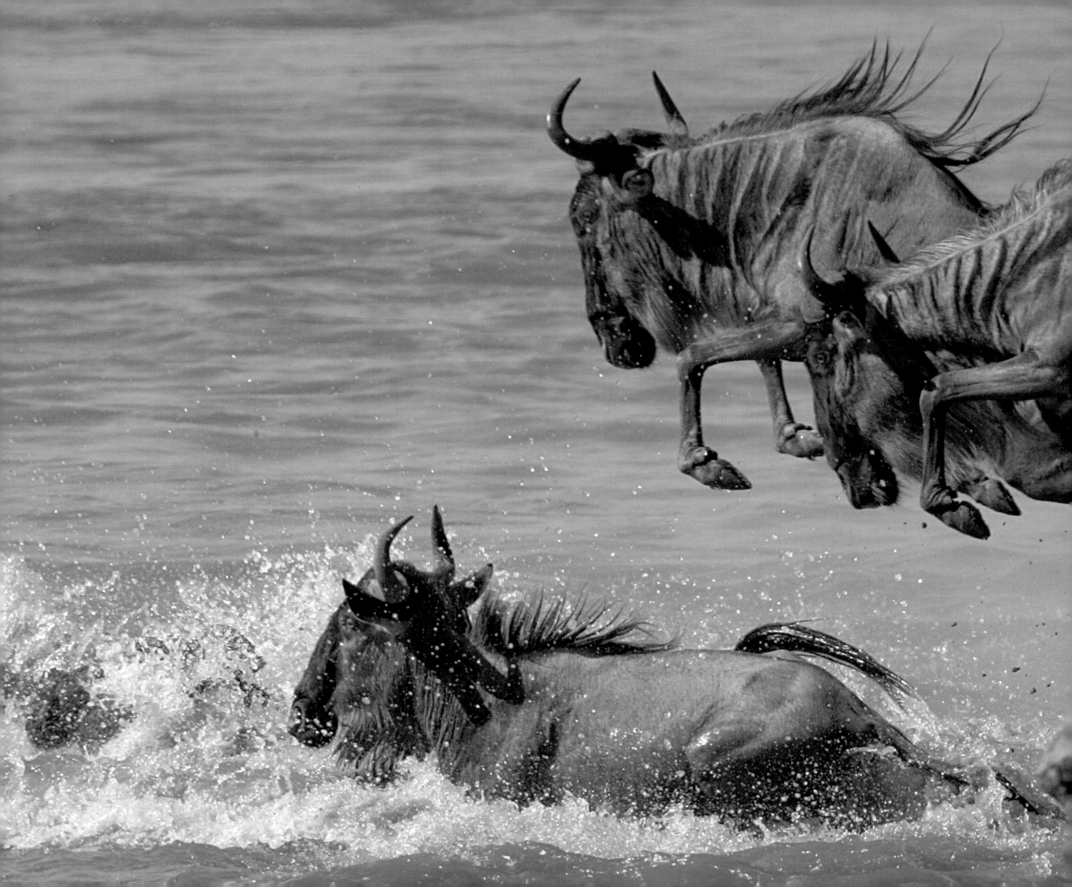

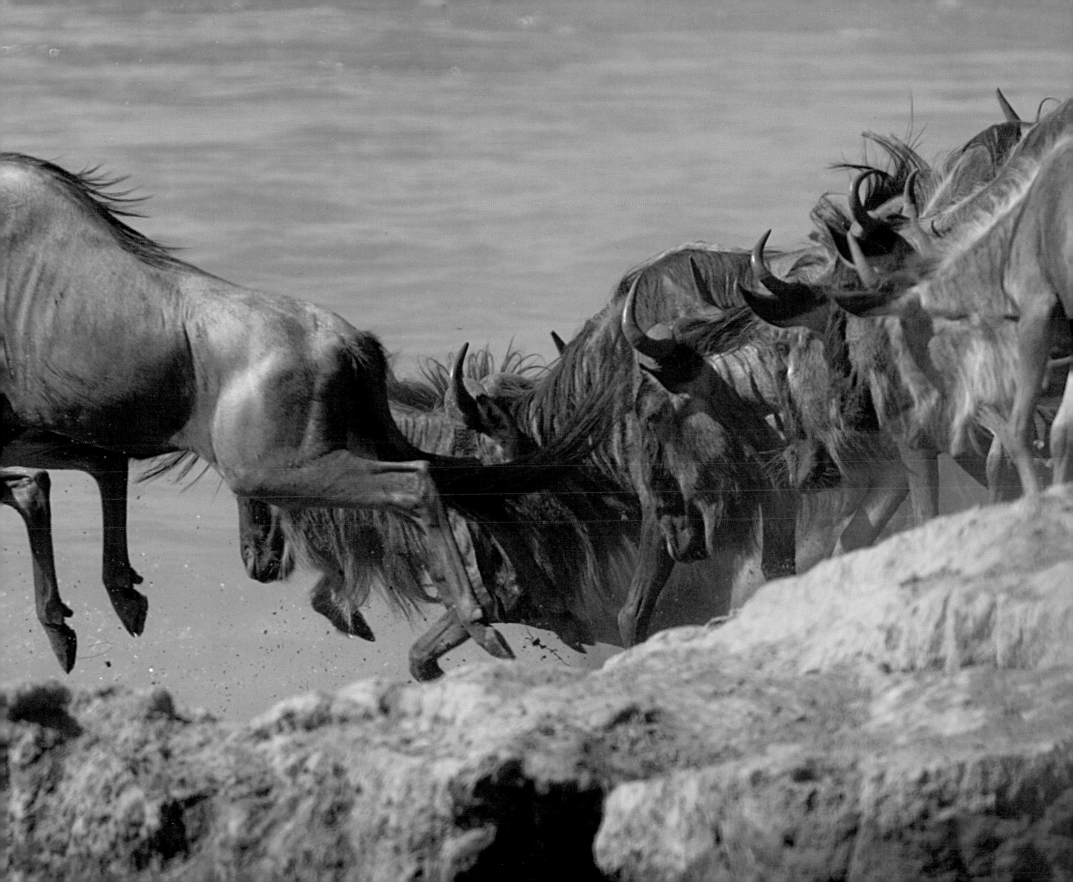

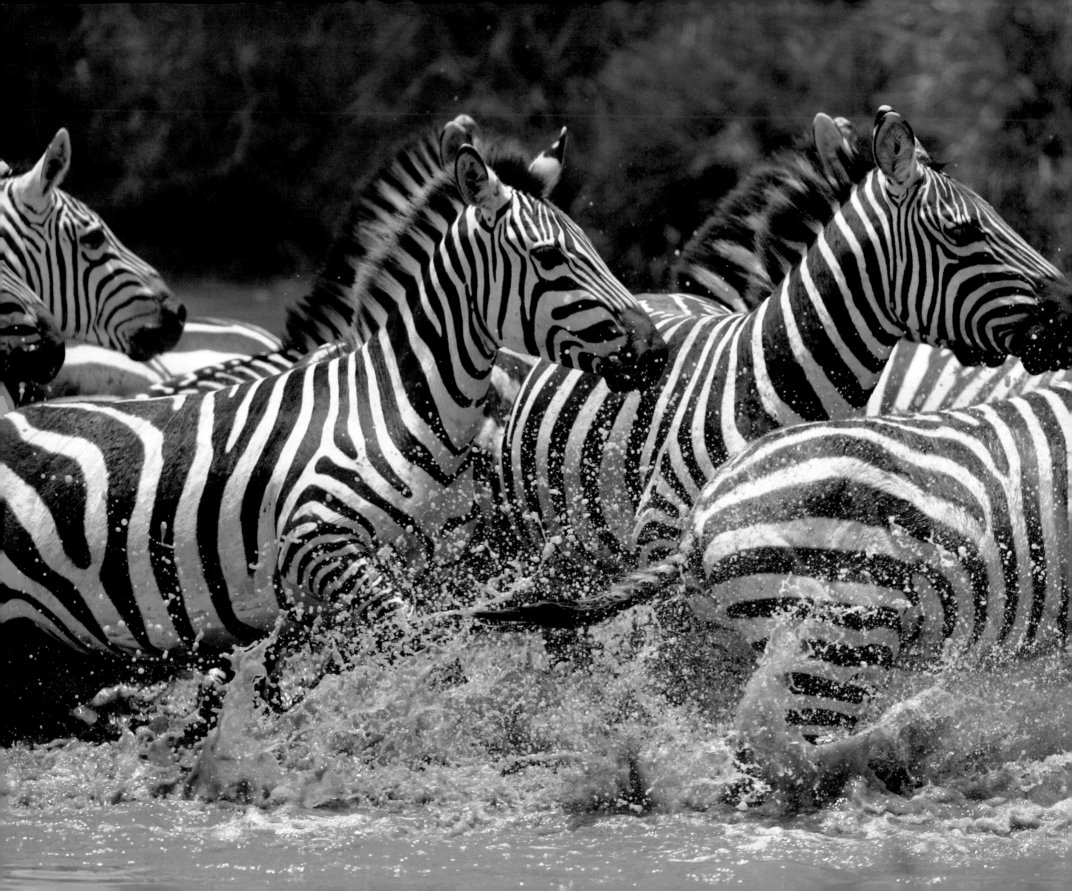

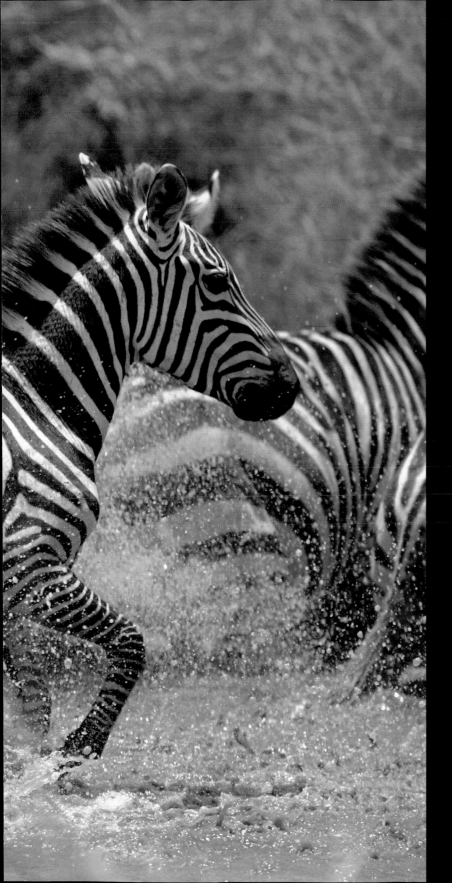

When the same mechanisms that accompany fear in humans also take effect in animals (and mammals in particular), we may assume that animals can feel fear.

Fear is a dynamic behavioral state generated in situations for which we have not stored an adequate behavioral response.

Günter Tembrock, Ethologist

LEFT Zebra are particularly wary at water-holes. As soon as one animal snorts in alarm, the whole herd flees.

PAGES 136–137 One frightened animal communicates its fear to the rest, spreading terror throughout the entire herd of wildebeest and eventually triggering a panic-stricken stampede.

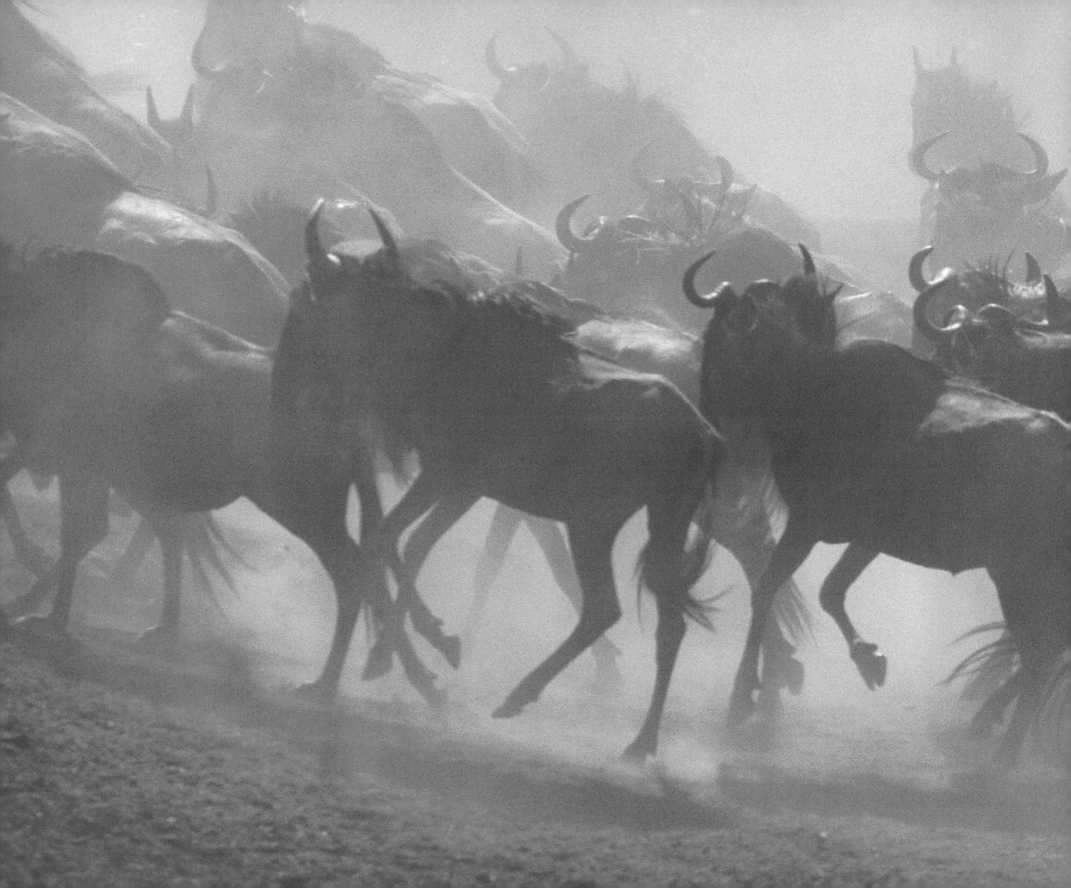

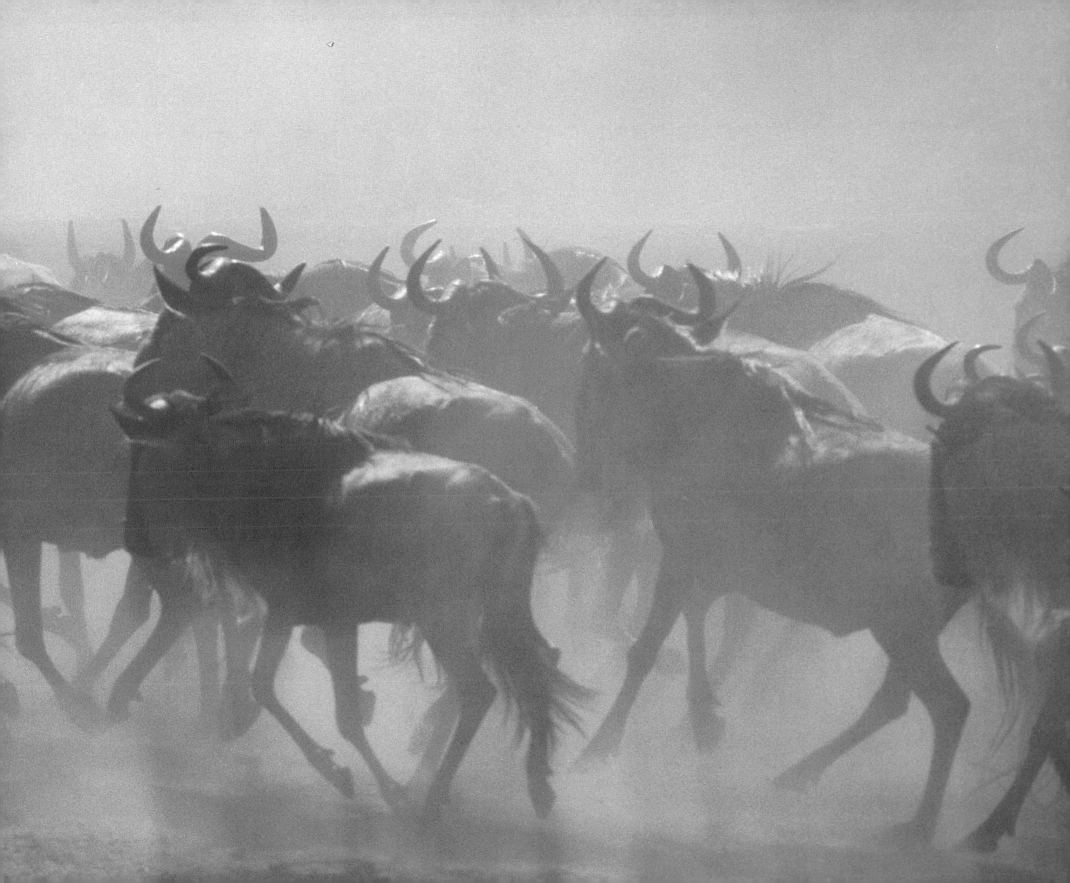

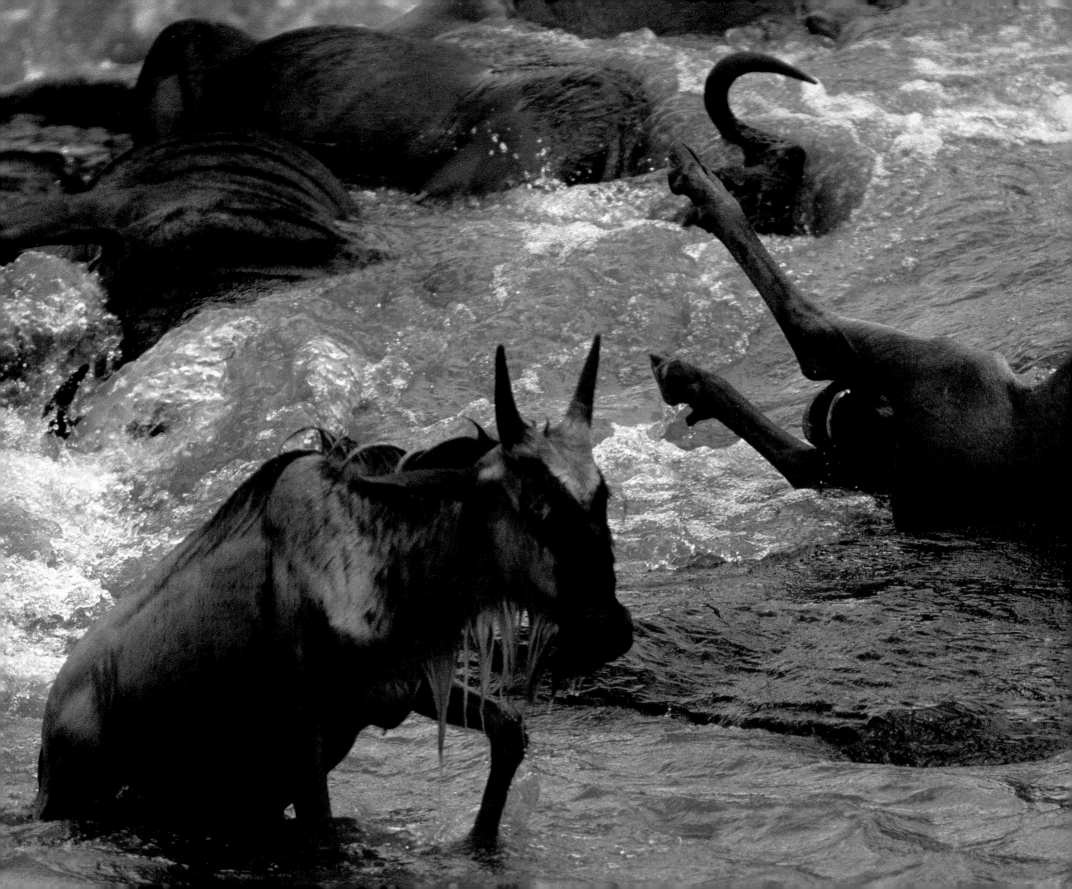

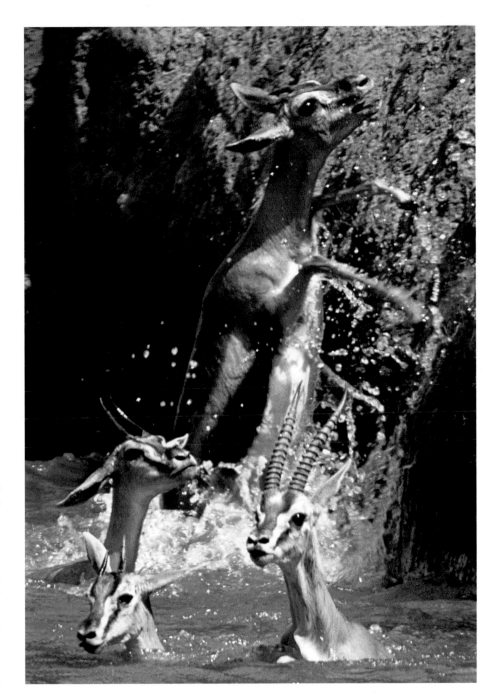

LEFT An isolated wildebeest struggles across smooth rocks, past the bodies of its drowned fellows. The death-throes of other wildebeest and the smell of carrion multiply its stress.

RIGHT Thomson's gazelles occasionally also swim across rivers in search of better grazing. They are pursued by crocodiles, and the steep bank on the other side is insurmountable. They strive in desperation to climb the vertical rock face, mortal agony in their eyes.

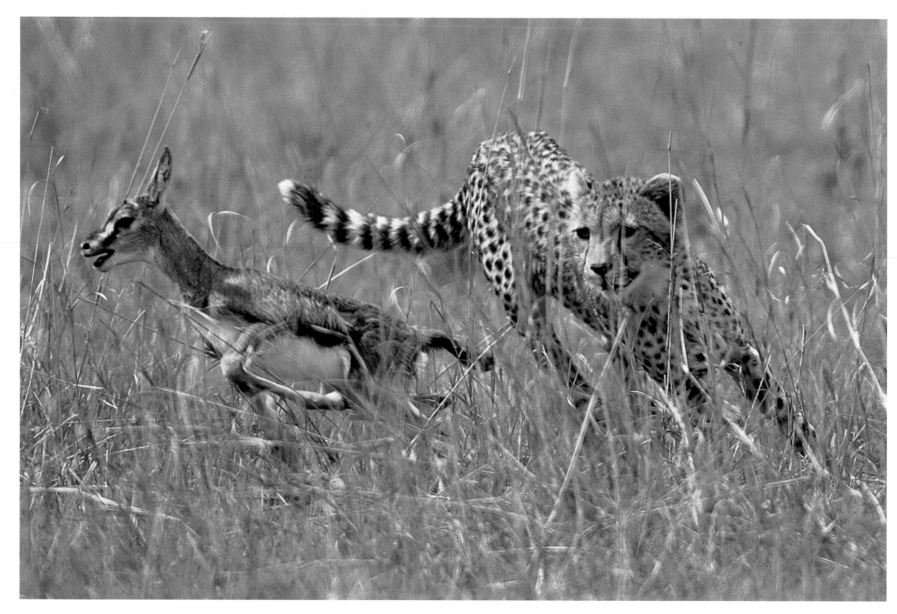

ABOVE Flight is a reflex action. With death at its back, the Thomson's gazelle kid zigzags in an attempt to escape the swift cheetah.

RIGHT The oxygen reserves of the Thomson's gazelle have been exhausted by its flight, and it rapidly suffocates. Death is inevitable; the gazelle offers no resistance.

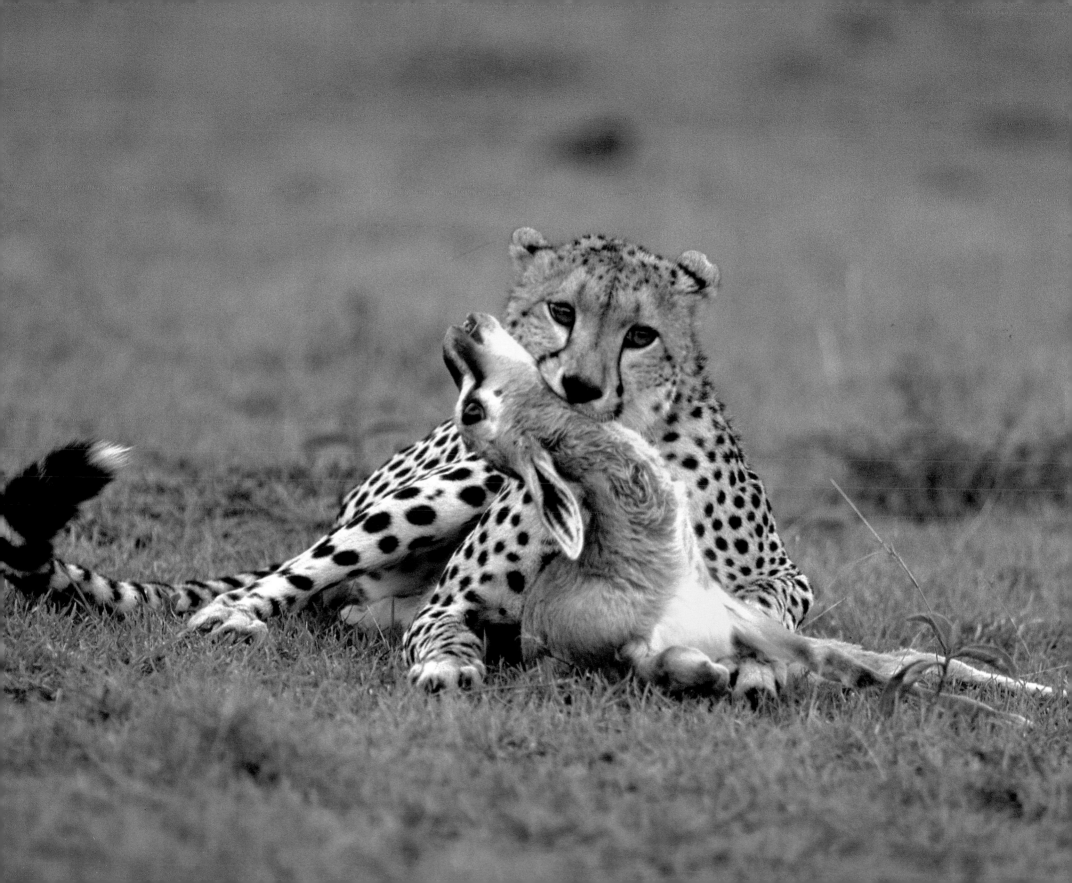

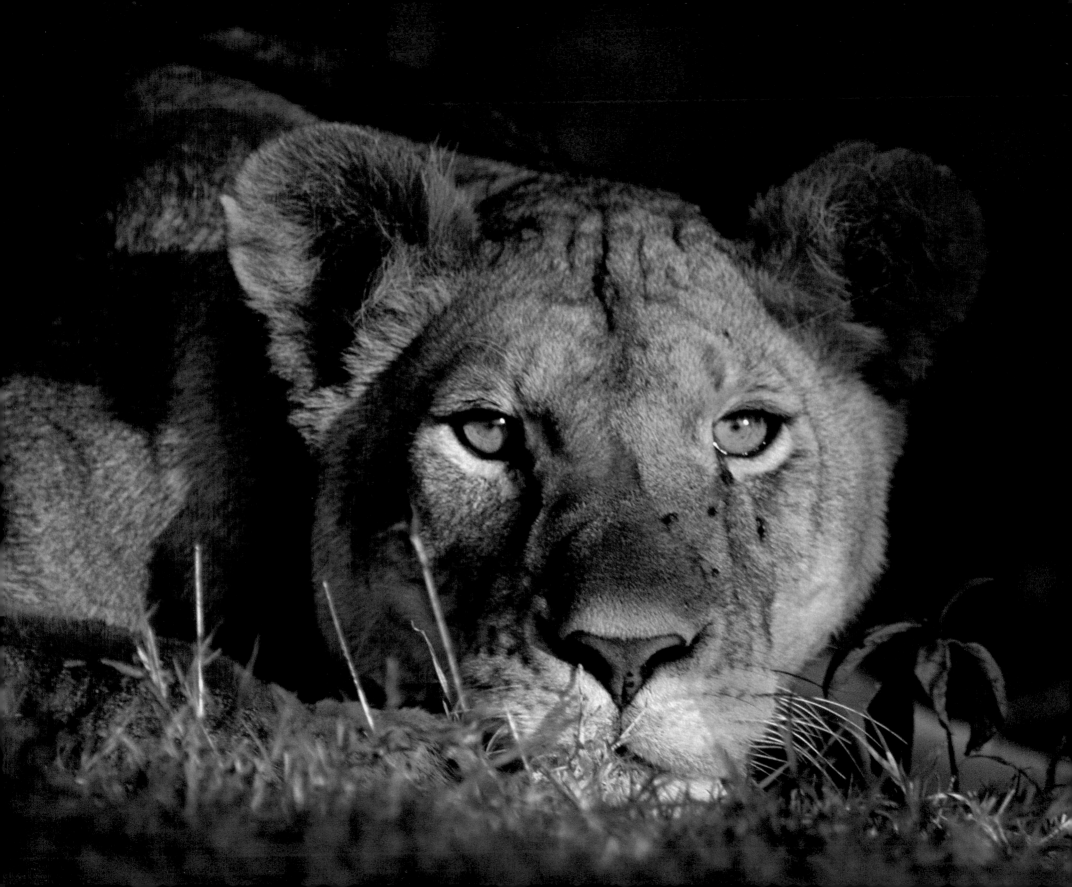

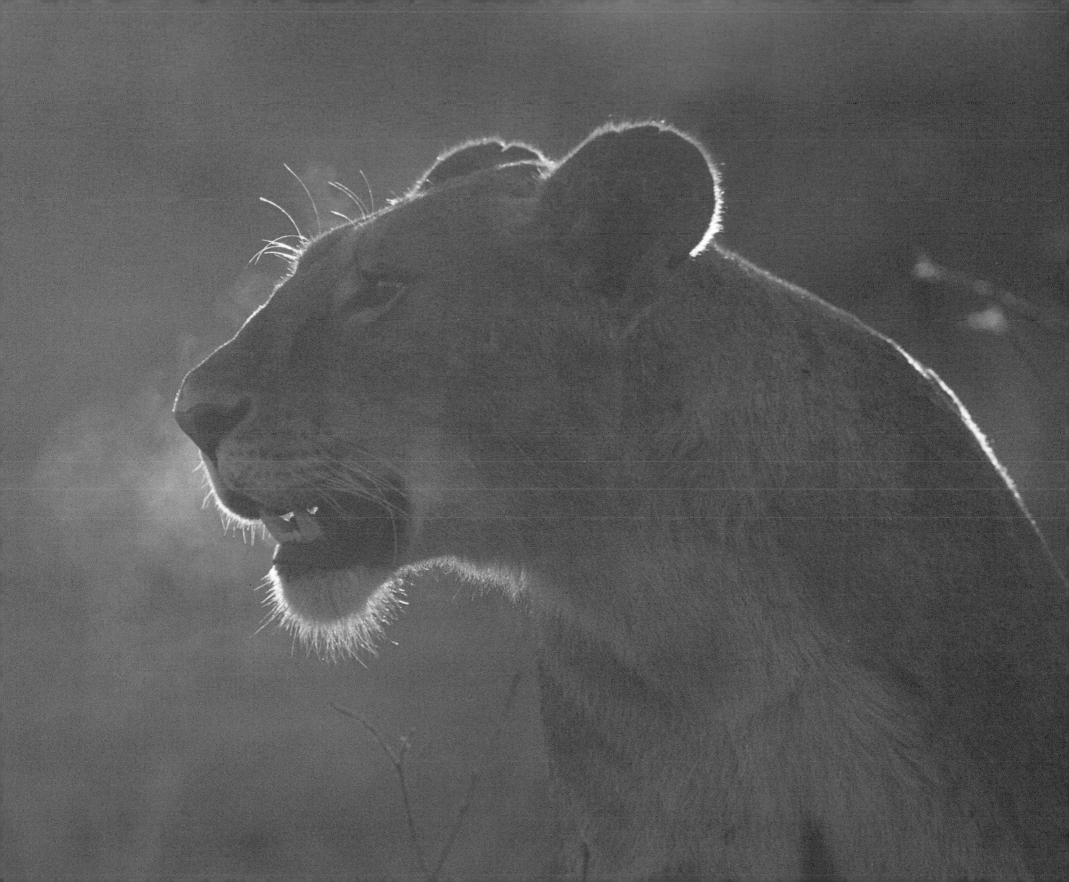

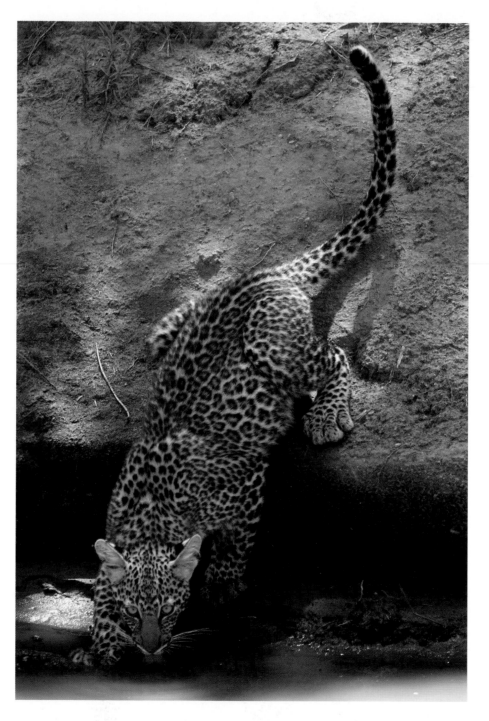

LEFT The drinking leopard does not lift its eyes from the surface of the water. A crocodile could surface, its jaws ready to snap.

RIGHT Vigilance may save the life of the leopard in the acacia tree. He will climb higher before the lions can spot him.

PAGES 142–143 The lioness scents danger. Fear hones her senses and tenses her muscles.

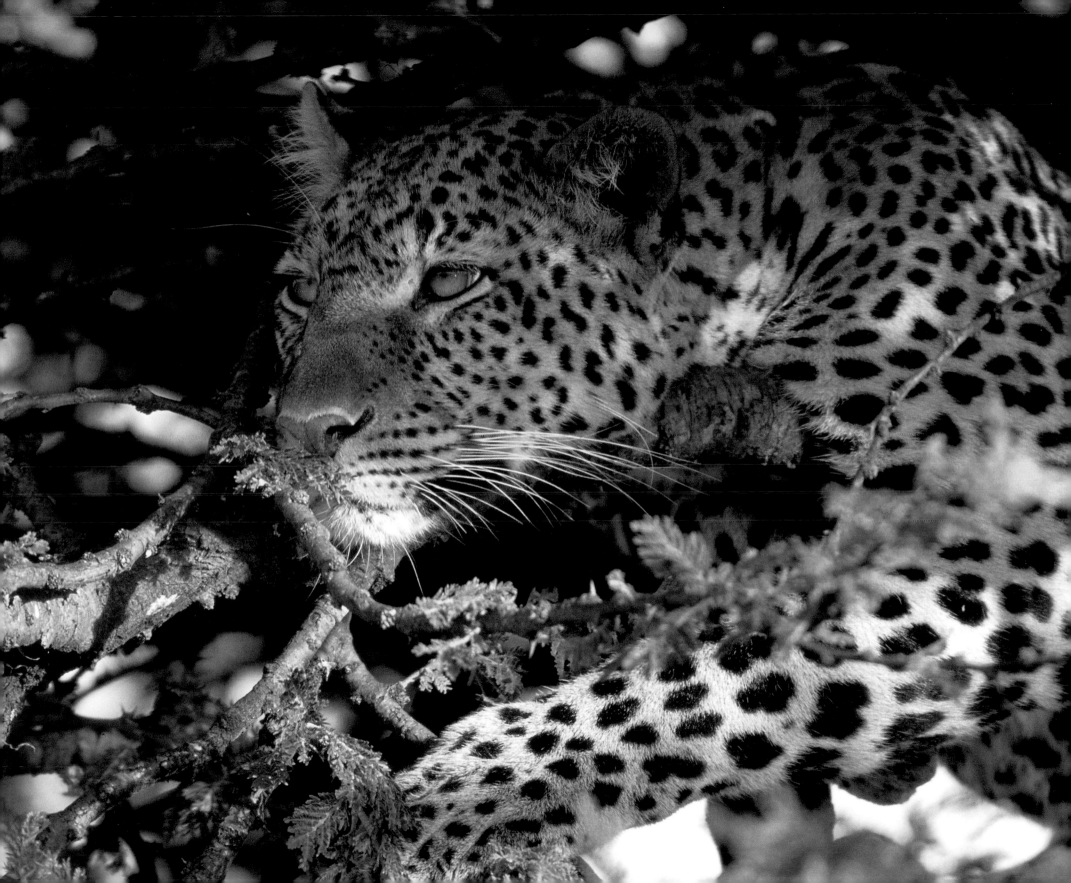

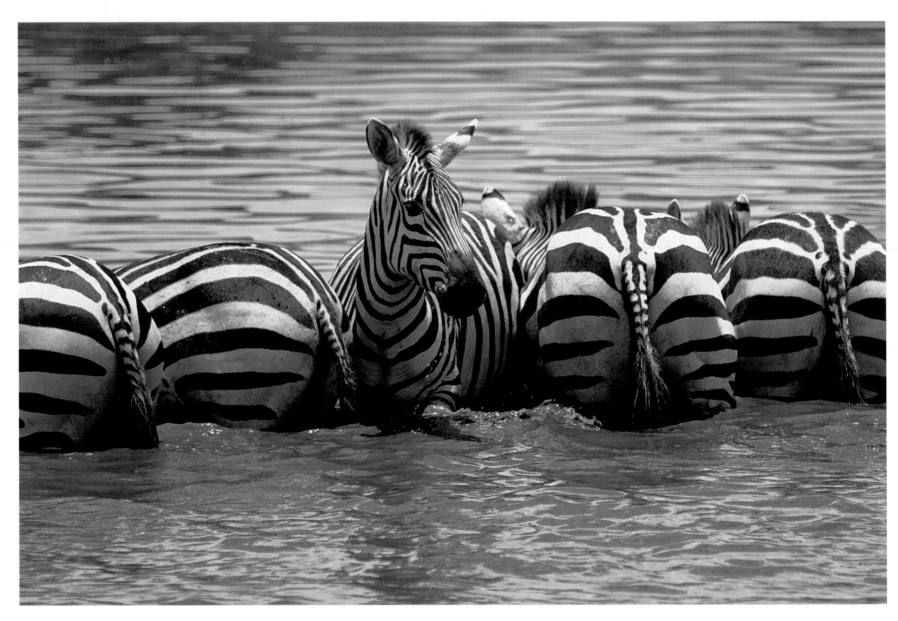

A zebra stands guard, allowing the remaining members of the herd to drink
in peace.

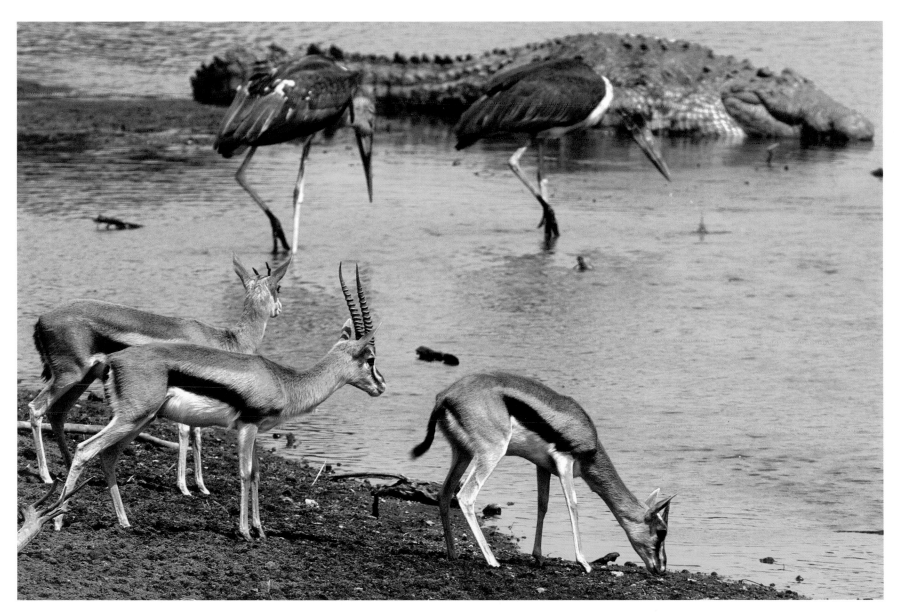

The Thomson's gazelles both sense and see the danger. But will fear deter them from swimming the river?

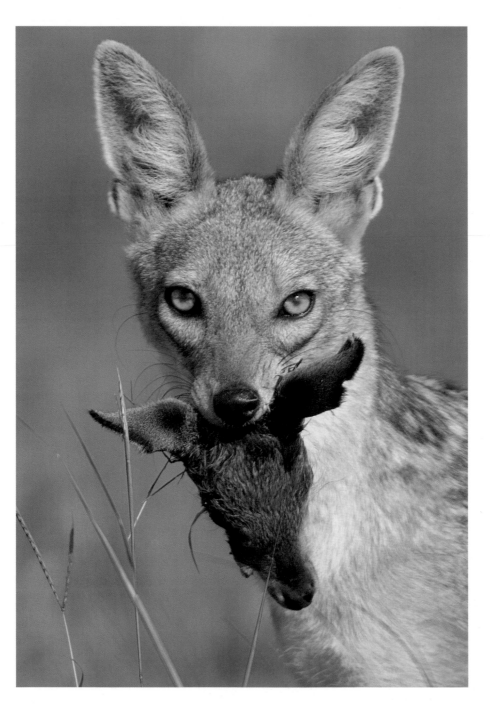

LEFT The jackal suspiciously scans its surroundings. Will hyenas drive him away from his prey?

RIGHT Even elephants are particularly cautious in the twilight hours and at night. The predators now on the prowl may be a danger to the elephants' young.

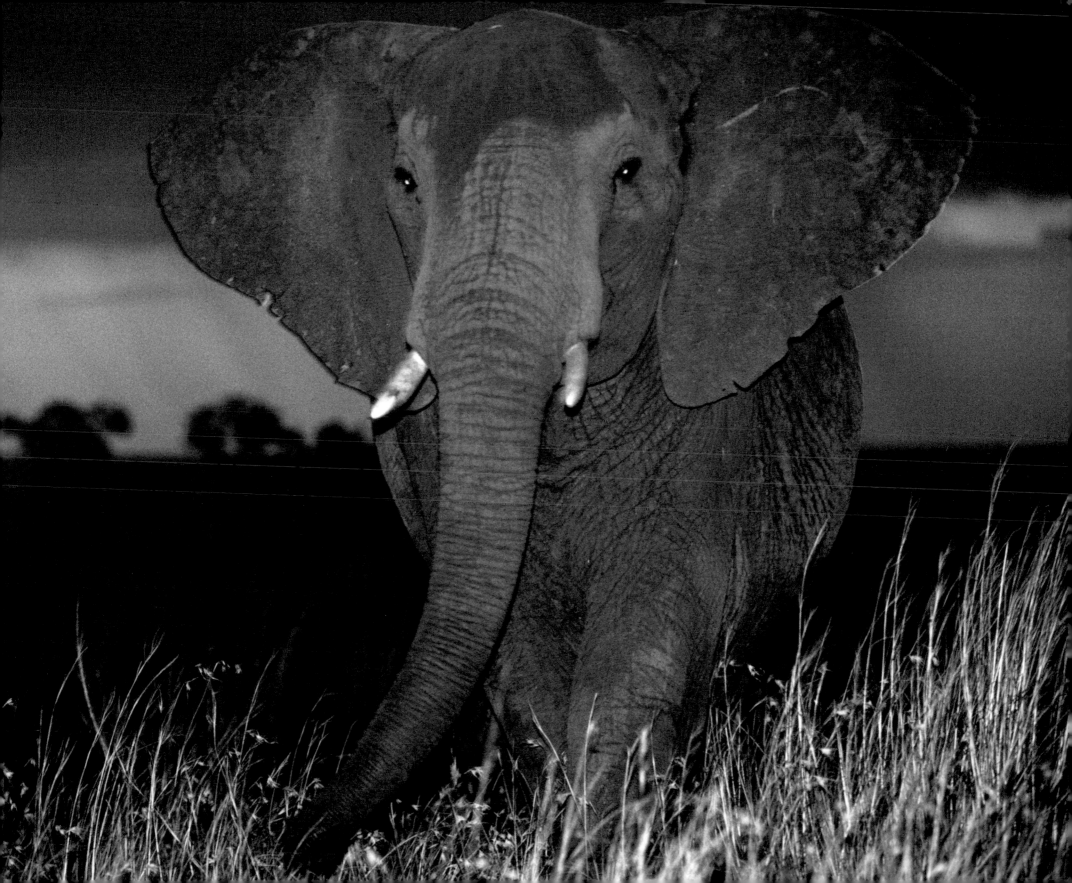

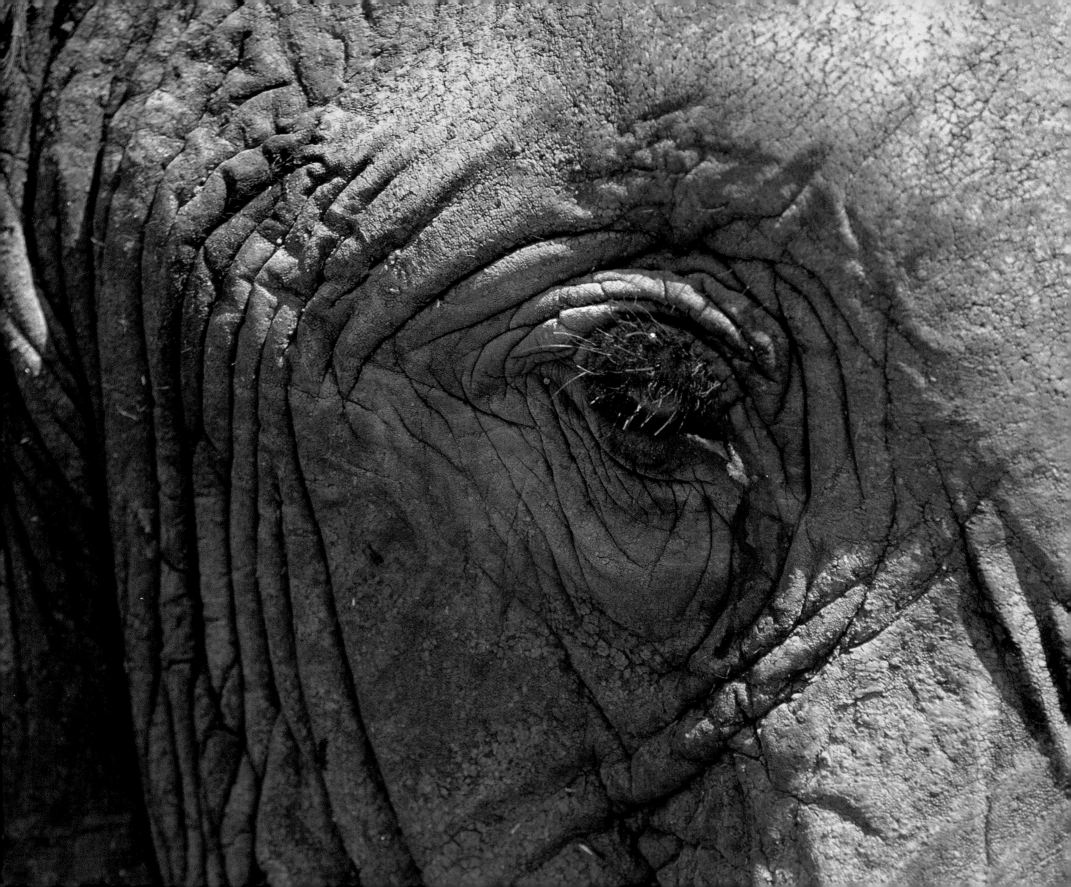

PAIN

Hunger and Thirst – Loneliness – Discomfort and Physical Pain – Grief

If wild animals are capable of experiencing sensations such as joy, they are also familiar with pain. Animals demonstrate a sensitivity to and an ability to experience psychic pain which is more or less marked depending on their species and level of development. They generally endure physical pain and mental distress in silence and withdrawal, uncomplainingly. Documenting their sorrow with the camera is difficult, and observing it and empathizing with them generates a feeling of poignant sadness.

Profound mental distress is triggered by the death of a member of a social group, if the animals knew each other and had established close ties, as is the case with elephants. They genuinely mourn, responding in ways similar to our own, as if they understood the nature of death. Elephants stand for hours next to their dead kin, occasionally touching the body with their trunks. The loss of young is also a tragedy for mother animals, as is the death of a partner for animals living in monogamous relationships. Animals do not weep. Behavioral biologists assume that the common denominator of human and animal grief is stress, triggered by the sensation of being alone and unprotected.

When the young of predatory species are left alone and unprotected because their mother must go hunting, the situation is often painful for them. Siblings react with unhappiness and stress if they lose their playmates. A cheetah cub was separated from its four siblings when they fled from hyenas in the tall savanna grass; the remaining cub and its mother set off to search for the strays, calling and looking out for them from every hill, until they were reunited. Creatures that are forced to abandon their familiar family contacts are unsettled and unsure. Adolescent male lions are driven away by the females of the pride as soon as they reach puberty. Young elephant bulls must also leave their families. Rejected by their familiar social framework, they initially suffer feelings of deep unhappiness and loneliness, and move on only with extreme reluctance.

When wild animals suffer major injuries, death is usually the result. Herd animals are no longer able to flee; predators starve and retreat to die, as they do in case of illness and great physical pain. They suffer in silence, with only their dull coats and desperate gazes betraying their misery. It is believed that prey animals pass into a state of severe shock at the moment of their violent death, and feel no pain. Nevertheless, the death cry of an animal is as terrible as the expression in its eyes.

Heat, cold, drought and flooding also cause distress to Africa's wild animals, which suffer from the bites of tsetse flies, go hungry and thirsty in conditions of drought and apathetically endure the shimmering heat. The herds wander through endless stretches of arid land in their search for water.

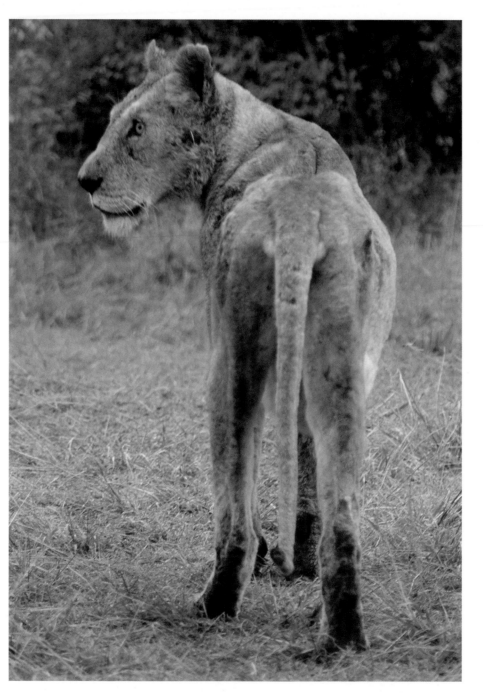

LEFT AND RIGHT Sick and injured, the lioness seeks out a secluded retreat to die. Her torments of hunger and thirst are finally brought to an end by death.

PAGES 156–157 Many animals suffer extremes of thirst during the dry season. Zebras depend more heavily on water than any other of the savanna's herbivores.

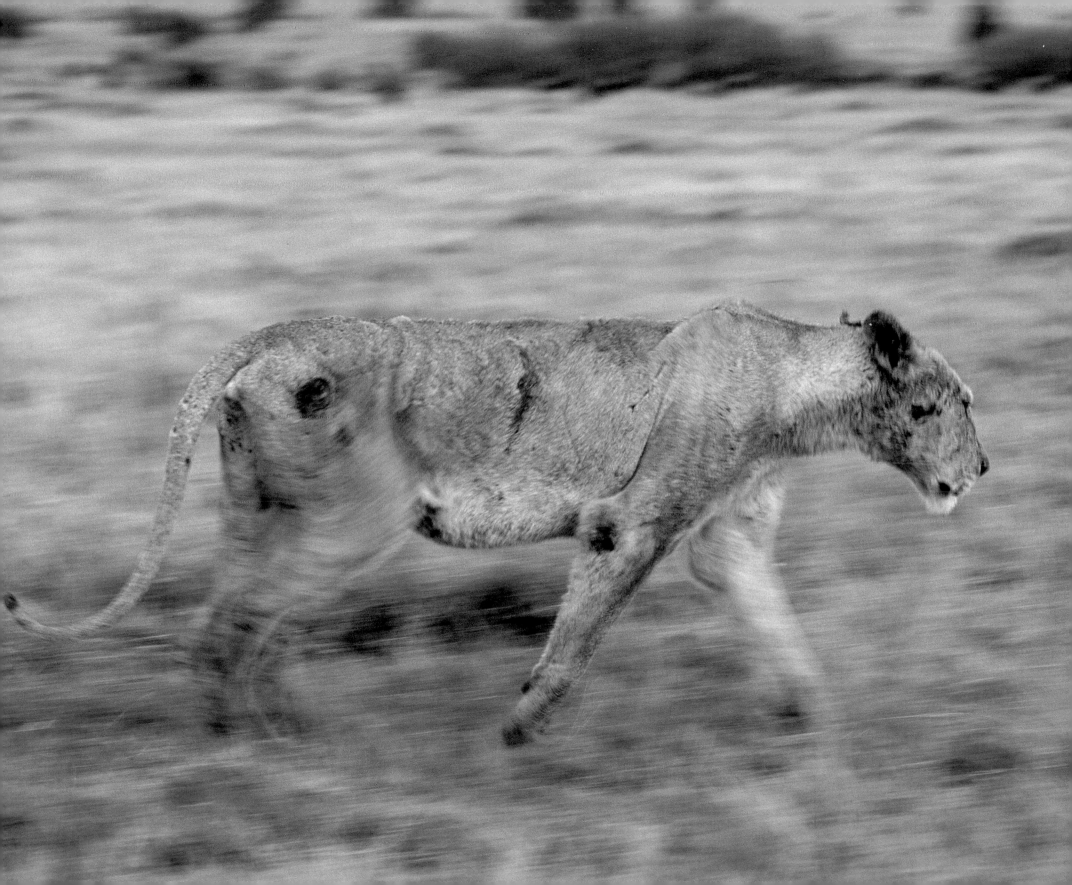

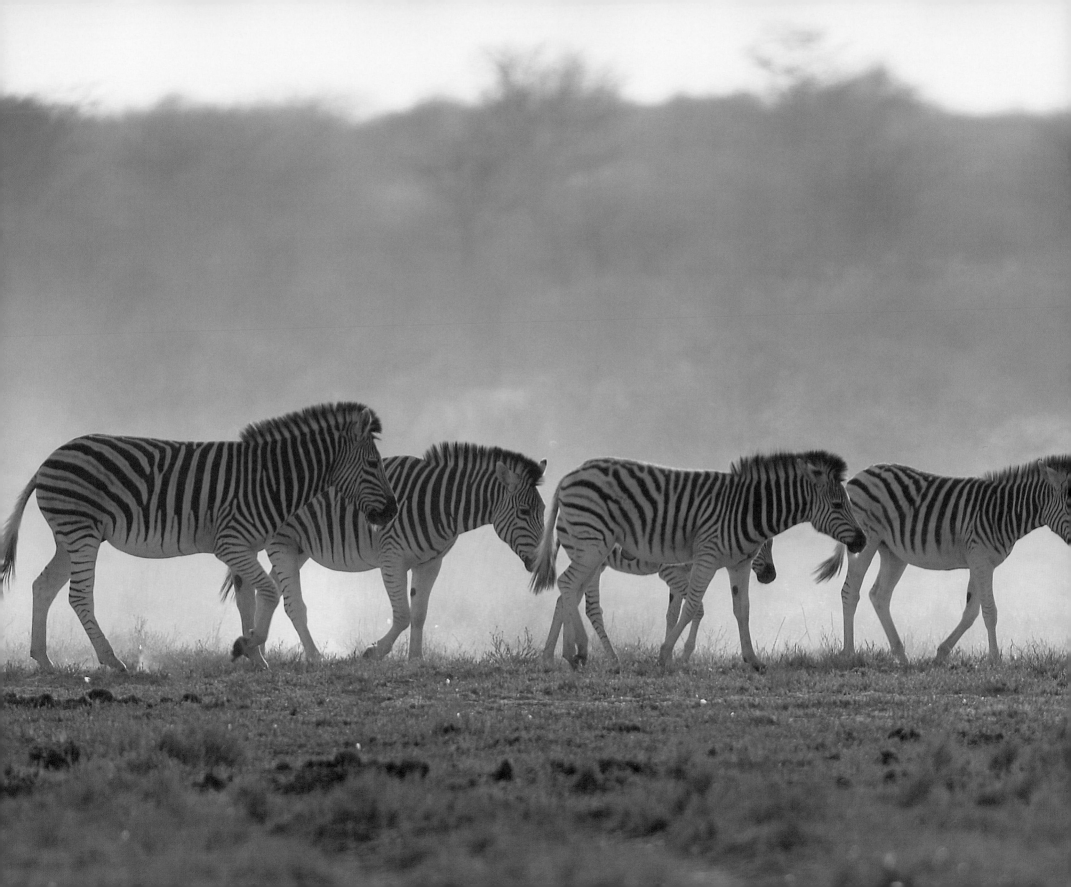

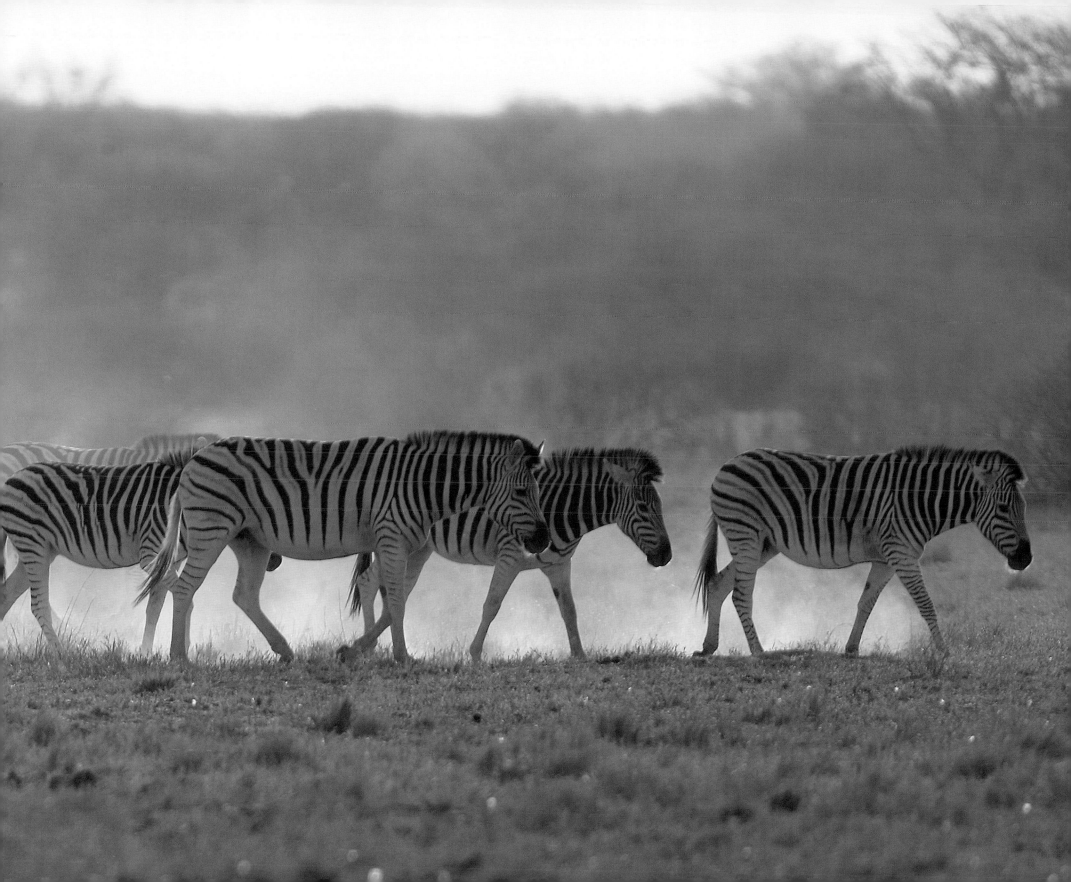

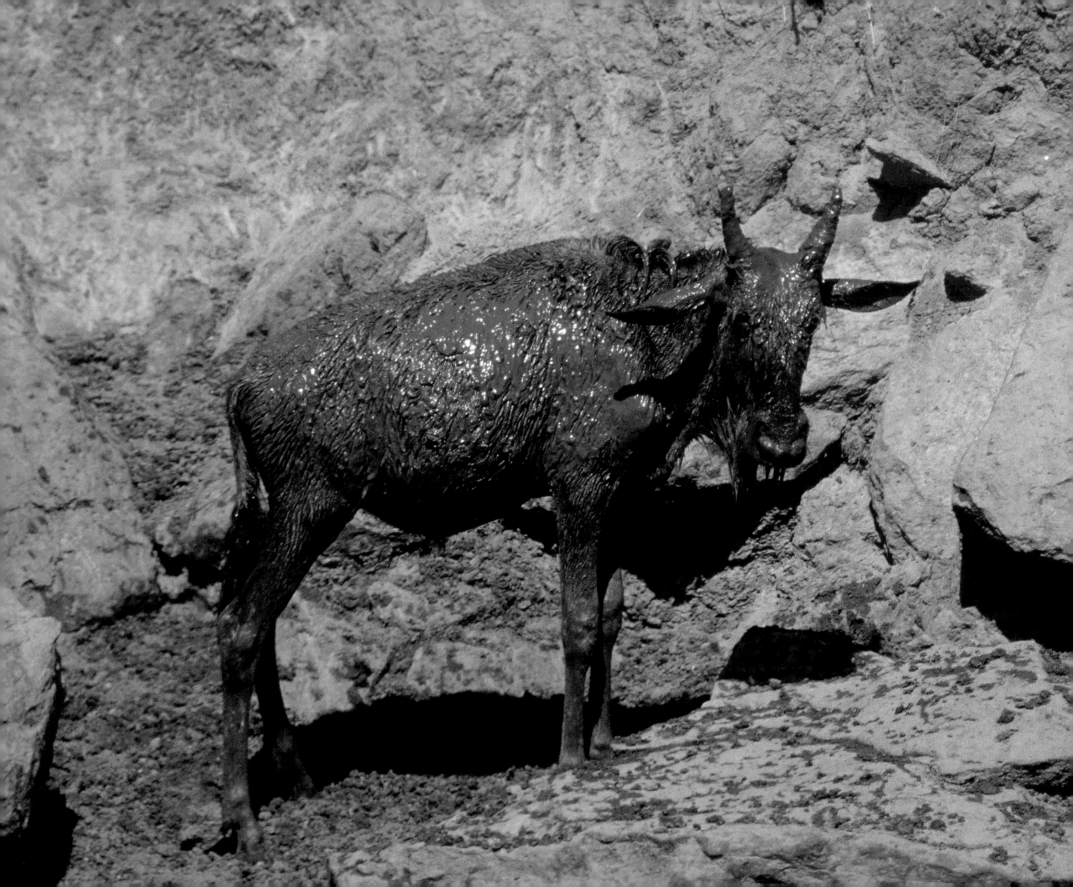

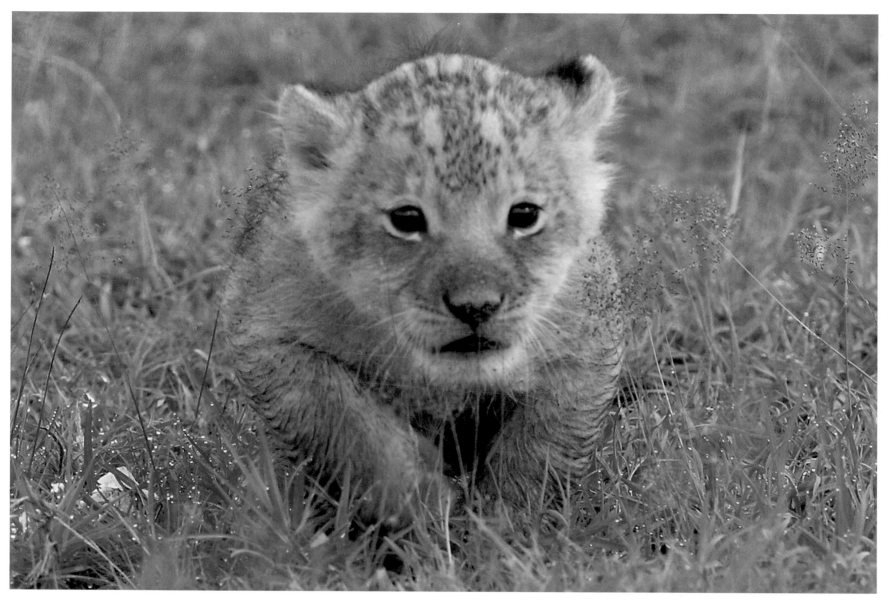

LEFT The wildebeest calf has barely survived the river crossing. Distraught, it remains alone on the bank. Its mother has not emerged from the water.

ABOVE The lion cub left alone by its mother suffers loneliness. This little fellow has no siblings; his mother will not introduce him to the rest of the pride until he is six to eight weeks old.

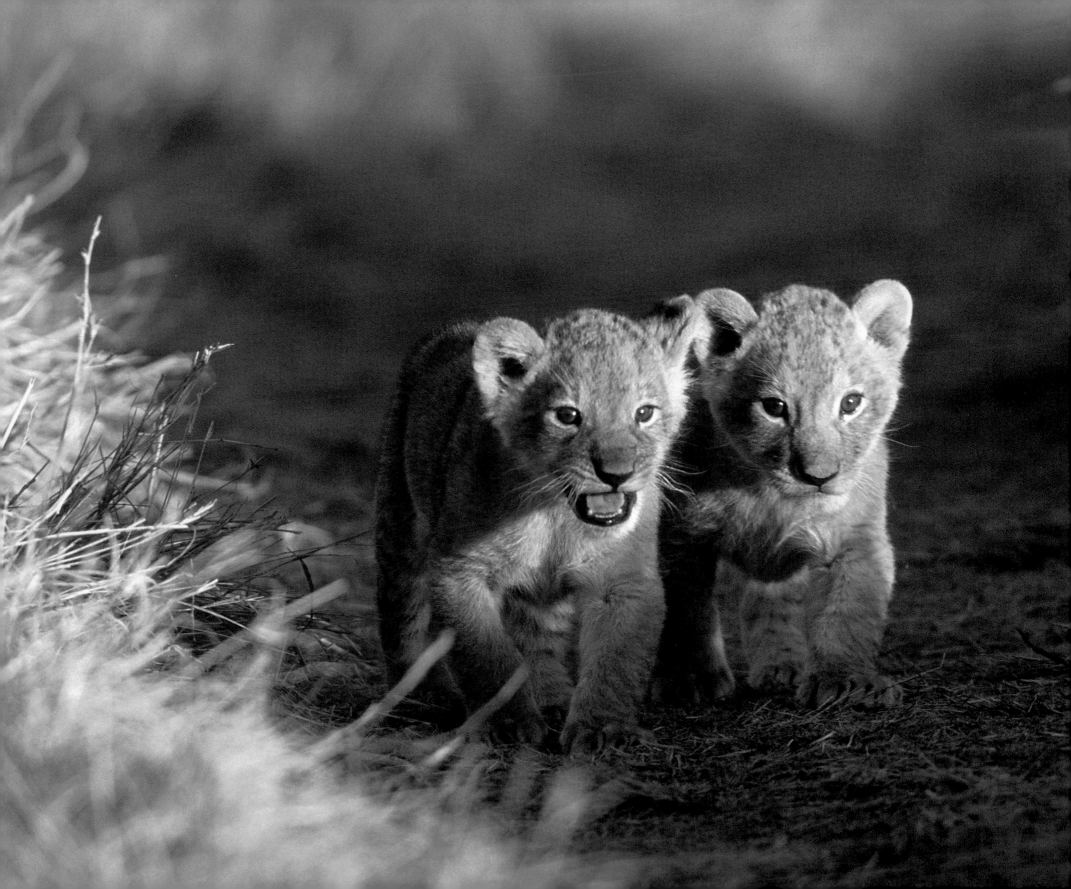

The lower animals, like man
pleasure and pain, happiness

Charles Darwin, Naturalist

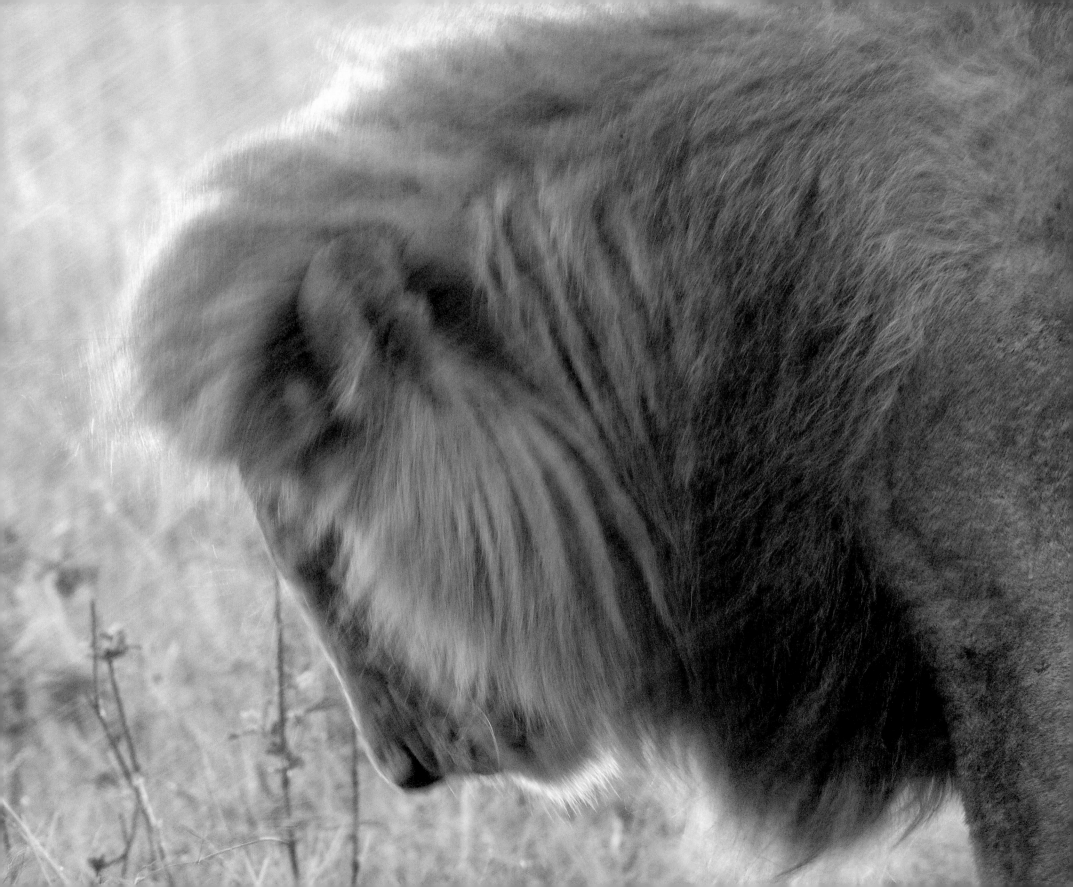

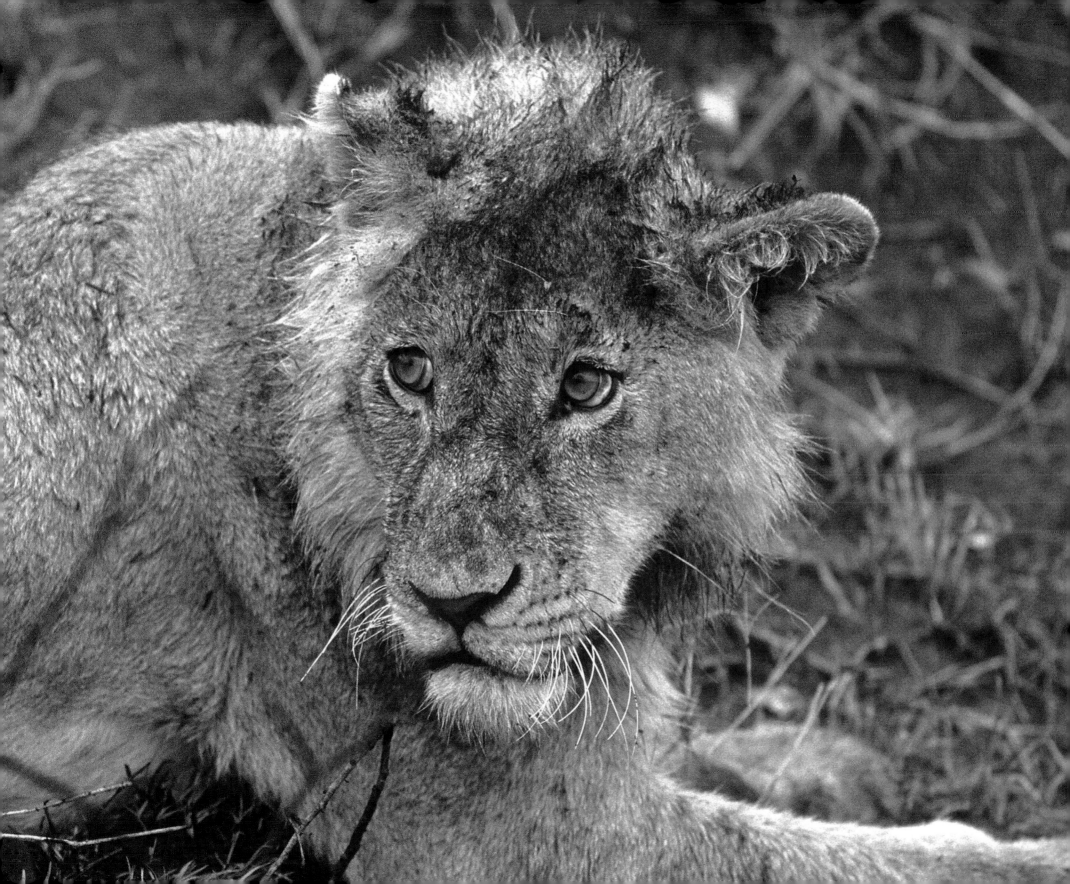

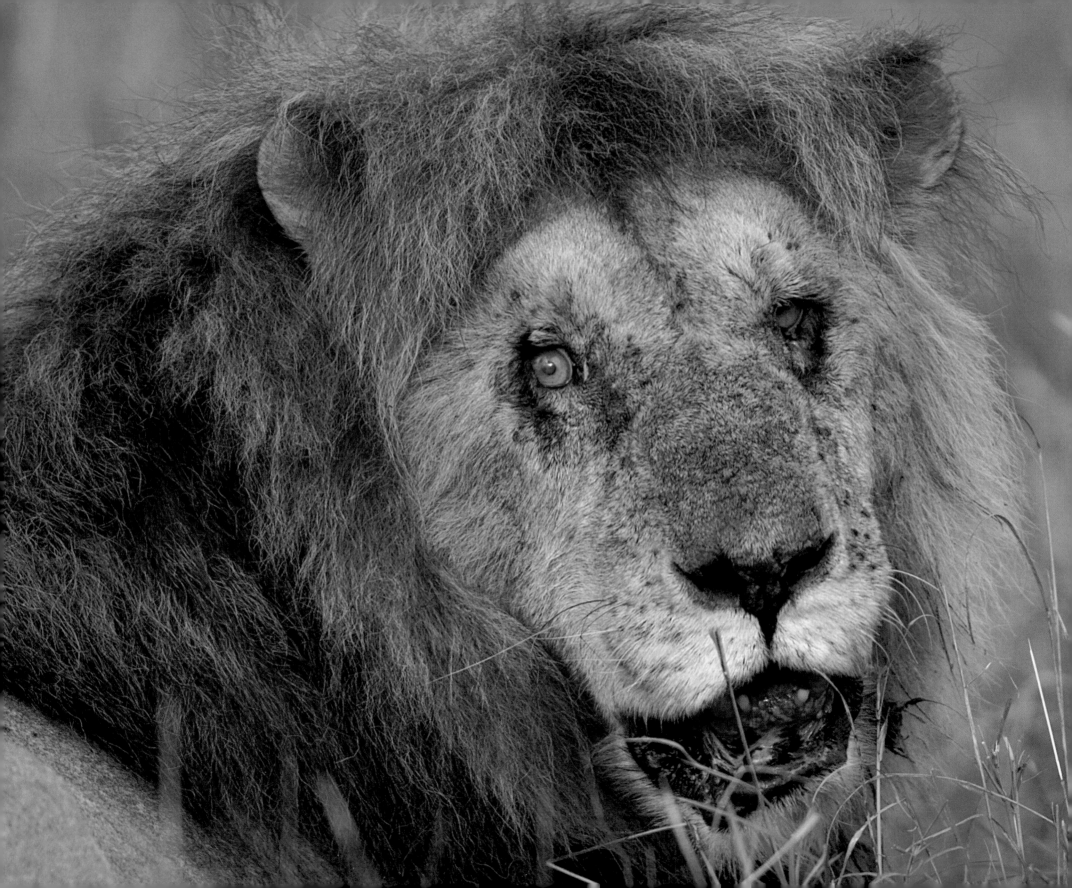

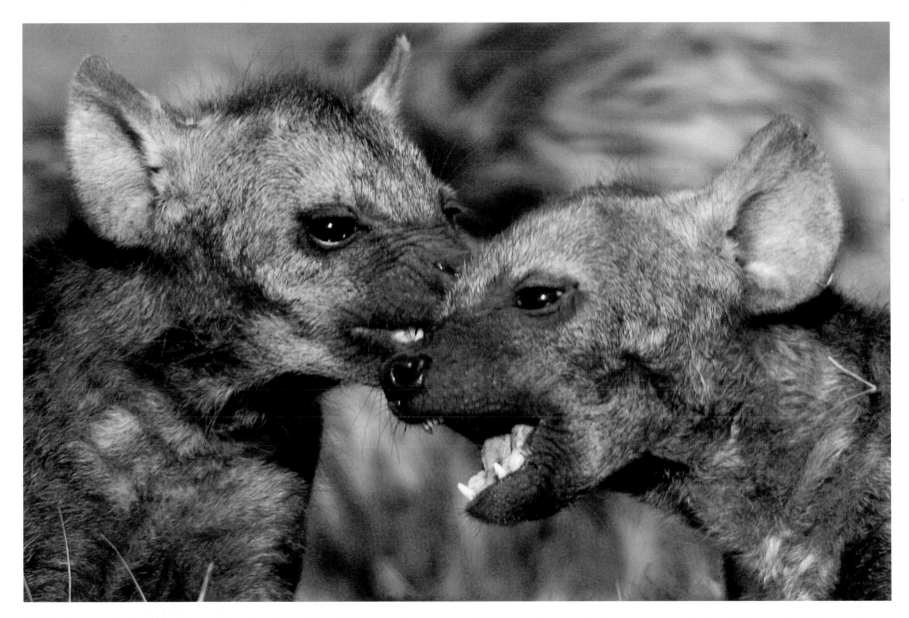

LEFT Broken-jawed, almost toothless, sick and weakened, the old lion must fear every attacker. His days are numbered. His gaze betrays the depth of his misery.

ABOVE These hyena cubs have razor-sharp teeth, which occasionally cause their games to end painfully.

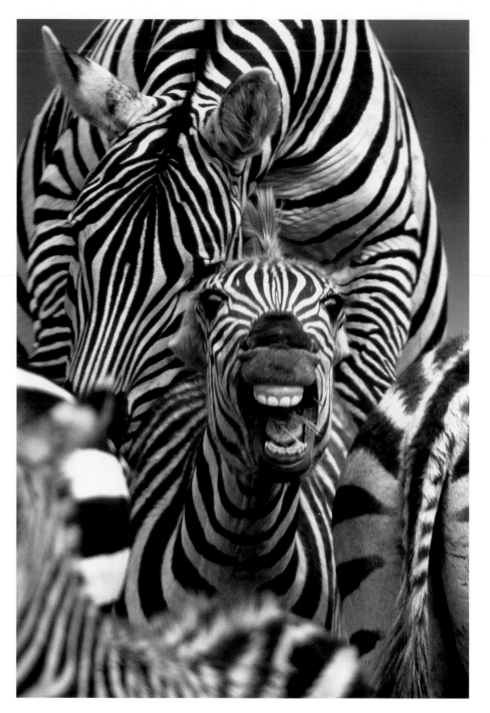

LEFT The stallion's advances are unwelcome. The mare is not ready to mate, and frantically strives to evade his forcible advances.

RIGHT Rival zebra stallions fight fiercely, lashing out with painful bites and kicks.

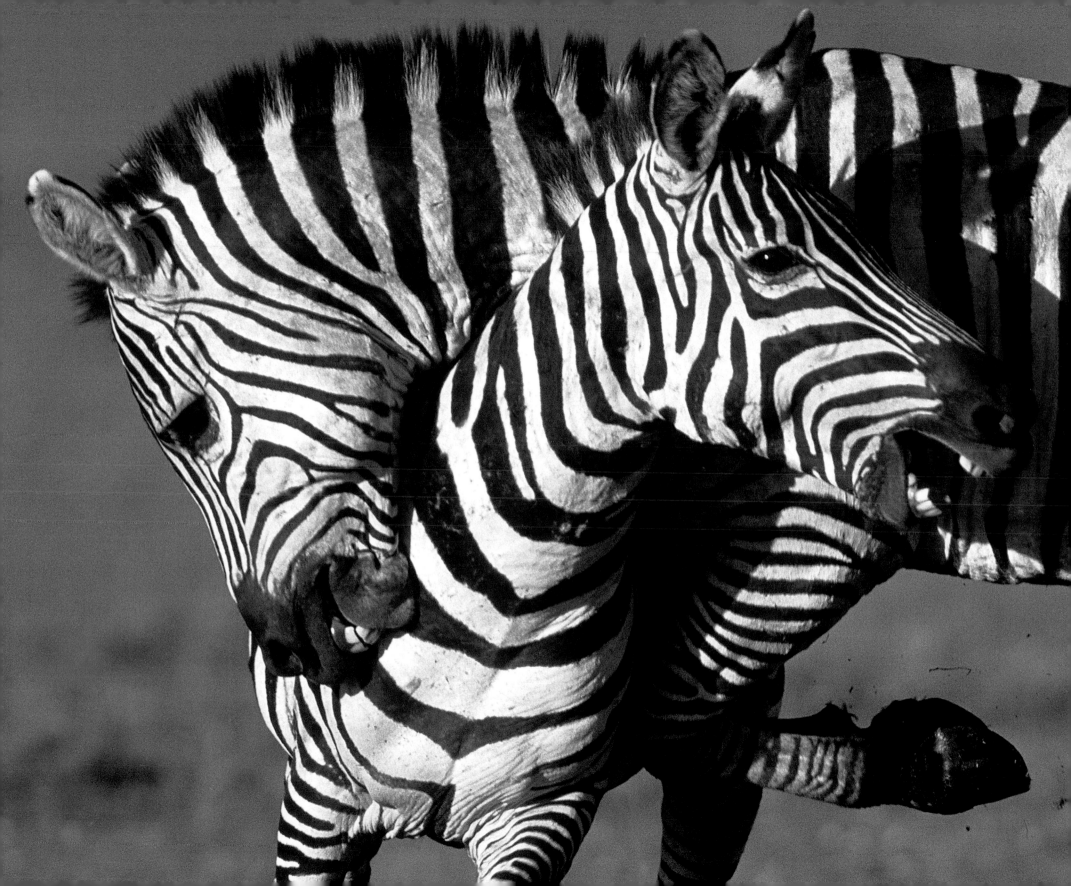

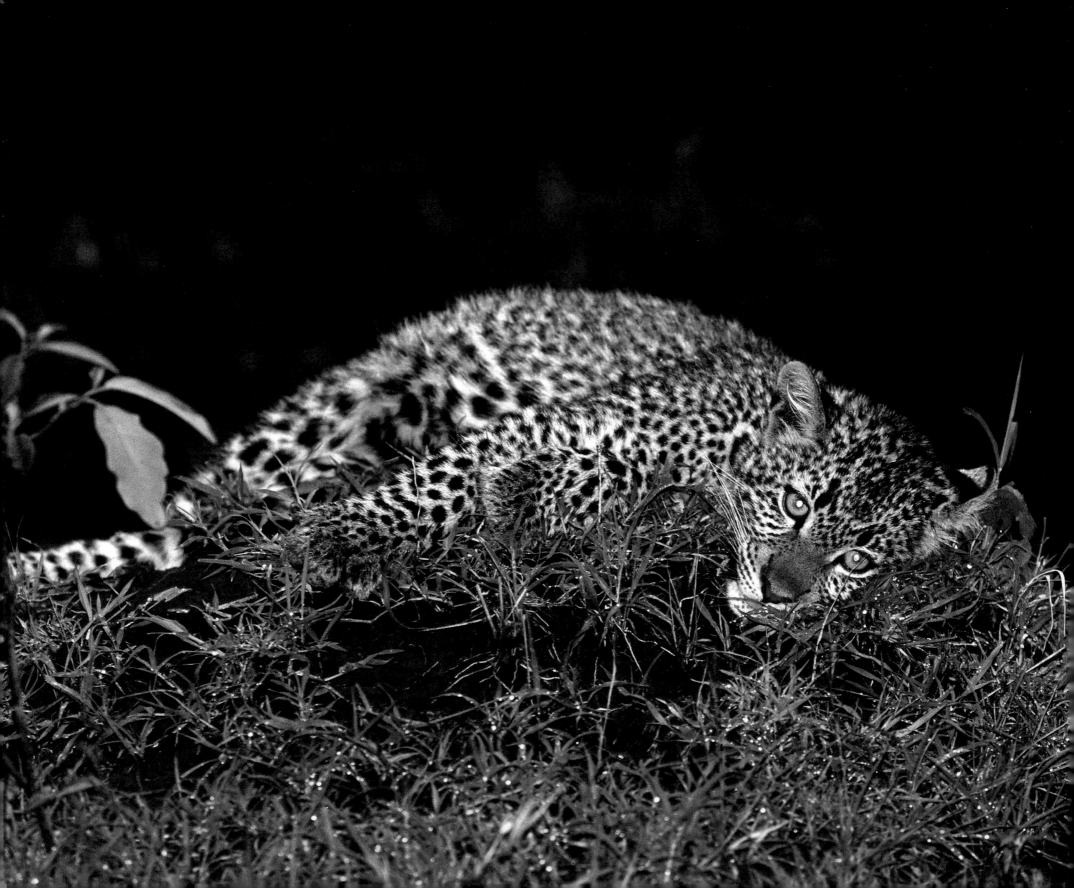

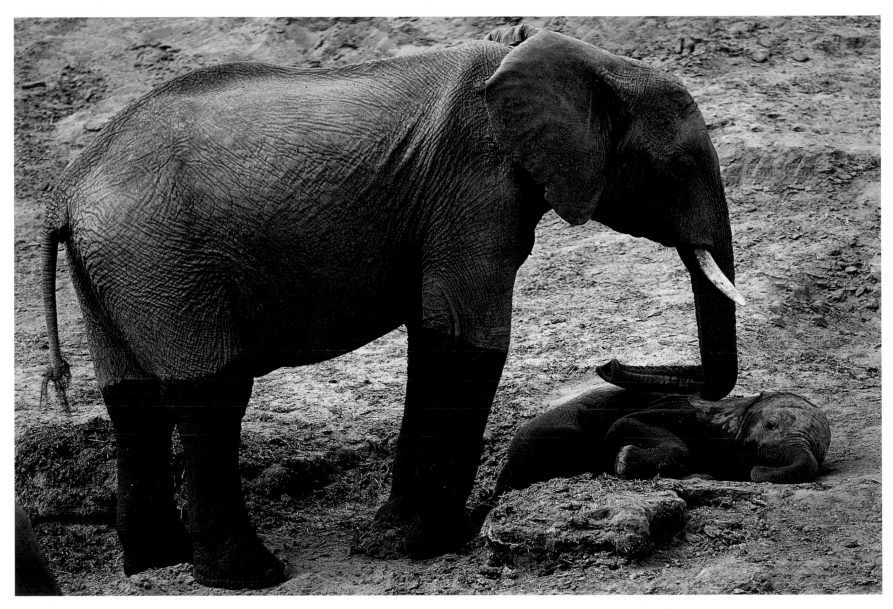

LEF At the age of 18 months, this young leopard is abandoned by his mother. From now on he must lead the life of a solitary loner, and is initially saddened by the prospect, suffering at the separation from his mother.

ABOVE Elephants feel deep emotional pain when a member of their family dies. They spend hours nuzzling the body with their trunks, gently touching it with their feet or attempting to lift it with their tusks.

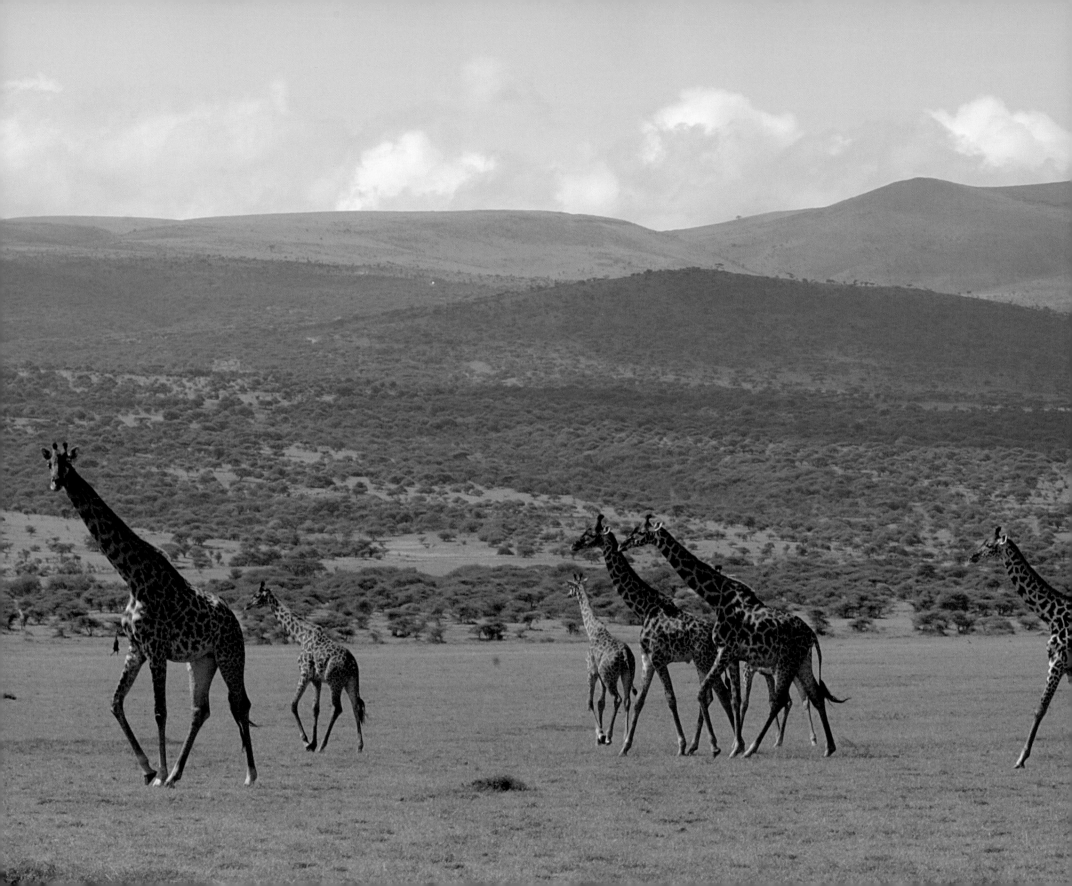

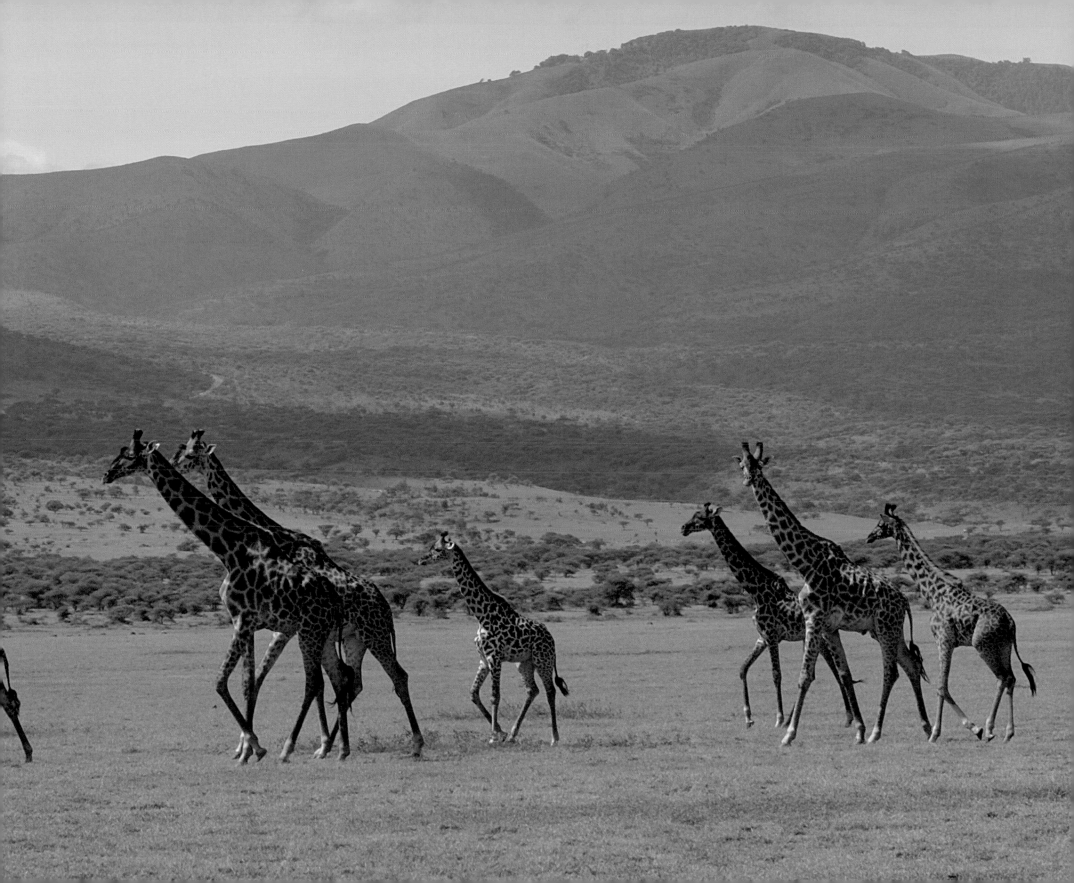

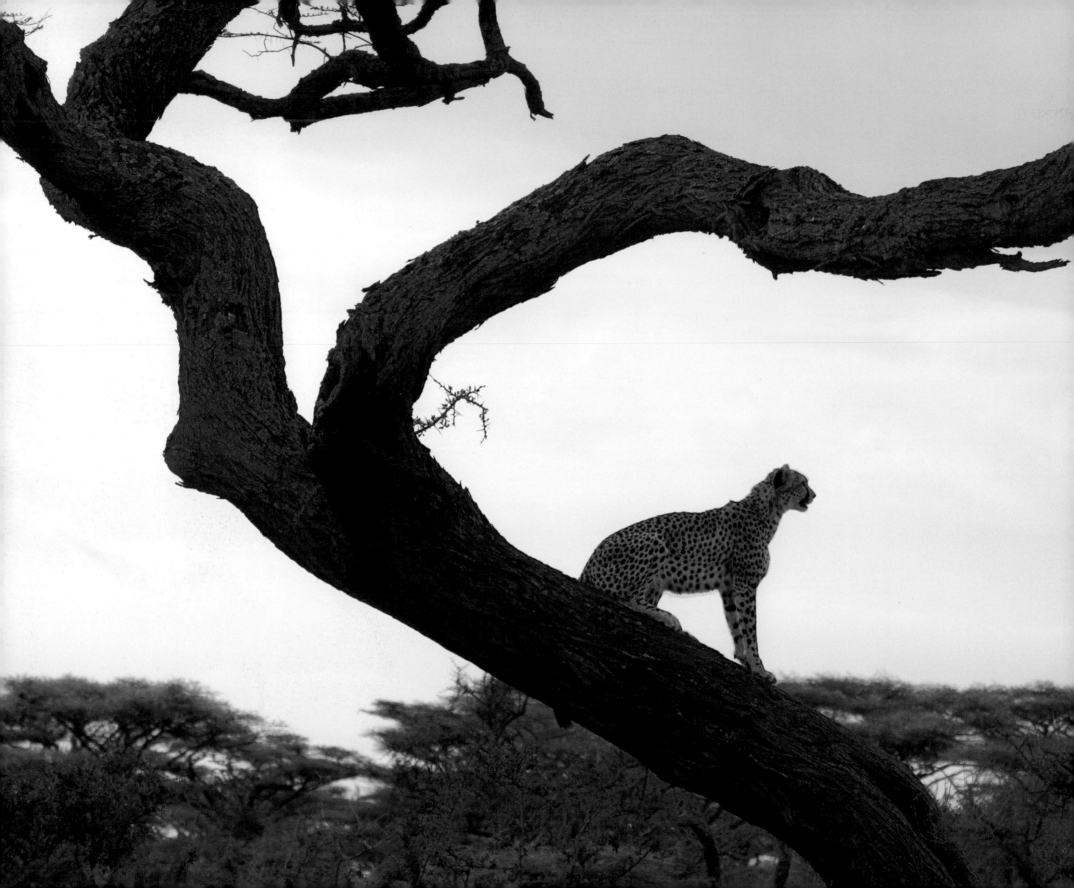

We know that many animals experience rich and deep emotional lives. They feel emotions such as joy, happiness, fear, anger, grief, jealousy, resentment, and embarrassment.

Marc Bekoff, Biologist and Ethologist

www.bucher-publishing.com

Experience the colors of our world

Kalahari
200 pages, about 300 pictures
ISBN 978-3-7658-1593-5

Little Polar Bears
176 pages, about 148 pictures
ISBN 978-3-7658-1586-7

Growing up Wild
144 pages, about 150 pictures
ISBN 978-3-7658-1636-9

Colors of the Tropics
176 pages, about 250 pictures
ISBN 978-3-7658-1691-8

The Earth as Art
300 pages, about 300 pictures
ISBN 978-3-7658-1628-4

Forest Planet
208 pages, about 350 pictures
ISBN 978-3-7658-1689-5

www.bucher-publishing.com

⊁B BUCHER

Gabriela Staebler is one of the world's most accomplished nature and wildlife photographers. She has published her work in magazines such as National Geographic, GEO, BBC Wildlife, and Nature's Best and is the recipient of more than 40 awards from renowned photographic competitions. She lives in Upper Bavaria, Germany. See also www.gabrielastaebler.de

The author is donating 25% of her royalty for this book to Frankfurt Zoological Society for the protection and conservation of the SERENGETI.

This work has been carefully researched by the author and kept up to date as well as checked by the publisher for coherence. However, the publishing house can assume no liability for the accuracy of the data contained herein. We are always grateful for suggestions and advice. Please send your comments to: C.J. Bucher Publishing, Product Management, Innsbrucker Ring 15, 81673 Munich, Germany. *editorial@bucher-publishing.com*

All photographs and text by Gabriela Staebler.

Translation: Alison Moffat-McLynn, Munich, Germany
Proof reading: Emily Banwell, Walnut Creek, CA, U.S.A.
Graphic design: Frank Duffek, Munich, Germany
Product management for the English edition:
Dr. Birgit Kneip
Product management for the German edition:
Joachim Hellmuth
Production: Bettina Schippel
Repro: Repro Ludwig, Zell am See
Printed and bound in Italy by Printer Trento

See our full listing of books at
www.bucher-publishing.com